M000085450

IMAGES
of America

ENSLEY AND
TUXEDO JUNCTION

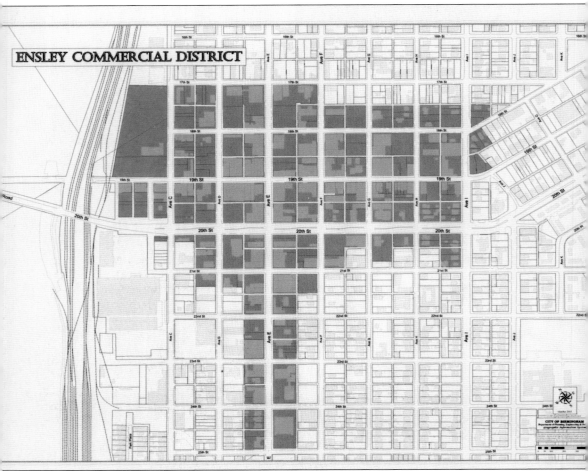

ENSLEY COMMERCIAL DISTRICT

This map of the Ensley commercial district (with the railroad lines still forming a north-to-south border along the western edge) demonstrates the layout and scope of the central business district that developed along with the rise of Ensley Works as one of the largest and most productive centers of steelmaking in the South. Many of the businesses and churches discussed throughout the book began within this grid. Lying just on the outskirts are the schools and neighborhoods. (Courtesy of the City of Birmingham, online GIS mapping system.)

ON THE COVER: Ensley's business district, as shown here around 1937, was a bustling mix of merchants, restaurants, banks, and churches. The towering 10-story Ramsay-McCormack building is the tallest building in Ensley and was the landmark structure in the community. The entrance to the massive Tennessee Coal and Iron Steelworks facility is on the horizon at the end of Nineteenth Street, which dead-ends into the factory. (Courtesy of Birmingham Public Library Archives.)

IMAGES
of America

ENSLEY AND
TUXEDO JUNCTION

David B. Fleming and Mary Allison Haynie

ARCADIA
PUBLISHING

Published by Arcadia Publishing
Charleston, South Carolina

Printed in the United States of America

Library of Congress Control Number: 2010929216

For all general information, please contact Arcadia Publishing:
Telephone 843-853-2070
Fax 843-853-0044
E-mail sales@arcadiapublishing.com
For customer service and orders:
Toll-Free 1-888-313-2665

Visit us on the Internet at www.arcadiapublishing.com

To the individuals who pursued their ideals, goals, and aspirations in Ensley and to the many industrialists, leaders, laborers, entrepreneurs, and artists for their contributions to the city of Birmingham, the state of Alabama, and the United States

CONTENTS

ACKNOWLEDGMENTS

The authors would like to acknowledge the assistance of so many people who answered the call to present photographs that represent a broad and inclusive documentation of the community's history. We also appreciate the archivists and curators of the collections we have researched for photographic and historic documentation of Ensley. This includes Jim Baggett and the staff of the archives of the Birmingham Public Library and Liz Wells of the Samford University Special Collections. Individuals, agencies, businesses, and churches that contributed include Ann Ruisi, John W. Nixon Jr., Hazel Freeze Percer, Ruth Harvill Hill, Lizzie Bass Allen, Violet Hester Hopping, Sue Hardy Thomas, Dana Crooks Dortch, Lucy Elaine Ray, Anthony Marino, Eddie Mae Thomas, Marion and Rick Spina, Magnolia G. Cook, John C. Meeham, Dr. Mabel Anderson, Vincent Mariano, Cotton's Department Store, Ideal Furniture, Fire Station No. 16, First Baptist Church of Ensley, Holy Family Church, and Abyssinia Missionary Baptist Church. Unless otherwise noted, all photographs are the property of the authors.

We appreciate Arcadia Publishing for taking interest in this project on Ensley and Tuxedo Junction and guiding us through the publication process. We would also like to give our thanks to the many people who not only shared their images, but also their stories, memories, and primary knowledge of the people and places of Ensley. Many current and former residents reached out to friends and neighbors to assist in the collecting of images and historical moments. Their dedication to the project made this experience in cultural preservation enlightening and possible.

INTRODUCTION

After the Civil War, Southern states like Alabama were looking for ways to recover from the devastation wrought by the five-year conflict. Many Southern cities were destroyed, the Southern economy was in ruins, and almost an entire generation of Southern men had been killed or wounded in the war. While Alabama did not see as many major battles and as much devastation as states like Virginia, Georgia, and Tennessee, she did possess something crucial to the Confederacy that made her a target for the Union—her ability to produce weapons. The state's arms production, ranging from swords to cannons and ammunition, made Alabama the "Arsenal of the Confederacy." The same natural resources that allowed Alabama to produce weapons when matched with the ambitions of men would lay the groundwork for a place like Ensley, Alabama, to be born.

As early as the 1820s, geologists had come to know that central Alabama had all the ingredients necessary to support a major manufacturing industry. The abundance of coal, limestone, and iron ore made it possible to build businesses to produce iron and steel and push Alabama into the industrial future. That future had to wait until after the Civil War and for the meeting of the Alabama and Chattanooga and the Louisville and Nashville Railroads in the middle of rural Jones Valley in Jefferson County. This new infrastructure would lead to the creation of the city of Birmingham and unlock the entrepreneurial spirit and vision of men like Enoch Ensley.

Beginning in the early 1880s, Enoch Ensley, a wealthy Tennessee merchant and planter, acquired property just west of Birmingham and adjacent to the Pratt coal seam. It was his vision to develop a major steel production facility, and it was here that he would found the town of Ensley. As the president of the Ensley Land Company, he assembled 4,000 acres of land. Ensley also served as president of the Tennessee Coal Iron and Railroad Company (TCI) and invested in a majority of the corporation's stock. The vision for Ensley was for a modern industrial town laid out in a grid pattern that paralleled the proposed iron and steel plant and featured a complete sewage system. Ensley was ready for business.

The town of Ensley was slow to grow in the 1890s, but boomed in the early 1900s. Its population was recorded as 10,000 people in 1901, had doubled by the time of Ensley's merger with Birmingham in 1909, and by 1934 had reached 41,000. People moved to Ensley from all over the world as they sought a new life and opportunity. Ensley became a bustling mix of people and cultures. African Americans made up a large portion of the population, but there was also a significant Italian American population. A 20-block residential area along Avenue F became known as "Little Italy." Ensley also boasted significant Jewish, Greek, and Irish communities as well.

Even though Ensley had merged with Birmingham, it retained a strong sense of separate identity, often called "a city within a city." Ensley's business district was a regional shopping destination that rivaled downtown Birmingham. Business there expanded well beyond the expectations of a simple company town to include major department stores, banks, theaters, jewelers, restaurants, lawyers, dentists, and more. The importance of Ensley is reflected in its architecture. Ornate structures with intricate details suggest that architects and builders wanted to make a grand

statement. This is most noted in the 10-story Ramsay-McCormack Building on the corner of Avenue E and Nineteenth Street. Started in 1926 by industrialist and businessman Erskine Ramsay, the skyscraper was the tallest building in the city outside of downtown Birmingham. From its top floor, one could see the entire sprawling TCI operation, now owned by U.S. Steel, and for miles around.

The Tuxedo Park section of Ensley developed primarily as a residential area for African Americans employed at the U.S. Steel Ensley Works. A small but vibrant African American business district grew around the intersection and turnaround point of the Wylam and Pratt City streetcar lines. The location came to be known as "Tuxedo Junction," where steel mill laborers shed their work clothes, rented tuxedos, and danced the night away in class and style. The area has significance in American musical history. Tuxedo Junction was immortalized in a big band song of the same name written by a local jazz musician Erskine Hawkins. When the Glen Miller Orchestra recorded the song in the 1940s, it became a long-running national best seller. Hawkins was a Birmingham jazz trumpeter whose parents took up Erskine Ramsay on his offer to pay families to name children after him. Many African American jazz musicians honed their craft in Tuxedo Junction and went on to play across the country and influence the art.

Ensley continued to prosper during the 1950s as steel from its plants helped America build during its post–World War II boom and fight the Korean War. However, by the late 1960s, competition from new malls and shopping centers had begun to take its toll on Ensley's business district. The automobile made living farther away from the center of cities possible, and people opted to move away from areas close to the smoke and soot of industry like that found in Ensley. In 1974, U.S. Steel significantly expanded its nearby Fairfield Works, and the Ensley Works became increasingly obsolete. By 1978, the operations of the last of the steel mill's open-hearth furnaces ceased, and with it went the original purpose for the existence of Ensley. Business in Ensley's downtown struggled and closed, and the landmark Ramsay-McCormack building became vacant in 1986.

Today Ensley is fighting its way back. People across the Birmingham metropolitan area and Alabama trace their family roots to Ensley. This strength has kept Ensley alive and helps to fuel its efforts at rebirth. Local neighborhood leaders, business people, and community development organizations are looking to the future of this great community. The national prominence of its jazz heritage, its industrial history, its immigration, and other themes make this an important place in American culture and history. This book pays homage to the steelworkers, musicians, businessmen, church leaders, and residents of one of the greatest of all Birmingham neighborhoods.

One

STEEL EMPIRE

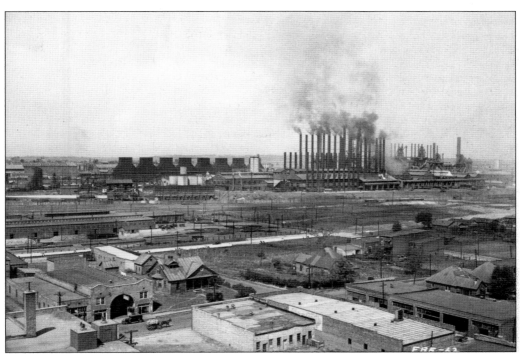

The Tennessee Coal, Iron, and Railroad Company (TCI) was granted its original charter by the Legislature of Tennessee in 1860. By 1900, TCI had grown to become the largest southern manufacturing entity by acquiring businesses, mines, factories, and industrial subsidiaries in resource-rich Tennessee and Alabama. These acquisitions included the Sewanee Mining Company, Alice Furnace Company, the Pratt Coal and Iron Company, and others. In 1888, Col. Enoch Ensley began the construction of four major blast furnaces in Ensley, each of 200-ton daily capacity. The last of these furnaces was lit on April 4, 1889, and was acclaimed to be the largest in the world. (Courtesy Birmingham Public Library Archives.)

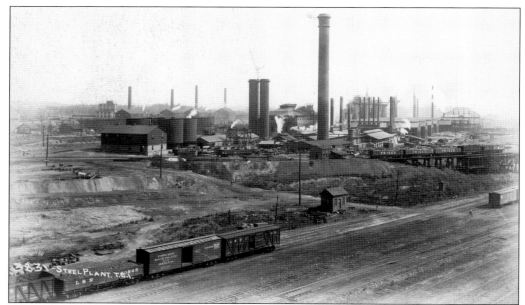

After Enoch Ensley's death in 1891 and the economic panic of 1893, TCI and the Ensley Land Company suffered financial setbacks. However, by 1898, active industrial development in Ensley increased as TCI began construction on the Ensley Steel Works and poured its first heat on November 30, 1899. As seen above, the location was ideal as it was bounded on two sides by the main lines of five railroad companies. Also, the sloping ground permitted both good drainage and a good arrangement of the several levels of operation. (Courtesy of What's On Second.)

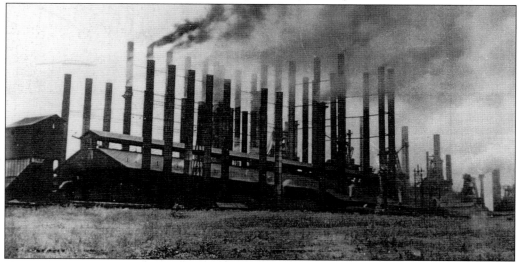

In the early 1900s, Ensley Works added to the production of pig iron and steel. The nation's second coke by-products plant, the Birmingham Cement Company, started processing slag as cement. The Alabama Steel and Wire Company established a rod, wire, fence, and nail works, and the Ensley Brick Company produced brick from shale underlying the TCI coal beds. As pictured, the Ensley Works eventually boasted six blast furnaces each 80 feet high, 16 hot-blast stoves, and two brick engine houses. By 1907, TCI had been acquired by U.S. Steel. (Courtesy of Birmingham Public Library Archives.)

A June 1898 article in the *New York Times* publicized and recognized TCI's announcement of plans to build a steel production facility adjacent to the iron-producing furnaces utilizing the open-hearth furnace method. By 1900, most steel production in the United States was converting from the Bessemer method to the open-hearth method. By 1920, half of the steel made in the South came from the Ensley Works open-hearth furnaces. The open-hearth method of steelmaking was eventually rendered obsolete by more modern integrated methods of steelmaking; however, for over 80 years this method was used in Ensley. Pictured are steelworkers pouring a heat from a 50-ton open-hearth furnace. (Courtesy of Birmingham Public Library Archives.)

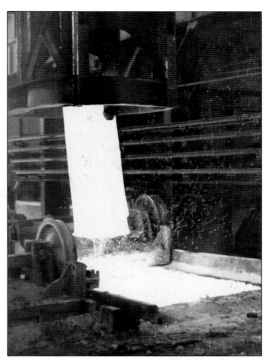

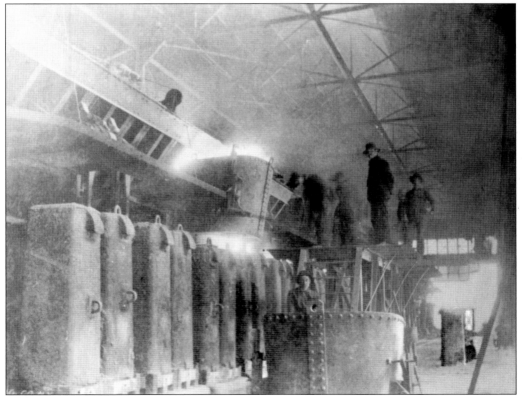

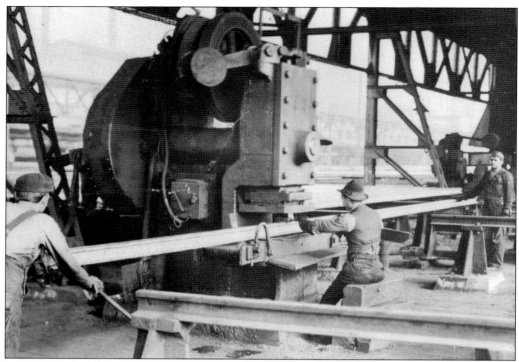

In 1902, Ensley mills began making train rails, and by 1906, plant production reached 400,000 rails. The men above are putting the final touches on some rail before it is shipped. In 1907, the Ensley mill gained national attention when a customer ordered 150,000 tons of train rails and eventually claimed the title of the largest producer of steel ingots and rail in the South. (Courtesy of What's On Second.)

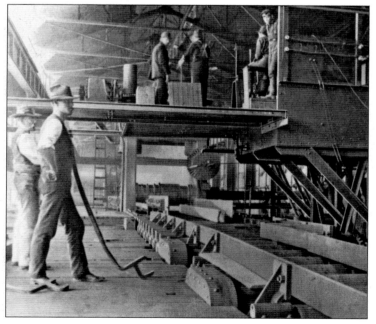

Workers at Ensley Works operate a 44-inch blooming mill where steel ingots are hot rolled into "blooms" or semi-finished steel. This is steel in the form of billets, blooms, and so on, requiring further working before completion into finished steel ready for marking. (Courtesy of Birmingham Public Library Archives.)

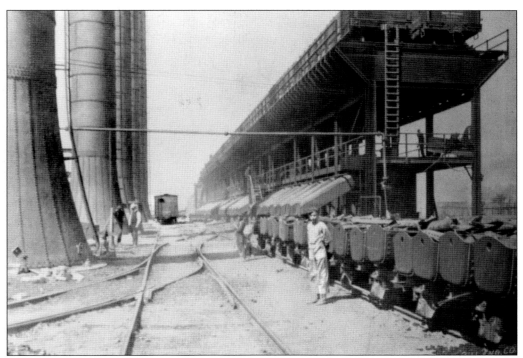

At Ensley Works, TCI built the gas producer parallel to the open-hearth furnaces. It was a plant of ample capacity to provide for the melting and heating of furnaces. (Courtesy of Birmingham Public Library Archives.)

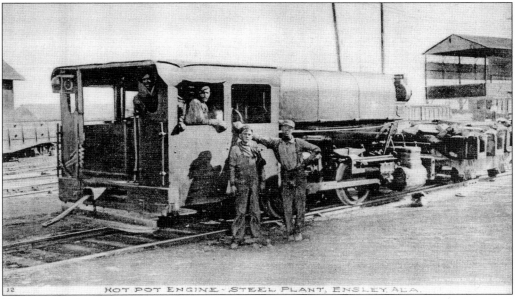

HOT POT ENGINE - STEEL PLANT, ENSLEY, ALA.

This picture shows a hot pot engine at the Ensley furnaces around 1911. Hot pots had no fired boiler to produce steam. Two different methods were used to produce the steam to make the engine run. These engines were workhorses around the furnaces. (Courtesy of Birmingham Public Library Archives.)

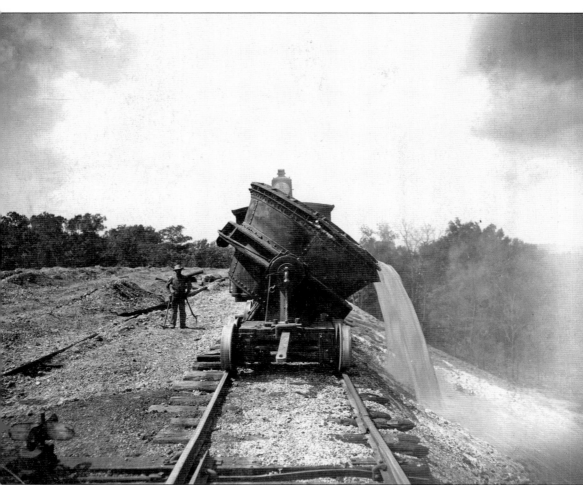

Slag was a by-product of the iron process. When the impurities were drawn out of iron ore the result was slag. Slag was separated from the iron ore and poured into heaps to cool. Slag would be used for more products that the company would sell, including cement. Many of Alabama's earliest paved roads had slag from Ensley and Birmingham industries as a base. (Courtesy of Birmingham Public Library Archives.)

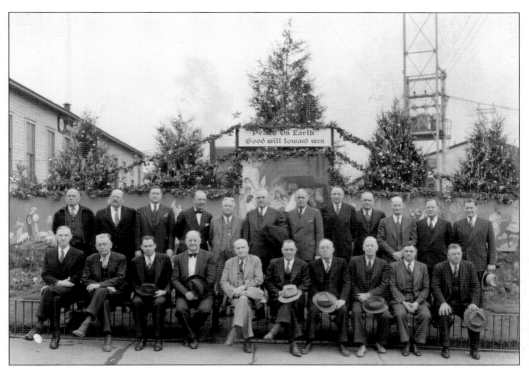

U.S. Steel department heads are, from left to right, (first row) E. W. Bliss, L. V. Vaught, R. L. Hall, Neal Dugger, J. V. Calvin, G. M. Harris, E. C. Hopping, S. S. Heide, J. A. Maxwell, and C. H. Bumgardner; (second row) J. R. Hurley, A. E. Kanze, E. J. Donnelly, R. C. Prince, A. J. Watson, N. L. Van Tol, A. L. Bowron, J. A. Cowman, S. B. Hayley, R. D. Osgood, E. J. Kohn, and W. W. Sauer. The 1947 image below shows the heads in front of a huge sign. From left to right are (first row) R. B. Kup, D. A. Miller, A. V. Jannett, J. L. Schneider, R. R. Devine, R. L. Hall, G. M. Harris, A. F. Trammell, S. S. Heide, J. A. Maxwell, J. W. Johnson, and O. C. Hassell; (second row) W. I. Drewry, J. F. Olive, J. W. Gay, R. D. Osgood, O. R. McHenny, H. A. Caldwell, E. J. Donnelly, A. J. Watson, R. L. Bowron, J. A. Lowman, G. D. Brengelman, E. J. Kohn, and E. M. Streit. (Courtesy of Birmingham Public Library Archives.)

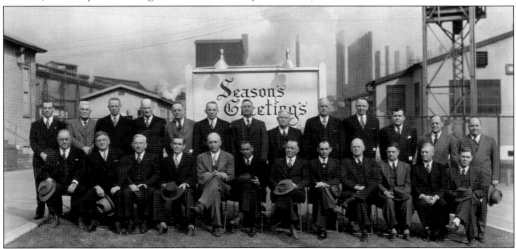

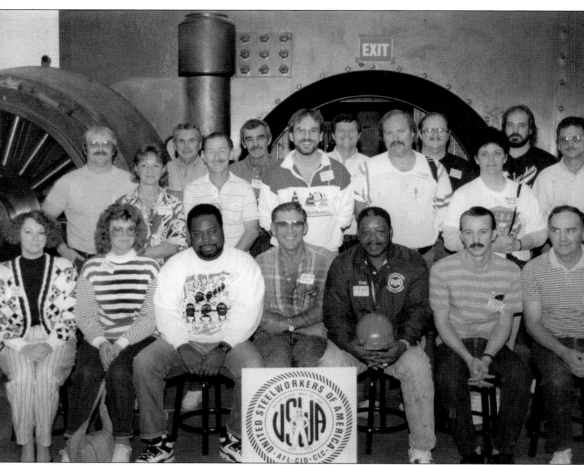

The United Steel Workers of America and other unions and organizations contribute to the life and work environment of the employees for U.S. Steel Company. Pictured here are 19 who gathered at a conference. In the first row, third from the left, is Wendolyn Cook, who worked for TCI of U.S. Steel until his retirement. He began at the Ensley Works site where he was stationed for 10 to 15 years and then transferred to the Fairfield location. He was a sampler in the chemical lab where they tested ore for coke. He is married to Magnolia Cook, president of the Tuxedo Neighborhood Association, and the chairperson of the Annual Function at Tuxedo Junction Jazz Festival. (Courtesy of Magnolia and Wendolyn Cook.)

Two

Trains, Trolleys, and Transportation

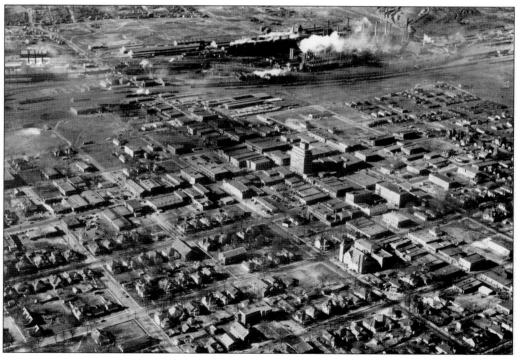

This aerial photograph of Ensley provides an overview of how this vast industrial landscape expanded out from the U.S. Steel operations and the relationship of the mills to the central business district and neighborhoods. Transportation corridors of rail, streetcar lines, and roadways created the grid and represented a strong infrastructure that included paved sidewalks, sewer, water, light, and storm systems. (Courtesy of Birmingham Public Library Archives.)

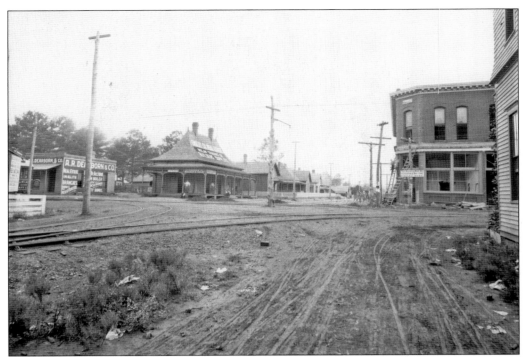

This 1899 photograph, taken from the corner of Nineteenth Street and Avenue E, captures downtown with the first Ensley bank under construction and the offices of the Ensley Land Company open to support real estate development. The view is west along Nineteenth Street and shows a row of frame homes on the south side that extended up to Avenue D. The tracks are the "Dummy Line" of the Ensley Railway. The photograph below of the Ensley Railway Company, founded by William A. Walker Jr., connected Birmingham and Ensley. One locomotive and two light coaches provided transportation services until 1890, when the company became the Birmingham Railway and Electric Company. The rail ran from First Avenue and Twentieth Street north in Birmingham to East Thomas, to Pratt City, and on to Ensley. Later the line extended to the fairgrounds. (Courtesy of What's On Second.)

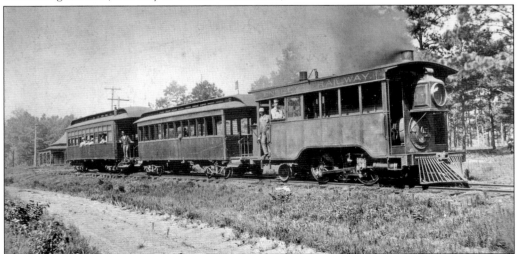

This photograph features the offices of the Birmingham Railway, Light, and Power Company freight house and substation. (Courtesy of Birmingham Public Library and Archives.)

Due to a ruling by the Alabama State Legislature in 1909, Ensley lost its civic independence. A 1909 lawsuit, *Simpson v City of Ensley*, and the countersuit, *City of Ensley v Simpson*, reached the Alabama Supreme Court. The ruling determined that the municipality of Ensley and its citizens did not have the right to contest annexation. "Greater Birmingham" supporters were pleased. Multiple annexations of various outlying communities resulted in Birmingham's city limits growing from 3 square miles to 48 square miles. The Ensley community gathered for a funeral and erected an obelisk resembling the Washington Monument. The footstone of the mock grave reads "Born 1899, Died 1909." Papers signed on December 31, 1909, made January 1, 1910, their first day as residents of Birmingham. (Courtesy of What's On Second.)

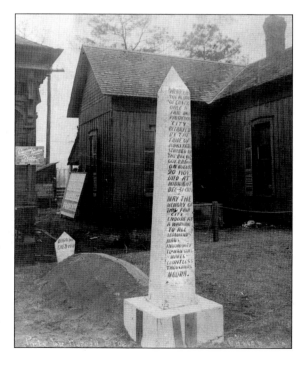

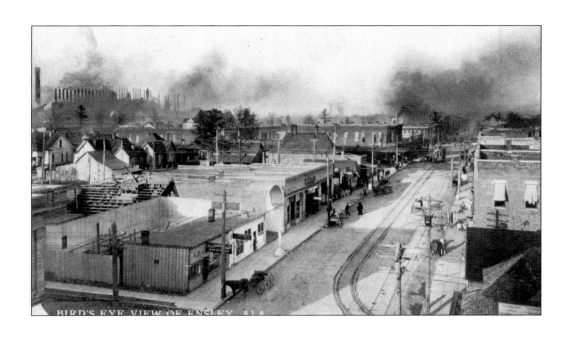

This 1910 bird's-eye view of Ensley features downtown with waves of smoke billowing in the background. The photograph shows a street lined with horses attached to buggies and wagons, still the main source of transportation at the time. Multi-story buildings constructed of brick outnumber the old wood-frame structures that remain in the image, and homes still line streets only one block from Nineteenth Street. Taken a few years later, the 1916 photograph of Ensley Avenue and Nineteenth Street below demonstrates the increased popularity of the automobile. The view is north along Avenue E towards Pratt City. (Courtesy of What's On Second.)

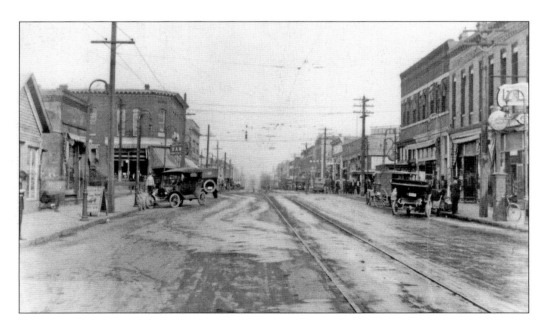

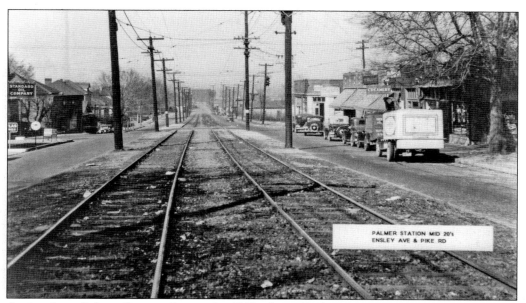

A view from Palmer Station during the 1920s shows Ensley Avenue at Pike Road and some neighborhood commercial enterprises located in one-story brick buildings. The track lines support transportation out of Ensley to Fair Park and Five Points West. A picture from 1915 shows a streetcar turning off Ensley Avenue and onto Twentieth Street. In the background, just to the right of the streetcar, a sign in the barbershop reads, "For Whites Only," a reminder that the bustling city of Ensley and its residents were all living and working according to Jim Crow segregation laws. (Courtesy of What's On Second.)

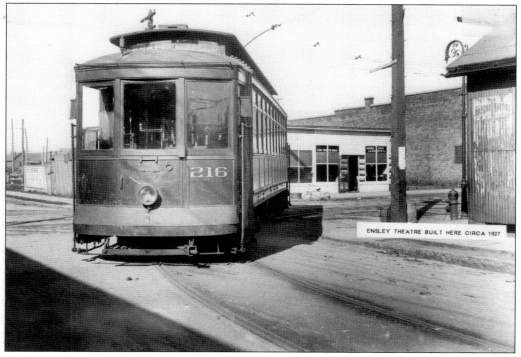

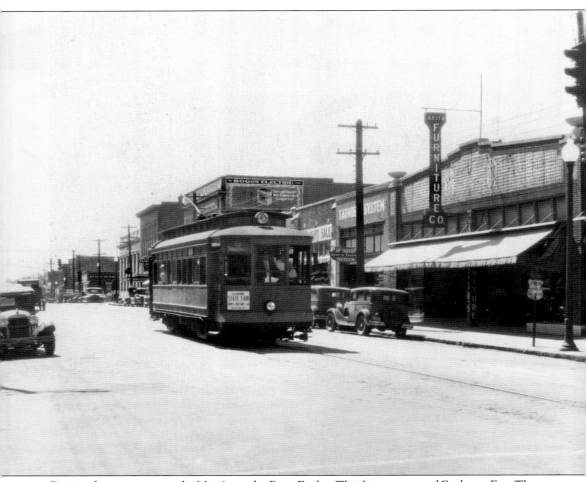

During the streetcar era, the No. 6 was the Pratt-Ensley. This line connected Ensley to East Thomas, Fountain Heights, Wylam, Bush Hills, and downtown Birmingham. In this photograph from the 1930s, the car travels west down Nineteenth Street, a transportation route that not only witnessed buggies, streetcars, pedestrians, and automobiles, but also droves of steelworkers with hard hats, lunch boxes, and boots in tow as they proceeded towards the mills. They marched in the thousands according to the mill schedule and stopped at the "check-house" at the entrance. They passed downtown businesses owned by both whites and blacks. (Courtesy of What's On Second.)

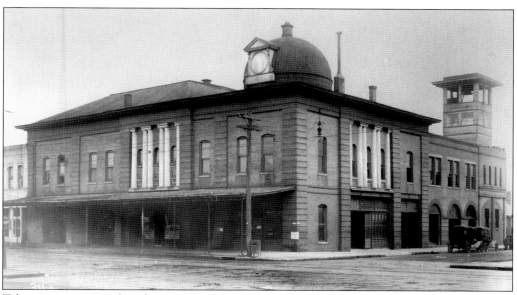

Taken prior to 1910, this photograph of the Ensley City Hall and Fire Station demonstrates the economic vitality the city experienced as the steel industry drove jobs, investment, trade, and commerce. A very stately building of stone and brick with quoins along the corners, arched windows and bays, encased classical columns in the second floor, an observation tower, and a domed cupola all added prominence to this massive structure that occupied almost an entire city block. The building housed the mayor's office, police department, fire department, jail, and courtrooms. Torn down around 1930, this structure is no longer extant. During the 1920s, the City of Birmingham made civic improvements to public systems and services. Plans included the construction of new firehouses and Fire Station No. 16 in Ensley moved into a new home. The Spanish Revival–style architecture made the building neighborhood-friendly in design but capable of housing modernized services in fire protection. (Above, courtesy of Birmingham Public Library Archives; below, courtesy of Fire Station No. 16.)

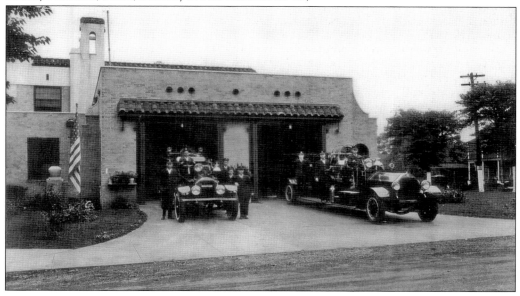

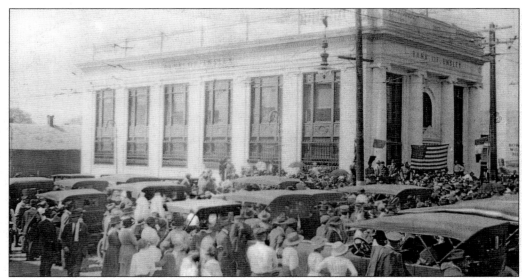

A Liberty Bond rally brought a crowd to the Bank of Ensley building in 1919. Like the first city hall, this neoclassical revival–style building boasts Corinthian columns across the facade and engaged columns along the elevations that separate large multi-light windows. Listed on the National Register of Historic Places, the building stands on the southwest corner of Nineteenth Street and Avenue E. Founded by Erskine Ramsay and George B. McCormack in 1899, the bank opened in early 1900 and then moved to this location in 1919. Officers included Erskine Ramsay, president; R. E. Chadwick, vice president; W. C. Maywell, assistant cashier; G. B. McCormack, vice president; S. C. King, cashier; W. D. Suppler, assistant cashier; C. E. Cole, assistant cashier; and H. J. Cummings, manager of the Wylam branch. (Courtesy of What's On Second.)

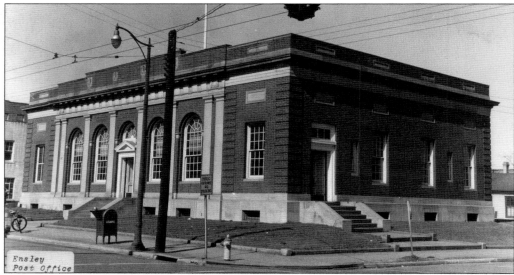

The Ensley Post Office, located on Avenue E between Nineteenth and Twentieth Streets, provided an additional neoclassical revival building to the urban landscape. Built around 1910, the heavy features matched those of the Bank of Ensley and the city hall. A tornado struck Ensley in 1956 and badly damaged the building. Demolished in the 1960s, this building is no longer extant. (Courtesy of What's On Second.)

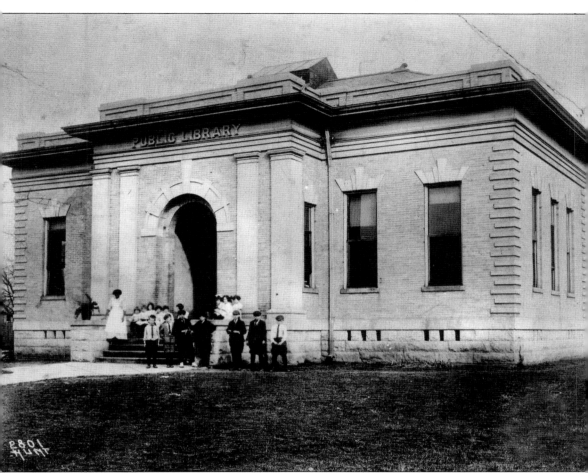

Built in 1909 on the corner of Avenue H and Eighteenth Street, the Carnegie Library was the third Beaux-Arts style civic building in Ensley. Andrew Carnegie, president of U.S. Steel Corporation, made a grant of $10,000 for construction, and TCI donated a collection of technical books. The Ensley Land Company covered subscriptions to periodical literature. The first librarian, Lila Chapman from Atlanta, Georgia, went on to become head of the Birmingham Public Library system that formed in 1907. Ensley became a branch in 1911. Today there are two branches in Ensley, both housed in modern facilities, and the old library is no longer extant. (Courtesy of What's On Second.)

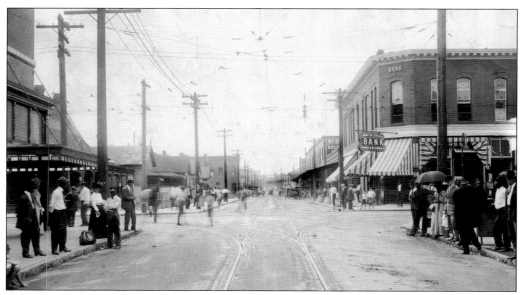

Taken in 1910, this streetscape provides another view of the business district while filled with pedestrian traffic. The original Ensley bank building, located on the corner of Nineteenth Street and Avenue E, is decorated with large striped awnings to shade the windows. A view down Nineteenth Street in 1925 shows a drugstore, a hat company, a men's clothing store, and the Tyler Theater on the left. The streetscape is growing with power lines and hanging projecting business signs as well as historic street lamps. (Courtesy of Birmingham Public Library Archives.)

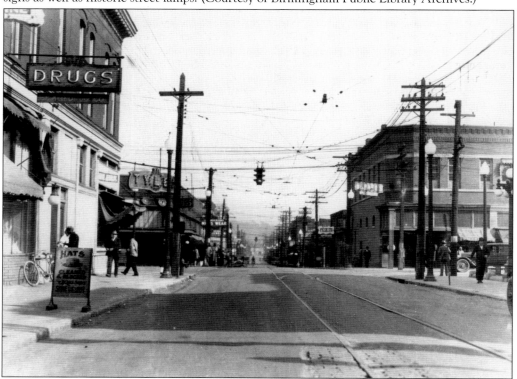

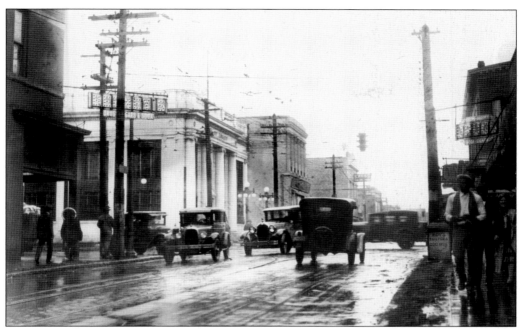

These two streetscapes, taken during the late 1920s, feature the rise of the automobile as a source of transportation that contributed to downtown Ensley's vitality and role as a destination point for residents of western Jefferson County. Knapp Automobile Company on Twentieth Street sold Model T and Model A Fords. A mercantile store, a furniture store, another men's clothing store, and the Belle Theater were occupants of Nineteenth Street. Ensley had many theaters, including the Franklin on Avenue E, the Tyler, the Ensley, and the Palace Theater for African Americans. Two drugstores located near the Bank of Ensley had lighted signage. The upcoming chapter will feature more theaters. (Above, courtesy of Birmingham Public Library Archives; below, courtesy of What's On Second.)

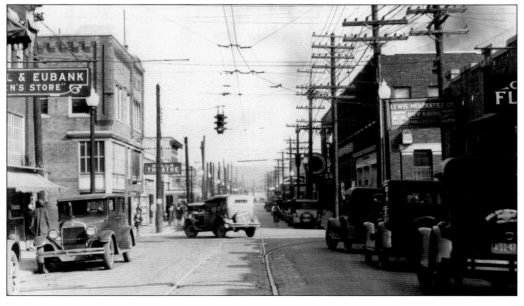

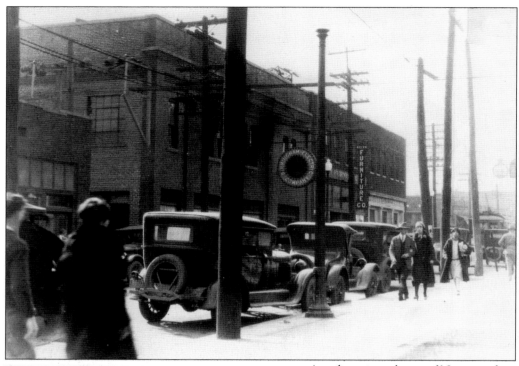

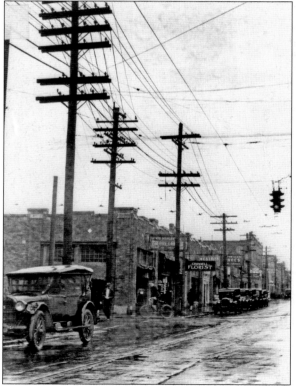

Another view, above, of Nineteenth Street between Avenues F and G taken in 1927 closes out this section on the early development of downtown Ensley. This wintertime photograph has pedestrians strolling the sidewalk in their winter coats. The round signage is that of the Birmingham Electric Company. Also taken in 1927, this view at left of Nineteenth Street at Avenue F shows a series of businesses on the left, including a dry goods store and mercantile, a florist, and a shoe store. (Courtesy of What's On Second.)

Three

BUSINESS BOOMS

An architectural rendering of the future Ramsay-McCormack Building showcases the rise of Ensley during the 1920s and the future vision of the first and only skyscraper-style building to be constructed downtown in the center of activity, at the corner of Avenue E and Nineteenth Street. Birmingham architect Brooke B. Burnham designed the building that is symbolic of the art deco period. (Courtesy of Birmingham Public Library Archives.)

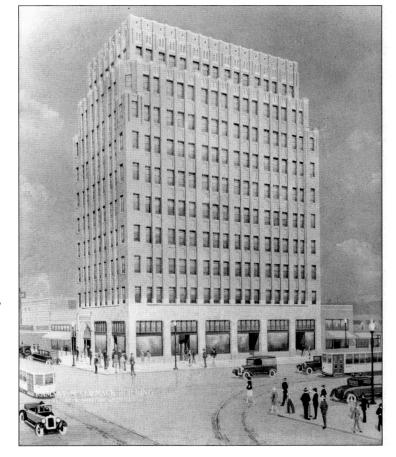

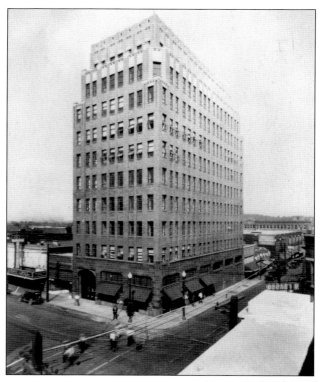

Constructed between 1929 and 1930 and listed on the National Register of Historic Places, the building is named for Erskine Ramsay, an industrialist, and Carr McCormack, a partner in real estate, coal, engineering, and invention. Erskine Ramsay was a millionaire, civic leader, and philanthropist who generously donated to the City of Birmingham public school system and served as the chairperson of the board of directors. The $500,000 ten-story building became an icon of the New South idealism represented so dramatically by the Ensley industrial landscape. The building housed many businesses and served as the headquarters for the United Security Life Insurance Business. (Courtesy of What's On Second.)

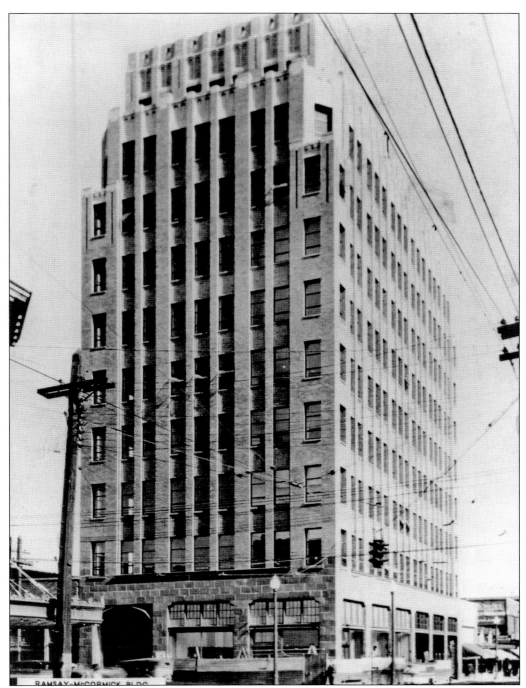

Visible from today's interstate corridor formed by I-59 and I-20, the Ramsay-McCormack Building, along with a series of smokestacks that remain at the old Ensley Works, are symbols of the once-bustling and thriving historic Ensley. Within this context, individual entrepreneurs and business owners thrived for many years. Today the empty building is an economic opportunity. Plans and efforts are underway to restore this unique Ensley landmark. (Courtesy of What's On Second.)

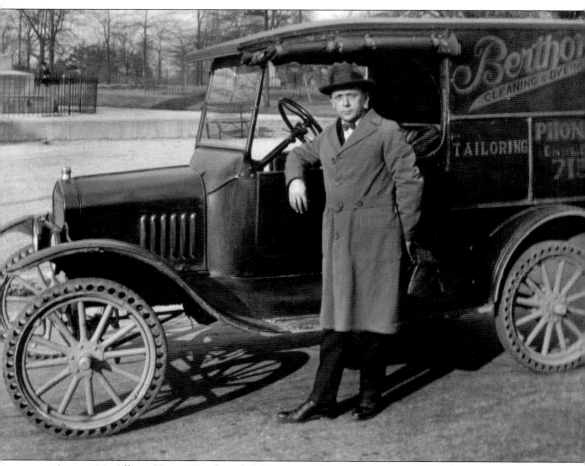

At age 14, Albert Henry Berthon left France and came to America, landing at Ellis Island in 1902. Upon arrival, he moved to Alabama, settled in the Morris area, and began working in the coal mines. He did not like that job, so he started working in a bakery. He quit to attend barber school and opened a barbershop. A shoe-shine boy working in the business convinced Berthon to purchase some hand irons so that he could press clothes for the customers. When Berthon purchased some kettles and placed them behind the barbershop, services expanded to include cleaning. Using gasoline, the shoe-shine boy scrubbed the clothes clean and the leftover smell became the signature of very good service and a quality job. Taken in the early 1920s, this photograph features A. H. Berthon standing in front of one of the delivery trucks. Berthon built his first cleaning business in Ensley in 1925 at 2213 Avenue E, where a company facility is still in operation. George Berthon II works at the southside location, but the family no longer owns the business. (Courtesy of Berthon Cleaners.)

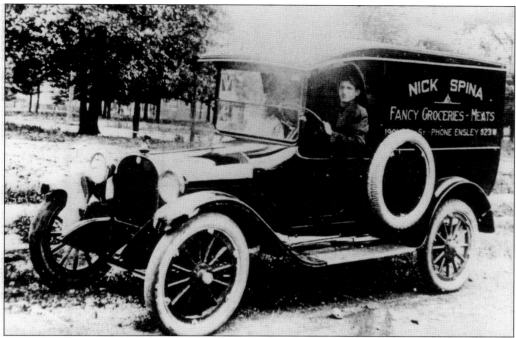

One of the many early Italian businesses was P. J. Spina grocery. A *c.* 1905 photograph captures the delivery truck for the shop, located in the 1900 block of Twentieth Street and close to Tuxedo Junction. Nick J. Spina left Sicily with his father and traveled by boat to America during the 1890s. He was nine years old and began earning a living by working in the mines. Originally the business used bicycles to make home and business deliveries. Paul Spina, the son of Nick J. Spina, carried on the tradition and today Paul's son Marion manages a design and marketing firm that provides specialized services to grocer businesses. The second photograph of the old store dates to 1938 or 1939. (Courtesy of Spina Marketing Company.)

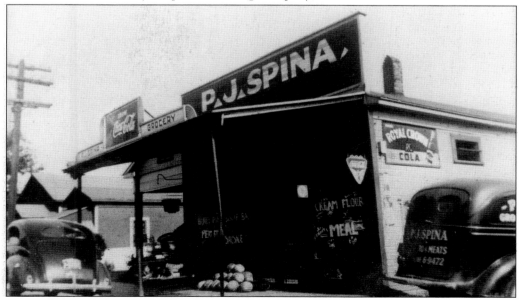

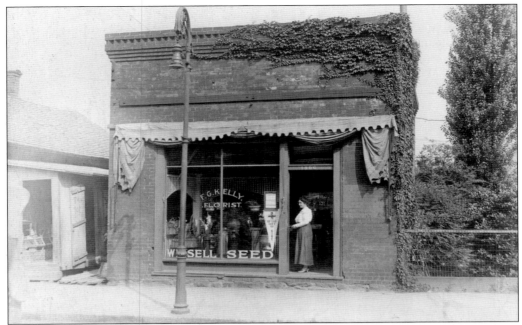

This photograph of the F. G. Kelly Florist provides a clear facade view of a single storefront in a one-story brick commercial space. Business owners in downtown Ensley and surrounding neighborhoods were both men and women of diverse ethnic and racial backgrounds. (Courtesy of Birmingham Public Library Archives.)

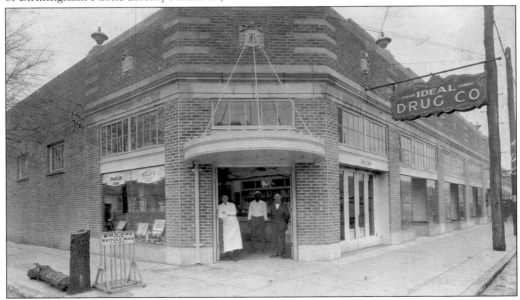

Nathan Zivitz started Ideal Drug Company on the corner of Nineteenth Street and Avenue G during the 1920s. Today at that same location, 702 Nineteenth Street, Nathan's son Melvin Zivitz and grandson Kevin Zivitz operate a furniture store out of the building that has been remodeled on the exterior and interior over the years. Like several other merchants, this family has stayed committed to Ensley. (Courtesy of Ideal Furniture Company.)

Russell Photography Studio in Ensley opened in the early 1900s. It played an important role in capturing the images of Ensley residents over the years. Between 1895 and 1900, brothers Robert and Samuel Russell decided to dissolve their partnership. Robert moved to Ensley, Alabama, to found a photography supply company and decided to continue the name Russell Brothers even though their businesses at the time were independently owned. When Samuel died in 1942 the negative file was sold to Lance and Angelese Johnson of Lance Johnson Studios. Their son Jim donated the negatives to the Public Library of Anniston-Calhoun County. These photographic examples are of Ensley residents. Jan Panzeca is captured in her mink coat (below) and a wedding gown photograph (at right) of Jane Panzeca was taken in 1917. (Courtesy of Vincent Mariano.)

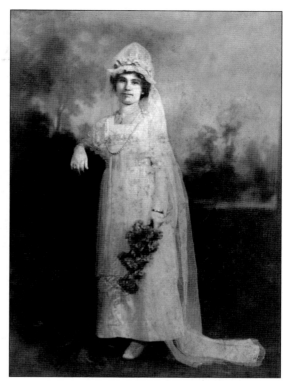

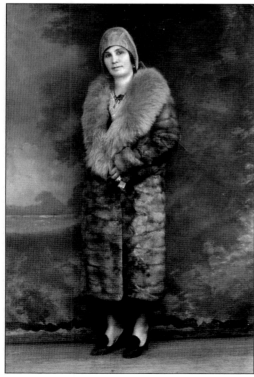

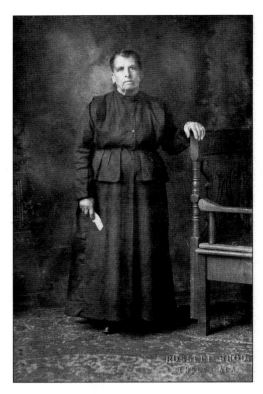

Eva Manisterrio, at left, was one of the early Italian Americans to move to Ensley. Due to the work of Russell Photography Studio, families with ties to Ensley have these valuable memories of the past. Taken in 1917, the photograph below shows Antonio (Toney) Mariano. (Both, courtesy of Vincent Mariano.)

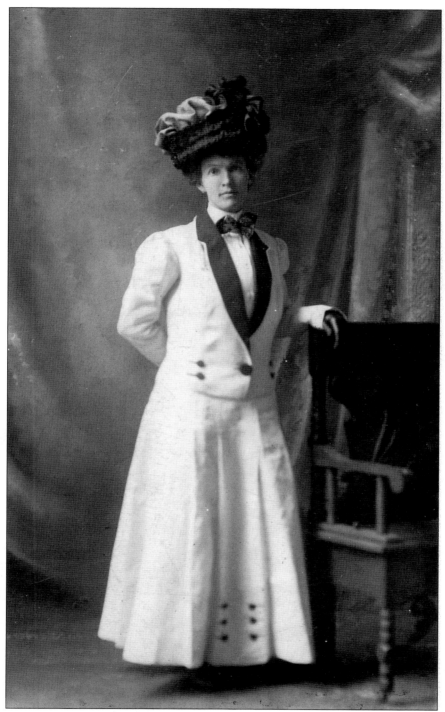

This is a postcard of aunt Bessie Storey, wife to an uncle Tom Storey, who was the great uncle of Sue Hardy Thomas. Tom Storey was the brother of Sarah Storey's father and Sarah Storey was Sue Thomas's mother. (Courtesy of Sue Hardy Thomas.)

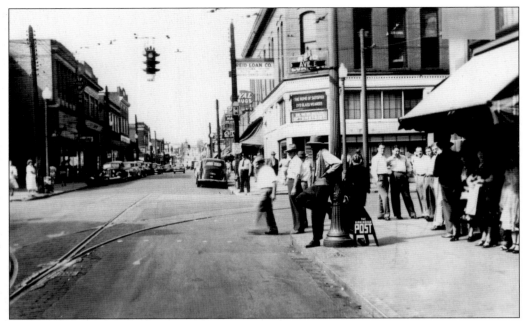

These 1950s views of the intersections of Avenue E and Nineteenth Street (above) and of Avenue C and Nineteenth street looking east (below) demonstrate the continued prosperity and success of Ensley as a center of trade and commerce. Despite the tough years of the Depression, which forced U.S. Steel to lay off workers, the Ensley community remained resilient and survived the test of time. (Courtesy of What's On Second.)

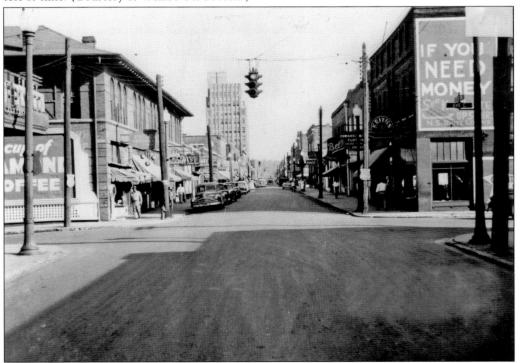

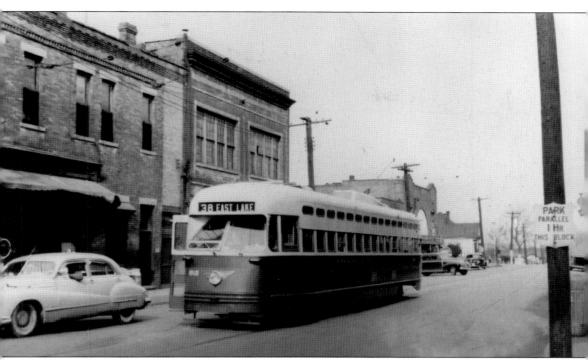

A new streetcar travels down Avenue F during the 1950s. En route back through the city of Birmingham, the car passes by the Palace Theater, the only one in Ensley for the African American community. Avenue D was the location for many black-owned businesses, including shops, professional services, restaurants, nightclubs, and a funeral home. Dr. James K. Robertson and Dr. Frank S. Simpson had medical offices in the area. (Courtesy of What's On Second.)

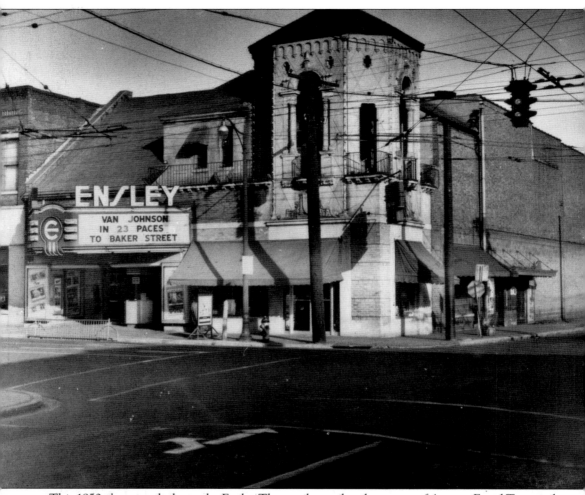

This 1950 photograph shows the Ensley Theater, located at the corner of Avenue E and Twentieth Street. The theater, movies, and vaudeville shows were a favorite pastime and source of entertainment. Ensley also had a starring role in the movie *Men of Steel* in 1926. Cast members included Milton Sills and Doris Kennon. The Franklin Theater hosted the world premier of the movie and many locals were extras in the film. When the Franklin closed, the building housed the Catfish King Restaurant, and when the Ensley Theater closed its doors, an apothecary moved into the space. (Courtesy of What's On Second.)

In the early 1920s, Ben Cotton, the original owner of Cotton's Department Store, opened for business at the corner of Avenue D and Nineteenth Street. Cotton's Department Store is a landmark operation in downtown Ensley that carries clothing, apparel, and shoes. Today Rhonda and Maureen, the granddaughters of Cotton and daughters of Howard Schultz, manage the business. Rhonda's husband, Harry Weinberg, shares in the management responsibilities as well. Mark Petrofsky, Maureen's husband, used to work in the store everyday but he has moved to a new position with a local eyeglass company. Like the Zivitz and Ideal Furniture Store, this family-owned and -operated business has stood the test of time and remained committed to a loyal customer base. A diversified staff has contributed to the operations of the store. (Courtesy of Cotton's Department Store.)

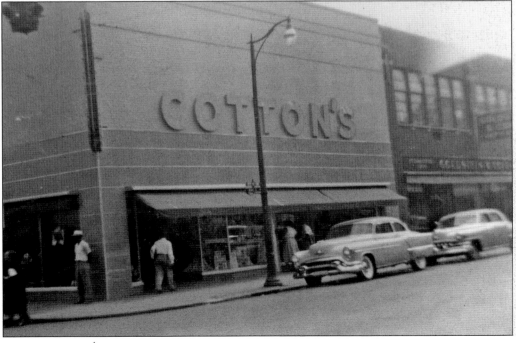

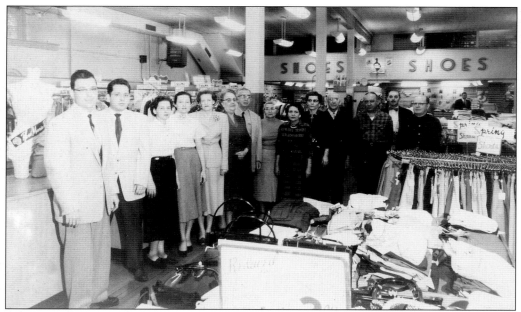

Dating to the 1950s, these interior views of Cotton's Department Store show the big open space, racks, stacks of clothing, and the staff members of the past. If customers were in need of a hat for church or other special occasion, Cotton's Department Store was the place to go to be sure they would be dressed in style. Cotton's recently opened an outlet store across the street on Nineteenth Street that sells affordable merchandise on Saturdays. (Courtesy of Cotton's Department Store.)

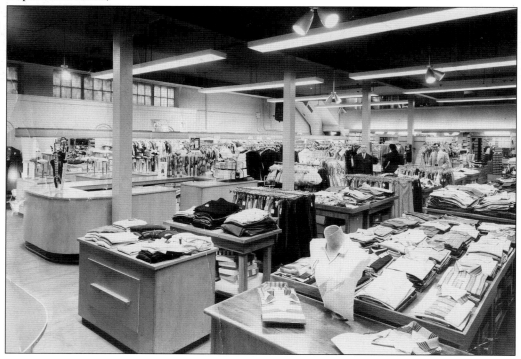

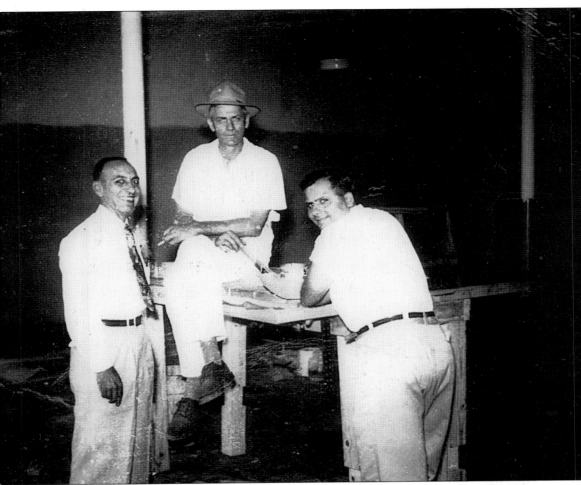

In addition to the Spinas, the Brunos, the Marianos, and many other Italians who occupied a section of town known as Little Italy, were the Marinos. The family of grocers, like others, has stayed dedicated to the city of Ensley and never moved out during the era of flight. From left to right, this 1953 picture shows Paul Spina Sr., an unidentified contractor, and Joe C. Marino, the owner, who was known as "Papa Joe." They are occupying the new space for Marino's Grocery Store at Twenty-fifth Street and Avenue E, a facility that needed remodeling after Hills Grocery and the A&P moved to new locations. Tony and Mary Marino first opened the business in 1925 on Twenty-ninth Street Ensley. Today the store is owned and operated by the third-generation Anthony C. Marino, and the fourth-generation A. J. Marino. (Courtesy of Anthony Marino.)

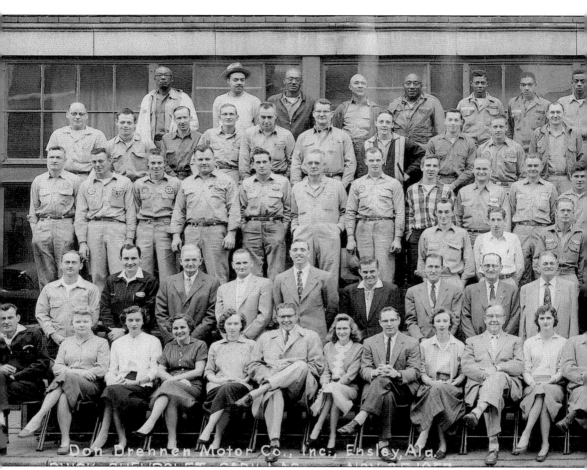

Don Drennen Motor Co., Inc., Ensley, Ala.

Founded in 1869 as a carriage business with buggies, Don Drennen Motor Company evolved into one of the largest and most historic automobile dealerships that began in Ensley and still operates. William Drennen started the company, and today his great grandson Ward Drennen continues the legacy passed down through brothers Don and Herbert Drennen. In 1908, the Drennen Motor Company became a dealership and franchise of General Motors, started by Billy Durant that

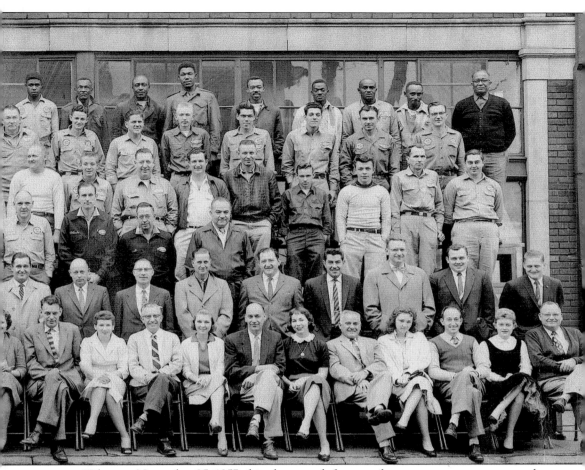

same year. Taken on November 25, 1957, this photograph features the owners, management, and staff of the Ensley dealership. Seated in the first row and eighth from the left is Don Drennen Jr. (Courtesy of Don Drennen Motor Company.)

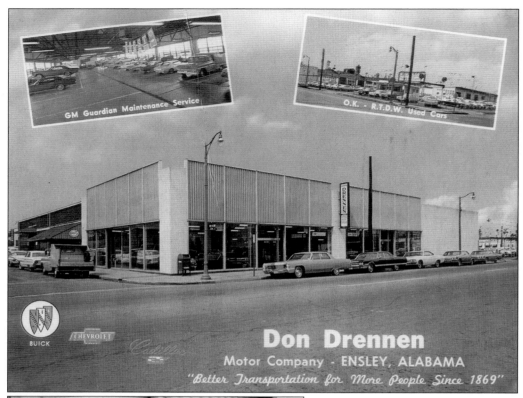

GM Guardian Maintenance Service

O.K. - R.T.D.W. Used Cars

Don Drennen

Motor Company - ENSLEY, ALABAMA

"Better Transportation for More People Since 1869"

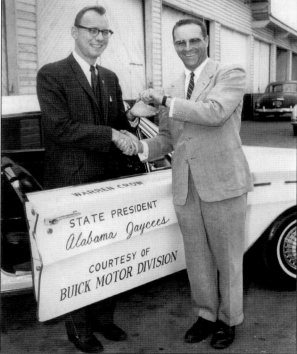

WARREN CROW
STATE PRESIDENT
Alabama Jaycees
COURTESY OF
BUICK MOTOR DIVISION

Taken during the 1960s, the photographic advertisement above showcases the salesroom, maintenance service, and used car lot of Don Drennen Motor Company, located at Avenue E and Twenty-third Street. As a General Motors franchise, the company sold Buicks, Chevrolets, and Cadillacs. The photograph at left features Don Drennen Jr. (left), handing the keys of a Buick over to Warren Crow, state president of the Alabama Jaycees. In the early 1970s, Don Drennen Motor Company left Ensley and moved to the suburban town of Hoover. The new business opened on April 1, 1973. John Lindquist, an employee for 47 years, works with Ward Drennen at the new location south of Birmingham. (Courtesy of Drennen Motor Company.)

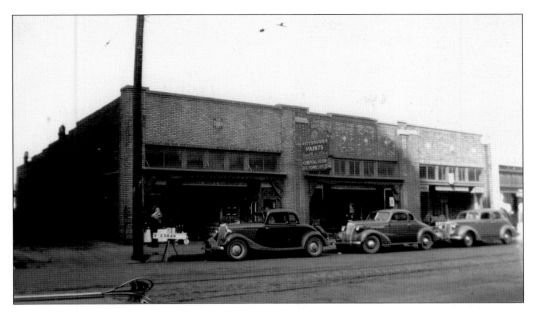

Chester Thomas Crooks owned Central Seed Hardware Company, which is featured in two streetscape photographs, one taken in the 1940s and one taken in the 1950s. In the earlier photograph, the storefronts have recessed entryways and large display windows above the bulkheads. By the 1950s, these had been altered to form a facade flush with the edge of the sidewalk, and large painted signs covered the transoms. The store was located at 2006 Front Street in 1915 and 2320 Avenue C in 1940. C. T. Crook's son Joseph Crooks took over the business and carried it until he passed away in 1986. He left the store in the hands of Joe Richey. When the store closed in 1989, it had been in business for 59 years. At the time of closing, the business still sold seeds in bulk from open wooden seed bins stacked behind the counter. (Courtesy of Dana Dortch, granddaughter of C. T. Crooks.)

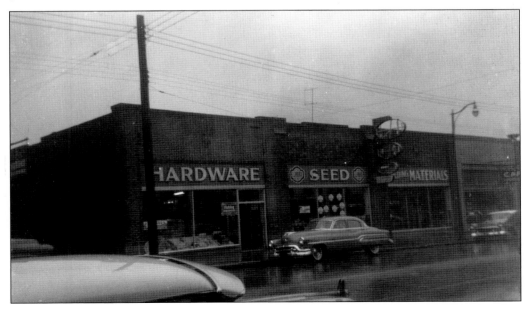

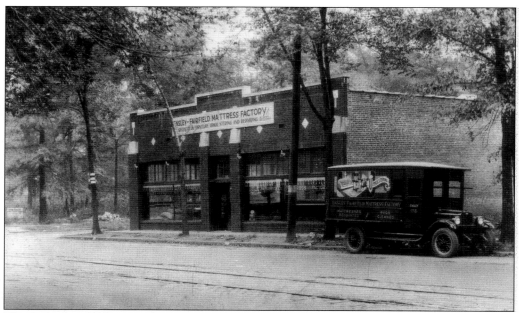

The Ensley-Fairfield Mattress Factory, shown with storefront and delivery truck out front, represents another one of the many businesses that had multiple locations in several business districts throughout the Birmingham area. The location of this business is Thirty-sixth Street and Avenue E, just at the gateway to Fairfield, Alabama. The interstate corridor now divides the two towns, but one can travel straight out Avenue E to reach Fairfield. (Courtesy of What's On Second.)

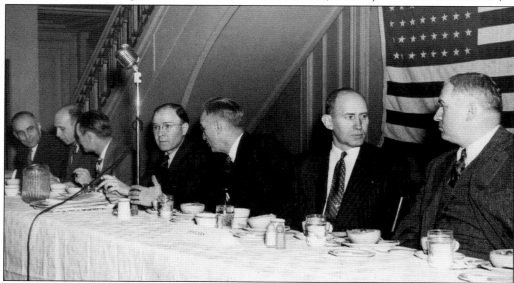

Along with the entrepreneurs of Ensley were the big business leaders and industrialists. These gentlemen formed the Ensley Chamber of Commerce. A very successful organization at one time, the chamber met and conducted business on a regular basis. In later years, they met in the basement of the AmSouth Bank (now Regions). The business association stayed together up through the 1970s and then declined along with the closing of the mills and the movement of businesses, people, and services out of the area. (Courtesy of Birmingham Public Library Archives.)

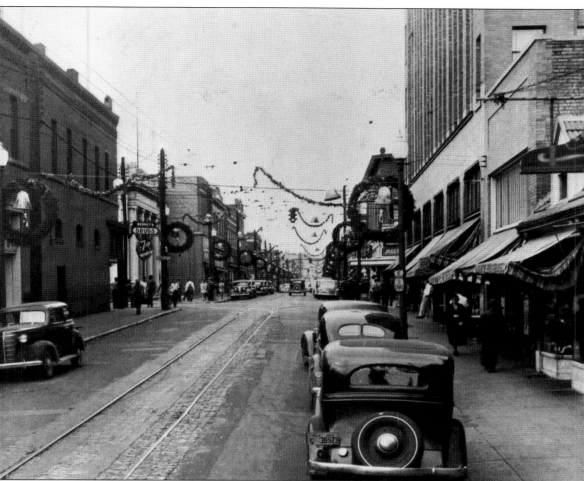

U.S. Steel decorated downtown Ensley for the holidays and hosted a parade as well as other activities. Residents enjoyed the festivities and still remember them well. With so many stores, Ensley was a destination for people from all over Jefferson County. (Courtesy of Birmingham Public Library Archives.)

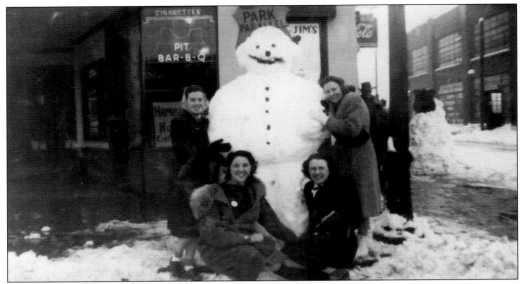

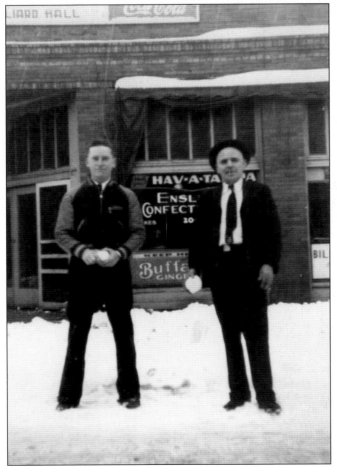

Violet Hoppings, whose husband, Jack, started working in the mills as a water boy during high school, has many memories of downtown Ensley. In the photograph above, she shares a rare snowstorm in Birmingham with her friends. They built a snowman in front of the Bar-B-Q Pit at the corner of Twentieth Street and Avenue E. Pictured in the photograph from left to right are Louise Hopping, Louise Pond, Margaret Jackson, and one unidentified friend. Also enjoying downtown despite the snow are E. C. Hoppings (left) and his son Jack Hoppings, husband to Violet. They appear at the corner of Avenue E and Nineteenth Street with snowballs in hand. Jack Hoppings worked for U.S. Steel for 46 years. E. C. was the yardmaster for TCI. (Courtesy of Violet Hoppings.)

This picture offers another view of the snowman with Violet Hester Hopping and an unidentified companion. During a snowstorm in 1940, she remembers walking from the fairgrounds to Ensley, a long trip down Ensley Avenue. On a warmer day, she enjoys time downtown with friends. Seated on a vehicle behind Silver's five-and-ten store are, from left to right, Gennette McDonald, Louise Pond, and Violet Hester. (Courtesy of Violet Hoppings.)

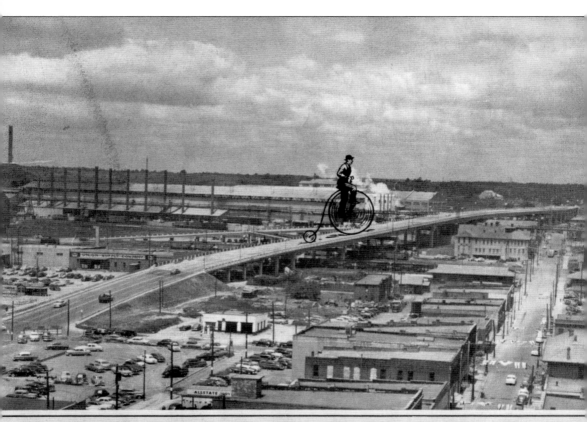

THIS IS THE NEW 1954 ENSLEY OVERPASS CONNECTING ENSLEY WITH THE WORLD. MAY 29th, 1954

The Don Drennen Overpass is a steel-span viaduct over the Birmingham Southern Railroad Yard in the Ensley community of northwest Birmingham. The bridge was designed and built by W. C. Howton Contracting. The span bisects the abandoned TCI Ensley Works. Currently the bridge carries traffic for Alabama State Highway 269 that extends to Birmingport, a loading dock on the Locust Fork of the Cahaba River that eventually flows into the Alabama River. Named in honor of longtime Ensley businessman Don Drennen, the overpass was a major accomplishment when completed in 1954. The Drennen Motor Company published calendars with their logo on top of a photograph of the new enhancement to the community. Twentieth Street Ensley or State Highway 268 continues to serve as a major transportation corridor for light industry, manufacturing, and commuting, and it has expanded over time. (Courtesy of Drennen Motor Company.)

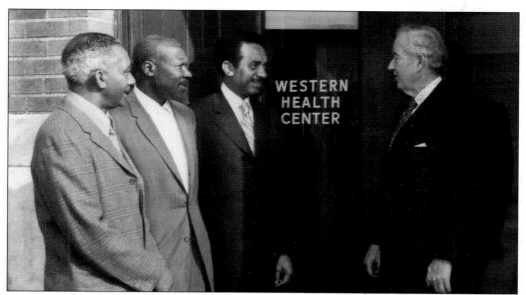

These two photographs demonstrate modern times, much different from the past. Dr. John W. Nixon Sr., a longtime business owner, dentist, educator, actor, and civil rights leader (shown second from right), joins other African American businessmen for the opening of the Western Health Center in Ensley above. In the photograph below, a group of men appear to review a set of development plans with the Ensley Works smokestacks in the background. The other gentlemen present are not identified. While Ensley was on the cusp of losing its heart, the U.S. Steel mill operations, the rest of Birmingham was planning to finally move forward with a new government with African Americans in leadership positions. (Courtesy of John Nixon Jr.)

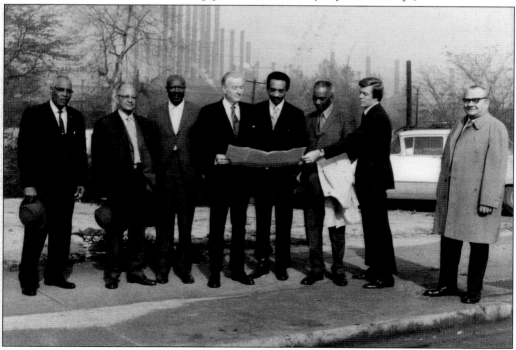

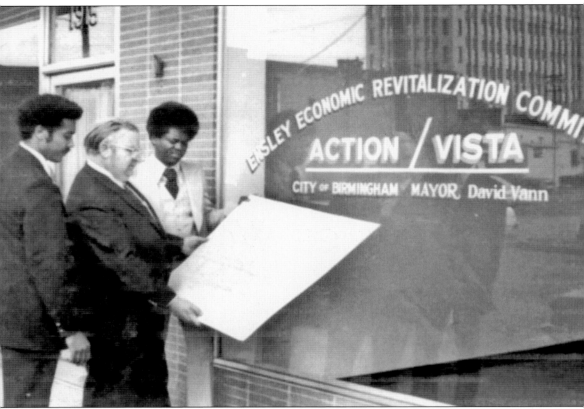

After the closing of the mill operations in 1978, Ensley declined rapidly and experienced an increased percentage of residents who fled to the suburbs. Individuals such as Aaron Carlton (right) and Mayor David Vann (center) started efforts to establish revitalization programs and projects to assist in maintaining Ensley's sense of identity and record of business success. Today Main Street Birmingham, Inc., a nonprofit on contract with the City of Birmingham, is leading those efforts. (Courtesy of Birmingham Public Library Archives.)

Four

HOUSES OF WORSHIP

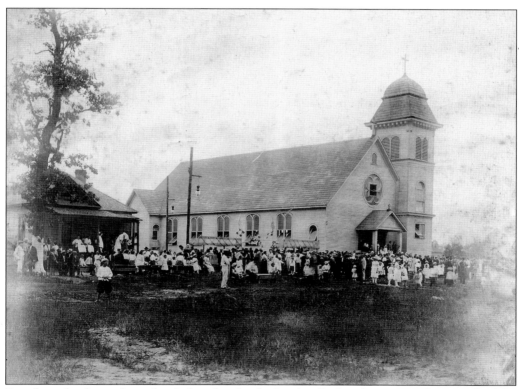

Sent from the descendent of an Italian family who lived in Ensley, this unique photograph of the original St. Anthony's Church could be one a kind. The Marianos lived in Ensley between 1910 and 1920. The first place for Catholics to worship was a frame building on Seventeenth Street. They named the church in honor of Saint Anthony of Padua. Over the years, a school opened, and the church grew into a modern facility in 1955. (Courtesy of Vincent Mariano.)

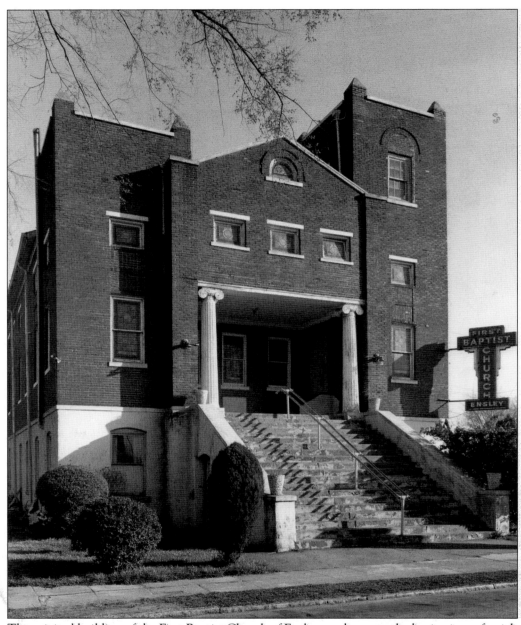

The original building of the First Baptist Church of Ensley was home to the beginnings of a rich heritage in Ensley, the city of Birmingham, and the state of Alabama. Built in 1926, this historic African American church survived many pastors over the years. Eventually the church moved into a modern facility to meet the needs of a growing congregation. (Courtesy First Baptist Church of Ensley.)

Rev. Alfred D. King, the younger brother to Rev. Martin Luther King Jr., served as the pastor of the First Baptist Church of Ensley from 1961 to 1965, during the final decade of the civil rights movement. Along with his wife, Naomi King, and their children, he resided in the church parsonage on 721 Twelfth Street in Ensley. Like his brother, he was a minister and contributed to the civil rights movement. Joined by a group of women from the church, A. D. King stands (right) on the church steps next to his wife and one of their sons. Eventually they had five children. In the picture below, King preaches from the pulpit of the old church. The current church is significant for contributions to the civil rights movement as a site of mass meetings that brought the foot soldiers in the movement together. (Courtesy of First Baptist Church of Ensley.)

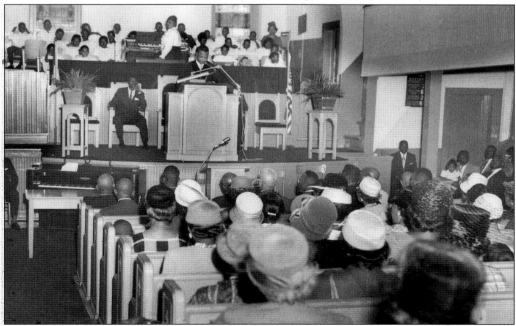

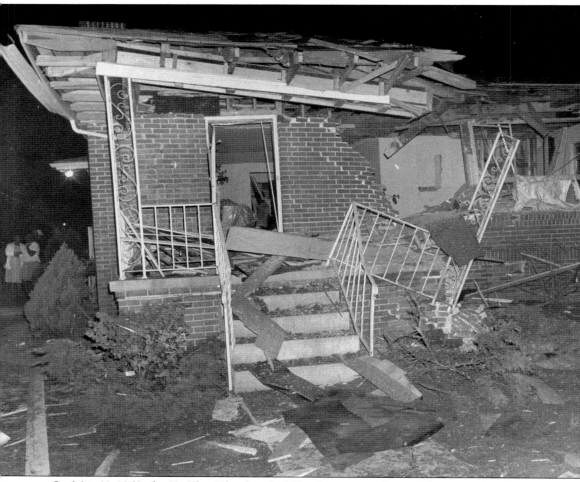

On May 11, 1963, the Ku Klux Klan bombed King's parsonage home. The entire family survived unharmed, but the event stirred up a crowd in the streets of Ensley. To try and prevent a riot, Rev. A. D. King spoke to them and encouraged the angry citizens to remain committed to nonviolent protest. King had been in the bedroom working on a sermon, rose to look outside the front door, and then turned around to walk with his wife to the middle of the home when the first bomb exploded. While evacuating their five children out the back door, a larger bomb blew off the front of the home. Omie Crockett Sr., a former steel mill employee, a foot soldier in the movement, and a member of the First Baptist Church of Ensley, purchased the parsonage to preserve the home for future generations. Today it is listed on the National Register of Historic Places, and in 2006, the parsonage also received a plaque marking it as a Civil Rights Heritage Site. (Courtesy of Birmingham Public Library Archives.)

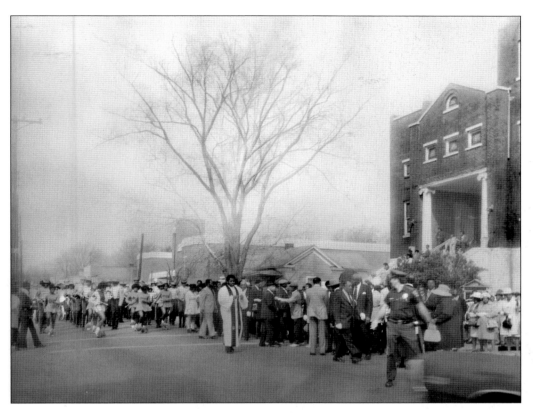

When the congregation of the old church completed the new church, they participated in a parade from one to the other. Gathered inside, they held a ceremony and program led by Dr. Thomas A. Hamilton. (Courtesy of First Baptist Church of Ensley.)

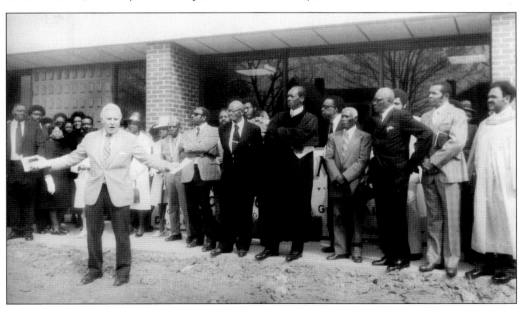

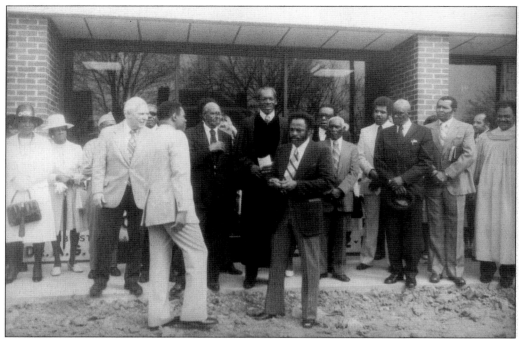

The group gathered outside as well to dedicate the new church, located at 1508 Nineteenth Street Ensley. Historical organizations and the Village Creek History Committee presented the church with a plaque to mark its contributions to the movement as an institution that hosted mass meetings of the Alabama Christian Movement of Human Rights. (Courtesy of First Baptist Church of Ensley.)

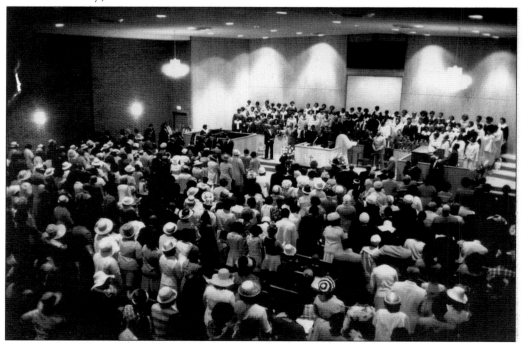

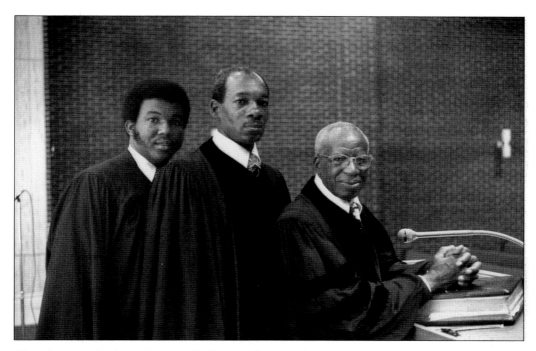

This photograph above features all three of the Hamiltons together, father, son, and grandson. Rev. William A. Hamilton presented a sermon from the pulpit in the new auditorium in the image below. Today Dr. Thomas Earl Gilmore leads the Ensley Baptist Church as pastor. He has been dedicated to service for over 50 years. (Courtesy of First Baptist Church of Ensley.)

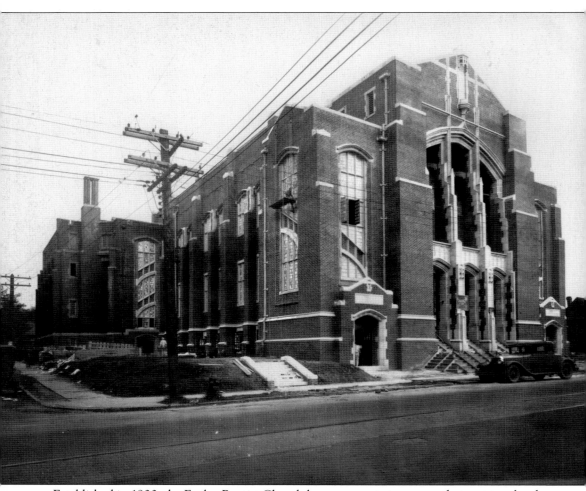

Established in 1900, the Ensley Baptist Church began as a mission group that met in a hardware store at 1712 Avenue E. The congregation built a church on the southeast corner of Eighteenth Street and Avenue G. In 1906, the church added more space, but eventually they would need a new structure. Once finished, the old building became the Sunday school. In 1924, the church launched a large building campaign and constructed this one at 2301 Avenue E. The church added an educational building in 1964. The structures are now occupied and maintained by Abyssinia Missionary Baptist Church. Since 1977, Dr. Reginald Leon Patterson Sr. has served as the pastor of Abyssinia and facilitated the movement into the building inaugurated by a joint service between the old members and the new occupants. (Courtesy of What's On Second.)

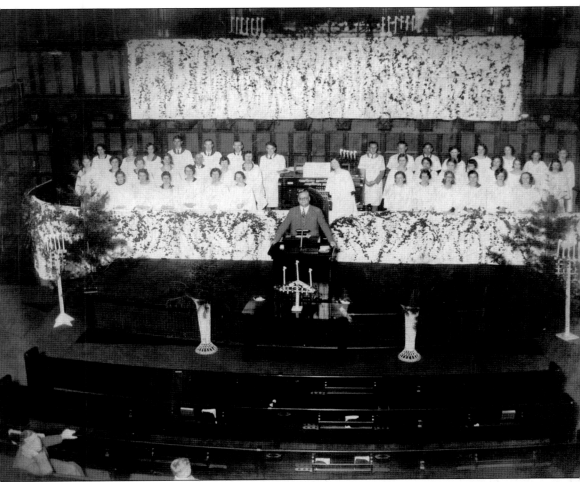

On the inside of the church, the pastor preaches with the choir standing in the background. Between 1900 and 1999, the church had 16 pastors, J. W. Willis (1900–1902), H. W. Provence (1902–1904), J. H. Longrier (1904–1907), O. P. Bentley (1907–1910), A. K. Wright (1910–1920), D. M. Gardner (1920–1929), C. B. Miller (1930–1942), W. C. Kirk (1942–1947), Lamar Jackson (1948–1957), Garnett Puckett (1957–1964), Hayward Smith (1964–1967), Robert Curlee (1967–1971), Jack Farmer (1972–1982), Gary Fisher (1982–1988), David Lowery (1989–1998), and Roy Morgan 1999-). (Courtesy of Lucy Ray.)

This picture is of Reverend Willis, the first official pastor of Ensley Baptist Church. When the Ensley Baptist Church first organized, W. S. Brown, the Birmingham Baptists' superintendent of missions, served as part-time pastor. Beginning in 1899, he worked with a committee of brethren, including J. V. Dickensen, J. W. Minor, and W. R. Ivey, to establish the church. Following the completion of an infrastructure of governance, Dr. J. W. Willis, a native of Auburn, Alabama, assumed duties as pastor and began work on November 25, 1900. Under Dr. Willis, $1956.76 had been spent on a building and seats, $140 on missions, $31 on an orphanage, $8 on the poor, $25 on communion service, and $17.50 on songbooks. (Courtesy of Abyssinia Missionary Baptist Church.)

Dr. David Gardner left the church in August 1929 on the heels of the Great Depression. At the time Dr. C. B. Miller took the position opening, the church had accumulated a huge debt forcing it to cut back salaries, supplies, and services. The church paid a bonded indebtedness of $175,000. With the leadership of J. A. Holcomb, Reverend Miller (shown at right) brought the church out of debt, and arrangements were made in February 1942 to refinance the bonded indebtedness and issue new bonds in the amount of $87,000. (Courtesy of Abyssinia Missionary Baptist Church.)

Rev. W. C. Kirk took over the pastorate just after the attack on Pearl Harbor and when 276 servicemen and women for the church were on the Service Roll. The church voted to make religious training and services available in all sections of the Ensley district. Under Kirk's leadership and the city superintendent of missions, the church organized Bethany Chapel, Calvary Chapel, and Trinity Chapel at separate locations throughout Ensley. Rev. David Lowry (below) became pastor in February 1989. Under his direction the church continued ministering and participated in the Here's Hope Simultaneous Revival. The church completed a census of the neighborhood and conducted vacation Bible school. At the close of his service, the attendance had dropped to around 60. (Courtesy of Abyssinia Missionary Baptist Church.)

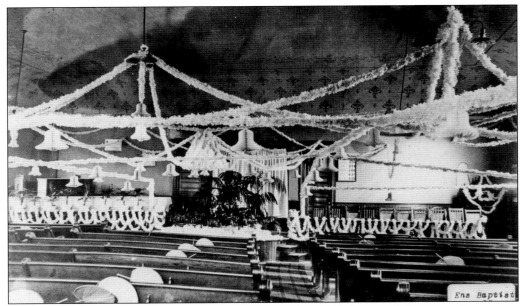

The interior of the original Ensley Baptist Church is shown all decorated for a special occasion. The original location was the intersection of Avenue G and Eighteenth Street. (Courtesy What's On Second.)

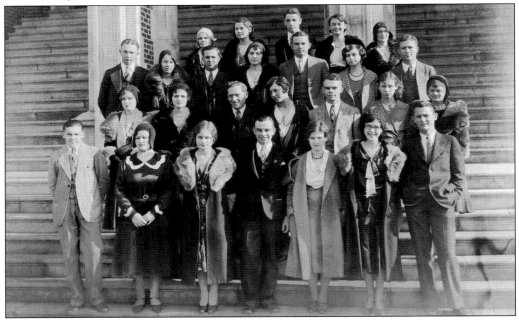

This photograph taken in February 1931 features a group of young people gathered on the steps of the Ensley Baptist Church. They were a Training Union Department, responsible for much of the Southern Baptist church's mission work education and some Bible teaching. Bonnie Jean Price Ray is second from the left in the second row, and Adele Price Wilkins is the fourth from the left in the third row. The two sisters also sang in the choir shown in the photograph on page 63. (Courtesy of Lucy Ray.)

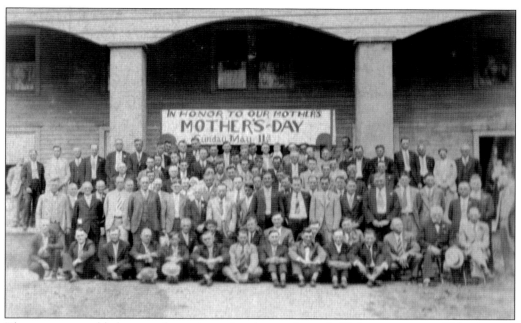

These two rare, old photographs, estimated to date to the early 20th century, are of Pike Avenue Baptist Church and the members, leaders, or congregation. The above photograph shows men wishing their mothers a happy Mother's Day on Sunday, May 11. (Courtesy of Sue Hardy Thomas.)

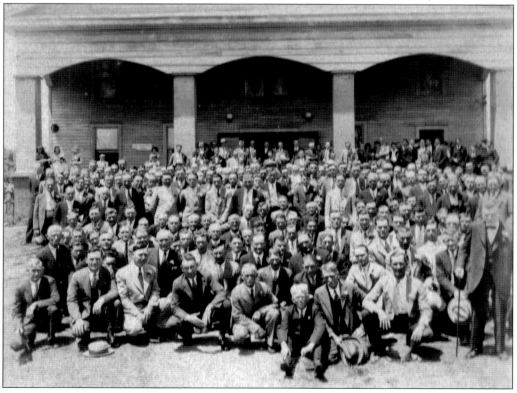

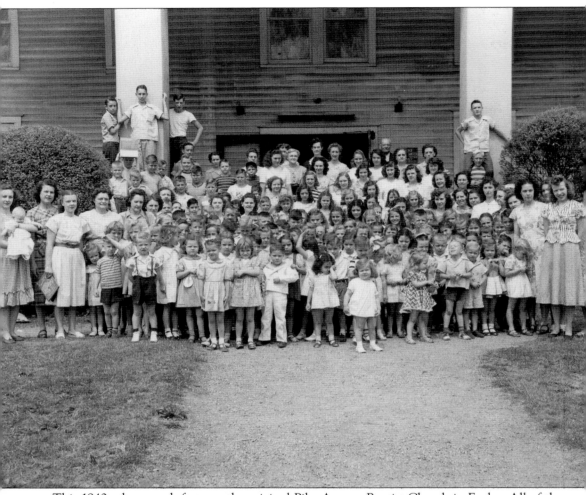

This 1940s photograph features the original Pike Avenue Baptist Church in Ensley. All of the women and children attending vacation Bible school gathered in front of the old frame church. At the time, Sue Hardy Thomas, a resident of Ensley, was 15 years old. She had many relatives who worked for TCI. (Courtesy Sue Thomas.)

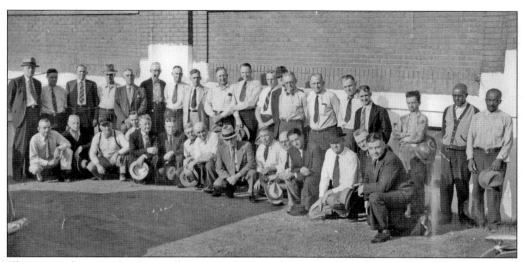

These two photographs date to the construction and occupation of the new Pike Baptist Church, built of brick. In the photograph with above, a man fourth from the left (first row) kneels down and holds his white hat facing the camera. He is Jesse William Hardy who worked for TCI, and just behind this gentleman in a white shirt is Lee Hardy, a union member, who also worked for TCI. Lee Hardy is Sue Hardy Thomas's uncle and Jesse William Hardy is her grandfather. In the second photograph, Rev. Theo Thomas, who served as pastor for approximately 40 years, stands sixth from the left in a very dark black suit. (Courtesy of Sue Hardy Thomas.)

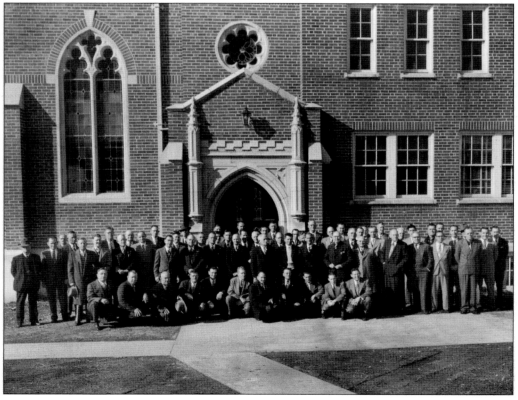

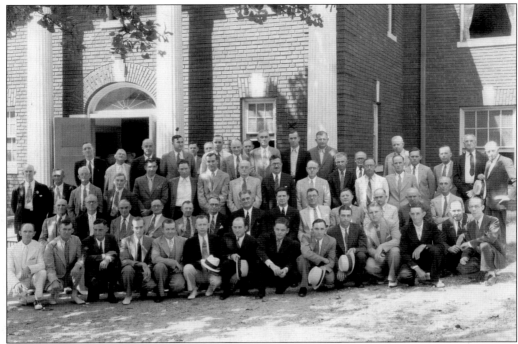

A photograph of Ensley Highlands Methodist Church includes two members of the Freeze family. Earnest Box Freeze is second from the left in the first row; Robert E. Lee Freeze is in the back row, second from the right. In 1911, the lots for the first church were purchased from the Ensley Highlands Company for $505. The present church is located at Ensley Avenue and Avenue South. This building has three stories, a basement and two upper floors. (Courtesy of Sue Thomas.)

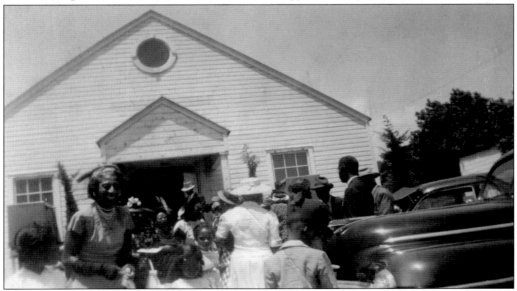

This photograph is of the Church of Christ at 1329 Avenue South. Rev. Marshall Keeble came to Birmingham in the early 1900s and established a black congregation. Founder F. L. Eidel Thompson was the first live-in minister. (Courtesy of Lizzie Bass Allen.)

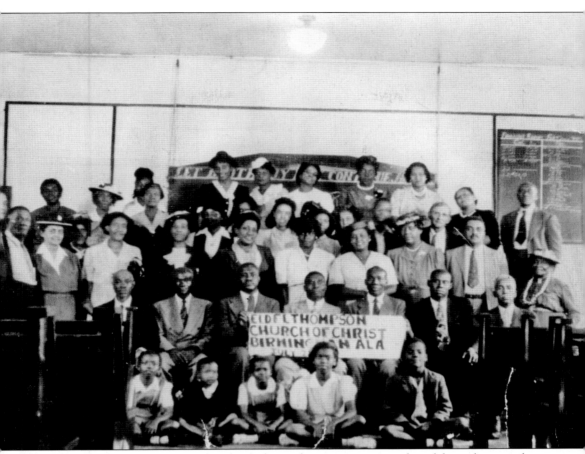

During the opening of the New Church of Christ, the congregation gathered for a photograph. Rev. F. L. Eidel is the man in the middle behind the hand-painted sign. Ruth Harvelle Hill is the girl seated up front in the center in front of the sign. She grew up to be a teacher and work as a hospital clerk at the TCI Hospital. Solemner Kate Bass stands behind the preacher and wears a white dress. She was the mother of Lizzie Bass Allen. They moved to Ensley in 1926 when Lizzie was one year old. Lizzie grew up to become an licensed practical nurse at the University of Alabama at Birmingham. (Courtesy of Lizzie Bass and Ruth Harvill Hill.)

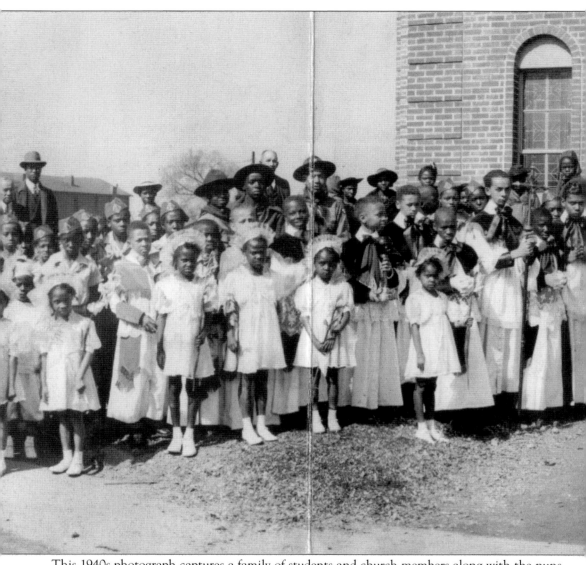

This 1940s photograph captures a family of students and church members along with the nuns and priests of the Holy Family community that included a school and church at the time. The Catholic complex grew over the years from its beginnings in Tuxedo Junction. For many African Americans, the complex has been a cornerstone to the community over time. Individuals like

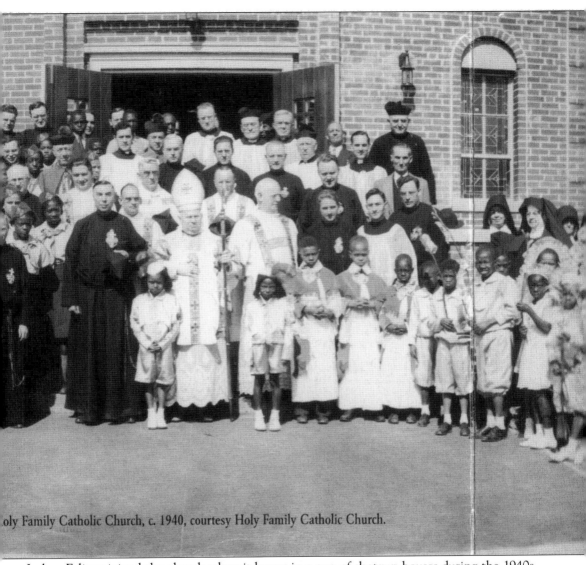

oly Family Catholic Church, c. 1940, courtesy Holy Family Catholic Church.

Joshua Felious joined the church when it began in a row of shotgun houses during the 1940s. All of his children and grandchildren attended the Holy Family schools. (Courtesy of Eddie Mae Thomas.)

This photograph of Holy Family Church is the first page of a compiled oral history of Holy Family. Holy Family is also the subject of a 1994 book, *Tuxedo Junction to Christ*, by Fr. Rian Clancy, C. P. (Courtesy of Eddie Mae Thomas.)

Five

GOING TO SCHOOL

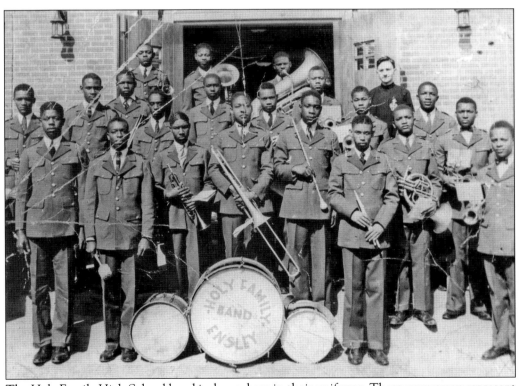

The Holy Family High School band is shown here in their uniforms. These young men represent a long-standing tradition of excellence and the contributions of the entire Holy Family campus to the communities of Ensley over time. Holy Family directs an elementary school, a high school, and at one time managed Holy Family Community Hospital. The high school opened with the first group in September 1943, and "moving day" into a new facility was in May 1955. (Courtesy of Holy Family Church.)

This photograph is of Holy Family Elementary School, a landmark at the gateway to Ensley. Located between Nineteenth and Eighteenth Streets, Holy Family really occupies a good portion of the area. The high school began in 1944 and still exists today. (Courtesy of Holy Family Church.)

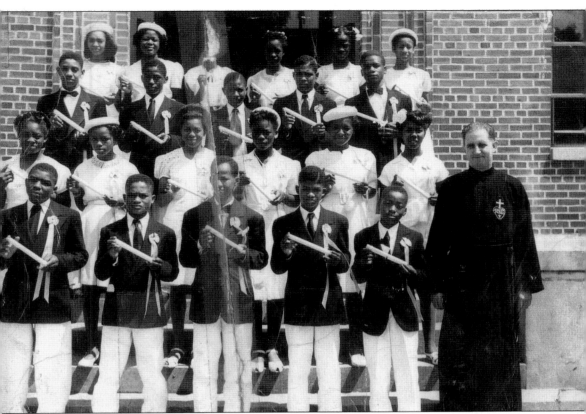

Dressed in their finest graduation attire, members of the eighth-grade graduation class of 1947 accept their diplomas. Former student Henrietta Flemming Watts started at Holy Family when she was four years old. She went on to have children and grandchildren who finished from Holy Family as well. (Courtesy of Holy Family Church.)

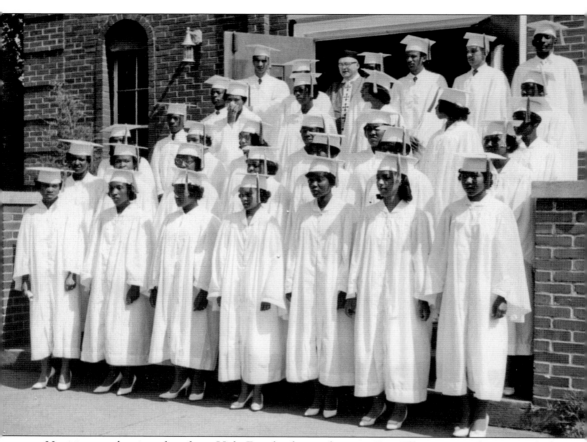

Here is a graduation class from Holy Family, date unknown. Don Ellison remembers attending high school when there were only nuns and no lay teachers or "civilians," as non-Catholic priests and nuns were called at the time. Father Philip, Father Nathaniel, Father Gilbert, Sister Joe, Sister Maureen, and Father Edgar are the teachers he remembers. He also remembers the importance of basketball season at Holy Family. (Courtesy of Holy Family Church.)

In 1968, students Cheryl Riley, Cheryl Boone, and Pat Davis join Vet Edmonds, Fance, and Eddie Krod for the photograph above. In 1970, another group poses in traditional African–style clothing with a modernized twist, popular at the time. While there are still many opportunities for student groups and clubs at today's Holy Family, many remember the Silver Barn as a center of social activity for the community. They had dances, banquets, roller-skating, and movies for young people. Community advocate and leader Magnolia Cook met her husband, Wendolyn Cook, at the Silver Barn. (Both, courtesy of Holy Family.)

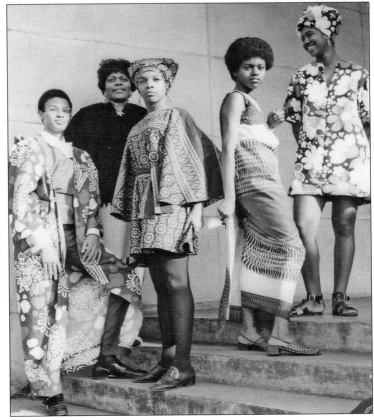

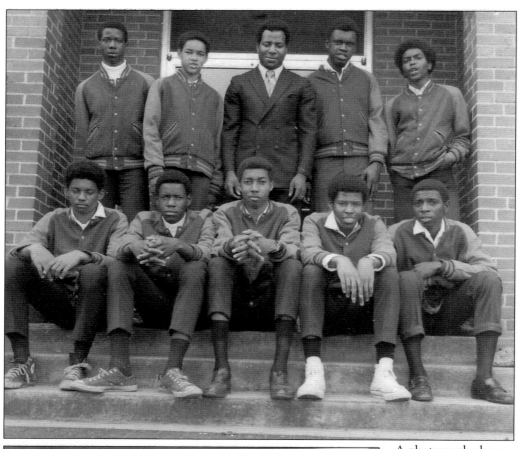

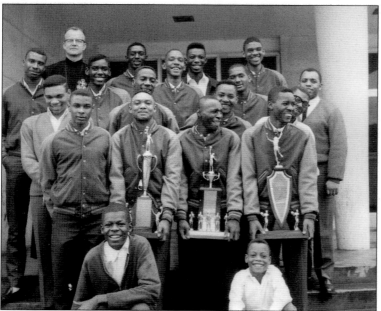

A photograph above dating to April 1970 captures Coach Jackson and the basketball team, and a photograph in 1965, at left, shows off a winning team with their trophies. Many graduates of Holy Family played on the sports teams and have fond memories of the diverse opportunities Holy Family provided. (Courtesy of Holy Family Church.)

The Tornadoes (below) are posed for the camera in white shirts and dark pants, and the cheerleaders for 1968–1969 (at right) pose in their white uniforms. Sports and music programs are two of the extra curriculum activities provided by Holy Family schools. The Tornadoes have a legendary tradition of success in basketball. Boy's varsity teams were Alabama State 1A Champions in 1973, 1977, 1982, and 1986, followed by State 2A Championships in 1987 and 2002. (Courtesy of Holy Family Church.)

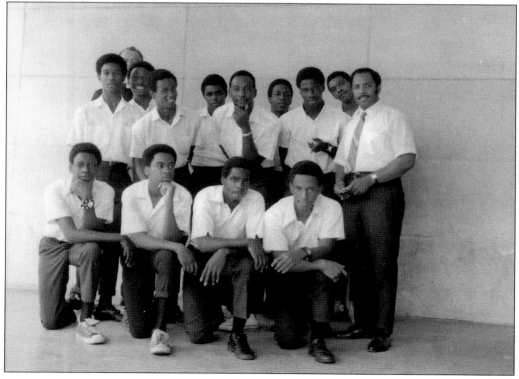

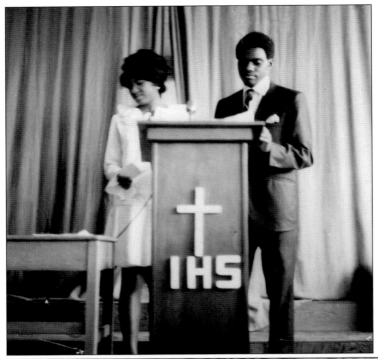

Cheryl Brown and Victor Spencer stand at the podium at a Holy Family senior assembly, at right. The photograph below features the senior team of 1968–1969. Current club offerings include choir, debate, drama, math, photography, video, reading, science, Spanish, step team, young authors, and praise dance. (Courtesy of Holy Family Church.)

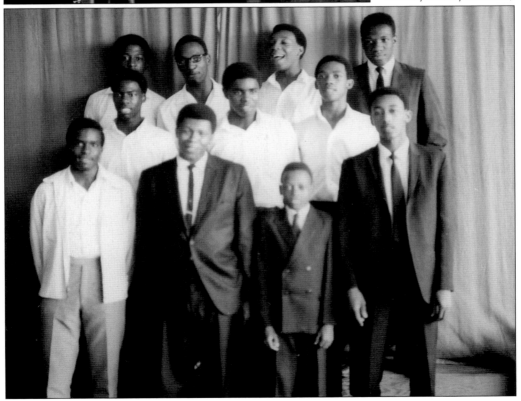

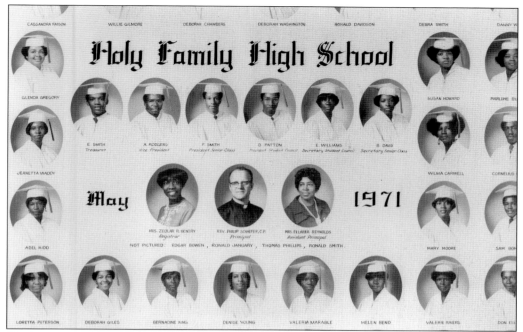

Graduation would not be complete without the class photographs for the years 1968 and 1971. According to many former students like Ola B. Walker, Holy Family School made them feel special if they helped. When she was chosen as one of the students to clean the blackboards, she felt special. (Courtesy of Holy Family Church.)

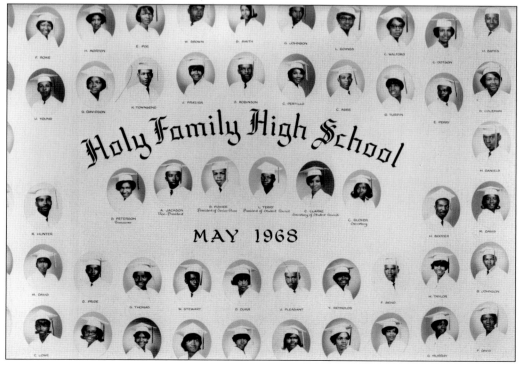

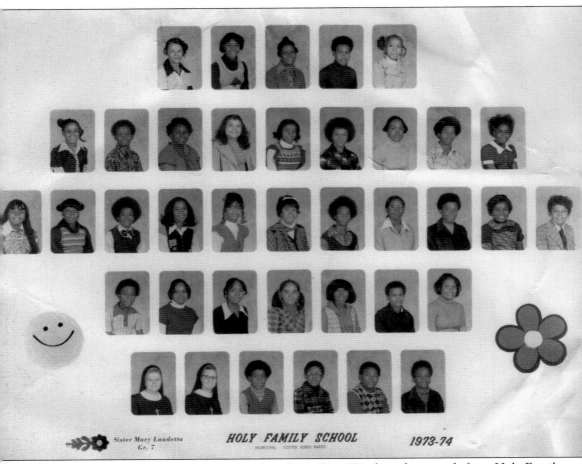

Memories of being young are captured in this 1973–1974 class photograph from Holy Family School. Omie Crockett's daughter Jacqueline Crockett Washington contributed her annual class photograph. (Courtesy of Holy Family Church.)

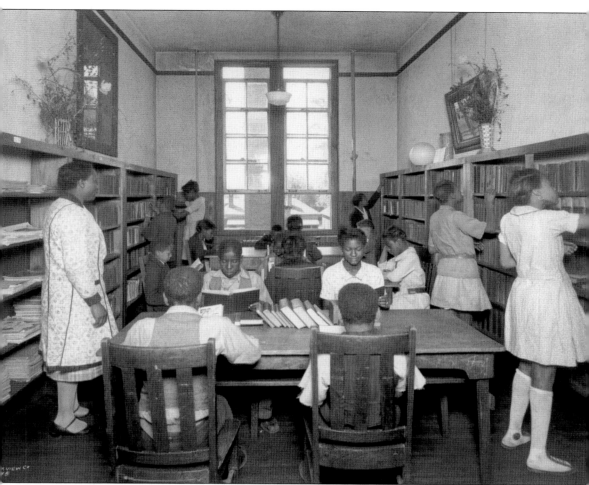

This April 1930 photograph shows a group of students at Councill School reading and conducting research in the library. Constructed in 1898, at the corner of Twentieth Street and Avenue L, the first building opened before the City of Ensley became incorporated. The first name was the Davis School named for Prof. Alfred Davis, and then later the name changed to Councill School in honor of Doctor W. H Councill, the founder and president of the Alabama A&M University. Councill is the oldest grammar school in the Birmingham area that is still being used and the first school for blacks to open its doors for night classes. It is now located at 1400 Avenue M in a building erected around 1925. The Birmingham school system provided separate facilities for blacks and whites during the era of Jim Crow segregation. (Courtesy of Sue Thomas.)

This St. Anthony's classroom photograph dates to 1943. The teacher was Mary Pennella. John Meehan, a local community advocate, can be found in the second row, second from the right. Father McQuillen invited the Sisters of Mercy to open a school in the parish. Fifty-one children enrolled in the school that taught in the parlor and dining room of the rectory. The curriculum included business and music courses. The rectory porch had to be enclosed and used to accommodate growth until a frame building was constructed in 1917. (Courtesy of John Meehan.)

This photograph, taken in 1968 in Ensley Park, features the cheerleading squad for Ensley High School. At the time, Peggy Burkhalter (brunette with bob haircut on a bar in the center) was captain of the group and the homecoming queen. She married Larry DePiano who she met in high school. (Courtesy of Birmingham Public Library Archives.)

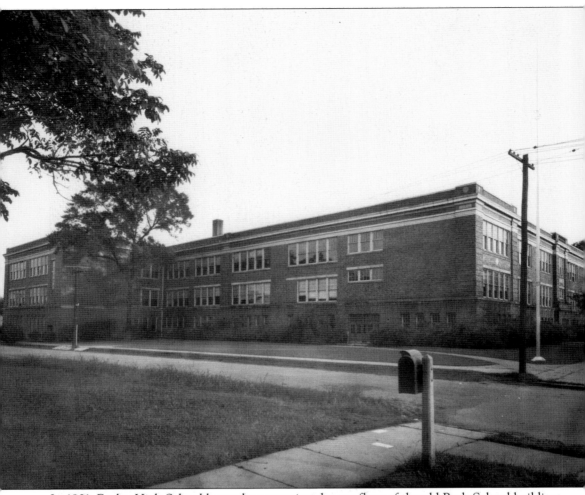

In 1901, Ensley High School began by occupying the top floor of the old Bush School building. A. A. Lyon was the first principal. In 1903, the first graduating class had just two students, Margaret Wright and Mattie May Williams. In 1904 there were 10 graduating students. Under the leadership of school superintendent Dr. J. H. Phillips, Ensley High School entered the Birmingham school system in 1910. The process required the Greater Birmingham Bill to pass in the state legislature. The principal, R. D. Tidwell, continued in his position until 1912, followed by R. L. Dimmitt. Dr. E. E. Sechriest was principal from 1931 until 1958. After 1917, the school enlarged to accommodate over 2,000 students. From that time forward, the school building continued to be remodeled and expanded to meet the growing needs of the local students. (Courtesy of Birmingham Public Library Archives.)

These photographs from the mid-1930s show the cheerleading squads for the Yellow Jackets. The young man with glasses is C. E. Wilborn Jr., who was head of the cheerleading squad. In later years, the squads returned to being girls-only. (Courtesy of Birmingham Public Library Archives.)

For female students at Ensley High School, the original curriculum included exercise class and etiquette in the tea room. The photograph above, labeled "playground class," shows students exercising outside. In the image below, taken in 1930, students sit at tables and learn how to behave as fine young Southern women. (Courtesy of Birmingham Public Library Archives.)

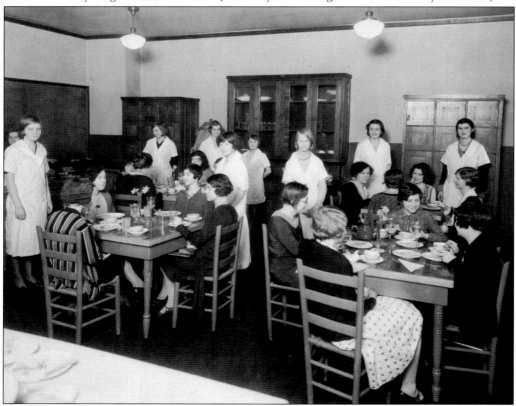

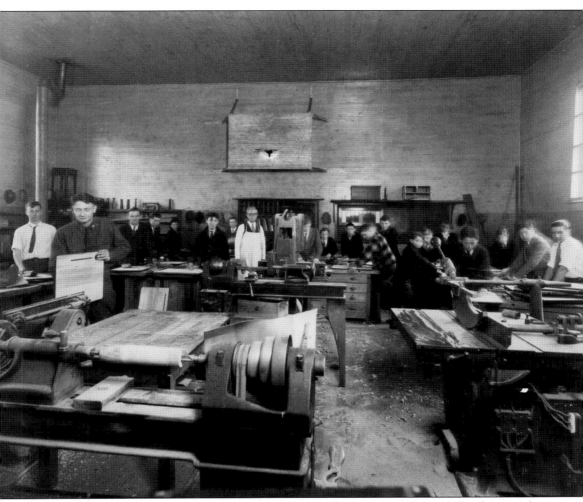

These industrious young volunteers are using planing tools to repair desktops. The photograph dates to the 1930s. (Courtesy of Birmingham Public Library Archives.)

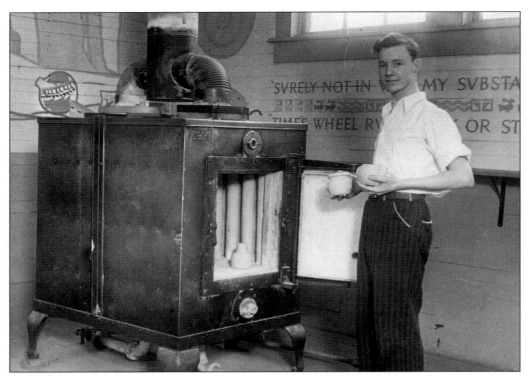

Instructor Caroline Dick led students in art classes. In this photograph from 1932, he is preparing to add two more works of art to the potter kiln. Below, in a second photograph from 1932, Students work at pottery wheels. (Courtesy of Birmingham Public Library Archives.)

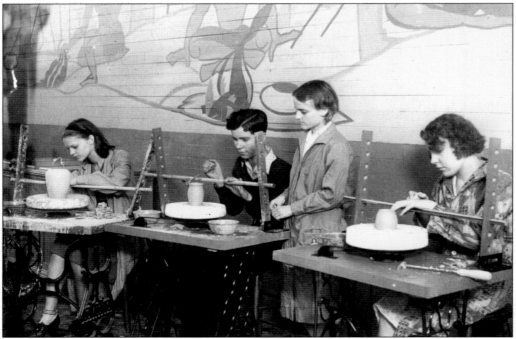

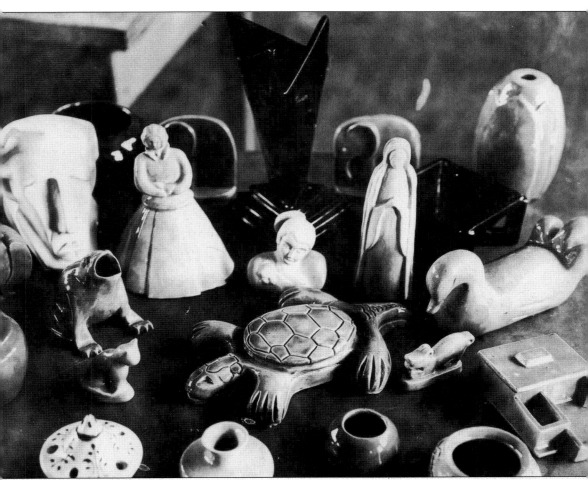

The products of the students included figurines, vases, pots, and other items, both functional and decorative. (Courtesy of Birmingham Public Library Archives.)

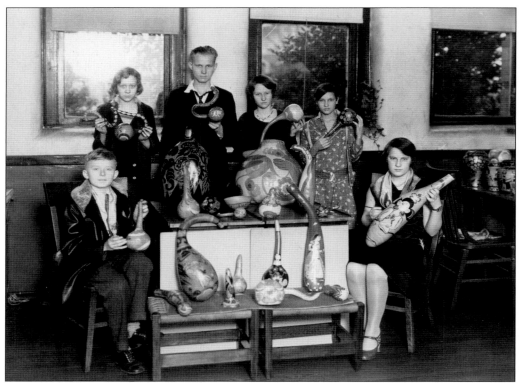

A folk art tradition in Alabama, these painted gourds demonstrate that during the early 1930s, school curriculum at Ensley High School included more art classes. (Courtesy of Birmingham Public Library Archives.)

Education began at an early age in kindergarten, and not all educational programs began in school. Violet Hester Hopping, who is not pictured in the photographs, taught for 14 years at Ensley Park. According to Hopping, several or all of the parks in Birmingham had kindergarten classes that received no financing from the City of Birmingham. (Courtesy of Violet Hester Hopping.)

The Mother's Club helped fund the programs, and they accepted many donations and leftovers. Hopping remembers using box paper from the five-and-dime store downtown for teaching. At one time they had very nice oak tables and chairs used by classes held in the parks, but all of these items plus others were lost when they closed the parks after integration. They also made the backdrops in the above photograph and the one on the bottom of page 94. One is a theater and the other is handcrafted items. (Courtesy of Violet Hester Hopping.)

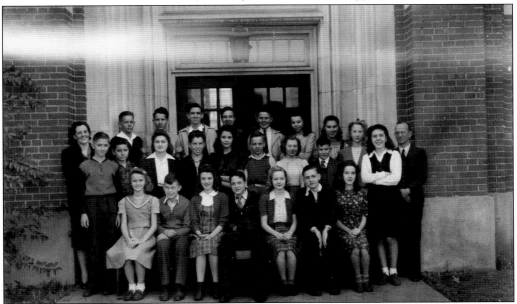

This 1942 photograph of the eighth-grade class at Minor School includes Hazel Freeze Percer, fifth from the left in the first row. She was 13 years old at the time. Minor School, an elementary school, taught grades one through eight. Located at 1916 Pike Road and constructed of brick in 1911, the student capacity for the facility was 335 pupils. The cost of construction was $15,000. Named for J. W. Minor, a businessman of Ensley, the school was closed in the 1960s, and the building was later used as a training school. (Courtesy of Hazel Freeze Percer.)

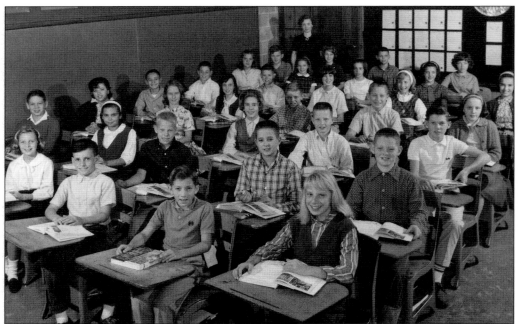

Located at 4811 Court J in the Ensley Highlands and Oak Hills area, the Charles A. Brown School provided an additional local facility for students living in those neighborhoods. Dating to the late 1960s, all of these class photographs record some of the last students to live in the area prior to the closing of the mills and the flight out of the area. Marjorie Crooks, related to Joseph Crooks of the Central Seed and Hardware store, is pictured as the teacher with her young students. Along with principal John R. Slaughter (second from left), the teachers gather in the lunchroom, below, for a group photograph. (Courtesy of Birmingham Public Library Archives.)

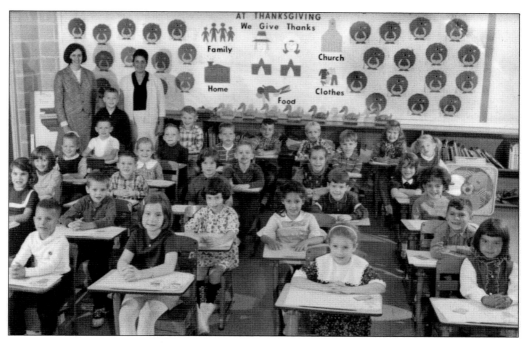

Above, Helen Homble is photographed in 1968 with the sixth-grade class. The photograph below shows the ninth-grade class of teacher Nannie Lee Moore. (Courtesy of Dana Crooks Dortch.)

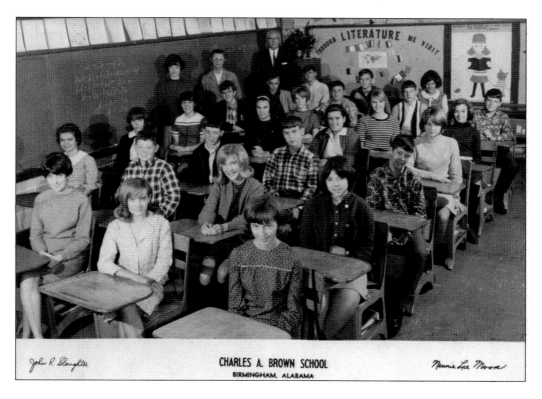

CHARLES A. BROWN SCHOOL
BIRMINGHAM, ALABAMA

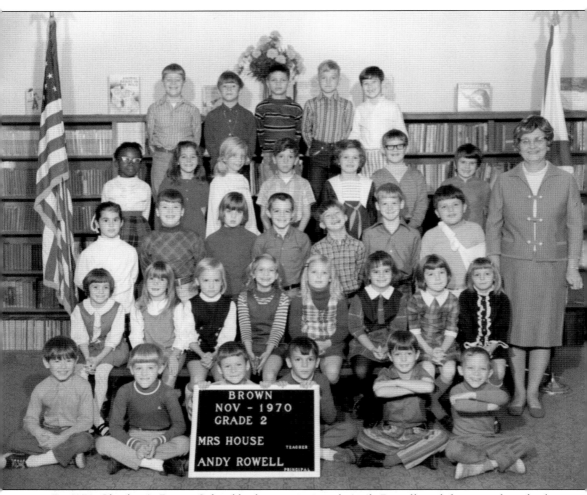

By 1970, Charles A. Brown School had a new principal, Andy Rowell, and the second-grade class included Dana Crooks Dortch, a descendent of an Ensley businessman. The teacher, Mrs. House, is shown far right. (Courtesy of Dana Crooks Dortch.)

Six

HOUSING AND
HEALTH CARE

This 1940 photograph of a frame craftsman-style home, located one block from the Tuxedo Junction area, features Louis Daye, Doris Freeze (age 15), and Hazel Freeze (age 11). Hazel Freeze Percer grew up in this home. Many people lived in wood-frame bungalow/craftsman–style homes, and later in bungalows that were accented with brick and stone. (Courtesy of Hazel Freeze Percer.)

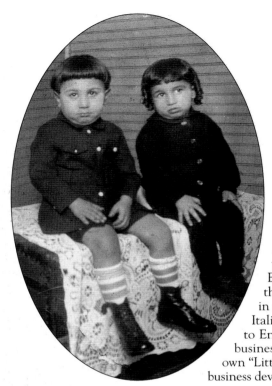

At left are Frank and George Mariano, two young Italian American boys who grew up in Ensley, Alabama. Those same two boys and a third are pictured below in the early 1900s outside in a yard surrounded by a white picket fence. Many Italian families, including the Marianos, migrated to Ensley to settle, work, raise families, and open businesses in the community. They formed Ensley's own "Little Italy" and made significant contributions to business development.

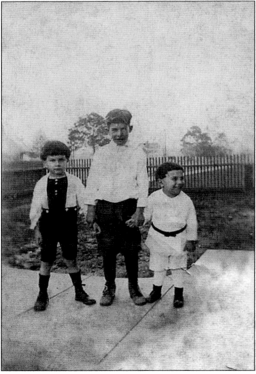

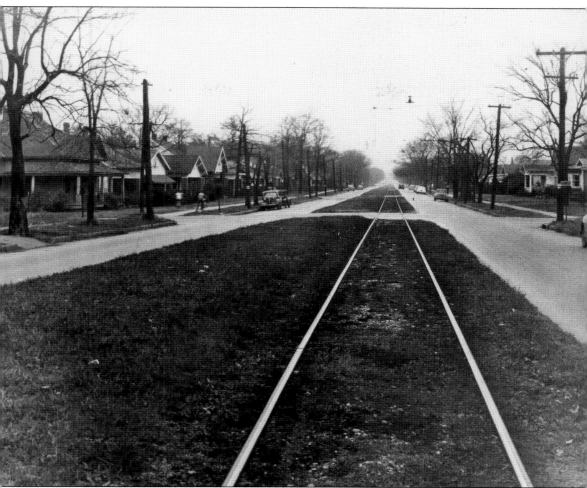

This 1940 streetscape of Avenue I shows a boulevard-style transportation corridor lined with a variety of vernacular cottages with features influenced by the Colonial Revival, Queen Anne, and craftsman styles. The dates of construction for these homes range from 1890 to 1925. (Courtesy of Birmingham Public Library Archives.)

Also located in the Pike Avenue area, this frame home is a gable-and-wing cottage with a large porch. The home belonged to Sarah and Nell Storey. Sarah was the mother of Sue Hardy Thomas, who was the niece of Bessie Story (see page 37). Thomas's uncle Lee Hardy and grandfather Jesse Lillian Hardy worked for TCI. The address of the home was Avenue K and Twenty-fifth Street. (Courtesy of Sue Hardy Thomas.)

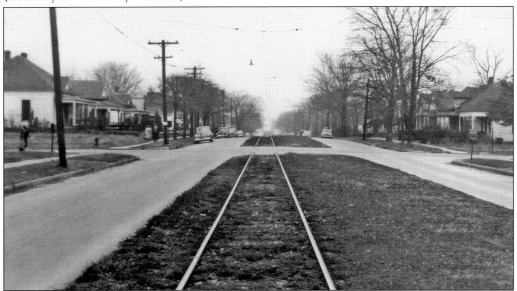

A 1950s image of North Avenue I and Twenty-fifth Street provides an additional streetscape view of an Ensley neighborhood, with the trolley lines extending down the grassy median and pedestrian-friendly corridors that had cottages recessed from the roadway and sidewalks. (Courtesy of Birmingham Public Library Archives.

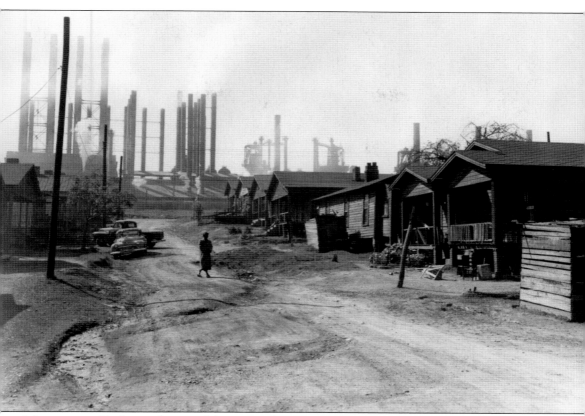

Many current Ensley residents and former residents grew up in the sections of company housing owned by U.S. Steel. This photograph, taken in the spring of 1953, is a shot of the housing area or "quarters" located directly adjacent to the mills. Other large sections of housing existed in the Tuxedo area and in the Village Creek floodplain located north of downtown Ensley. Visible is a washed-out dirt road that symbolizes the environmental conditions of these areas selected for housing. Most were low lying and often flooded. Not visible are the outhouses located in the rear of the homes. (Courtesy of Birmingham Public Library Archives.)

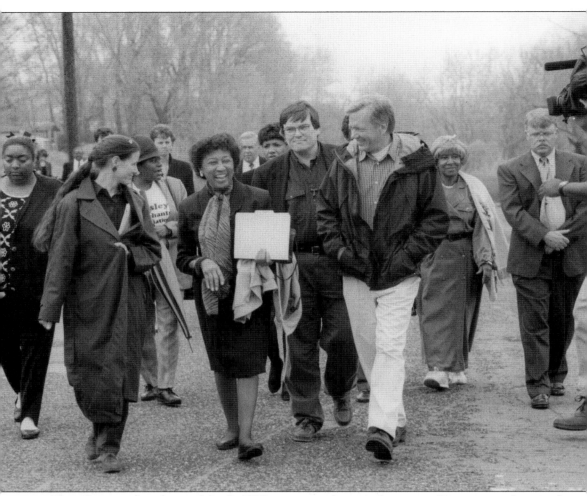

This photograph, taken in March 1997, captures a historical moment for many residents and members of the Village Creek Society. The photograph features U.S. Secretary of the Interior Bruce Babbitt walking with local residents of the Village Creek area also being led by Dr. Mable Anderson, a longtime resident and community advocate. Babbitt steps out in front wearing white pants, and Dr. Anderson is left of him. Behind both of them is John Meehan, a community advocate and native of Ensley. The visit from U.S. Secretary of the Interior Babbitt in March 1997 marked the announcement that the Federal Emergency Management Agency (FEMA) would be partnering with the City of Birmingham to buy out the homes of 200 families living in the floodplain. Plans are to restore the area as a natural greenway and environmental classroom. (Courtesy of Dr. Mable Anderson.)

Due to community advocacy, changes to other neighborhoods are also underway. In the Tuxedo area, where housing projects replaced the original labor housing, a new Hope VI project is under construction. Magnolia Cook, whose husband worked for TCI, has been a longtime community leader and advocate for the Tuxedo neighborhood, assisting it through many transitions. Community leadership provided by the late Rev. Ron Nored led to the development of the Sandy Vista neighborhood to replace the homes surrounding Bethel African American Methodist Episcopal Church. The organization is called the Bethel Ensley Action Task Force (BEAT). (Courtesy of Dr. Mabel Anderson.)

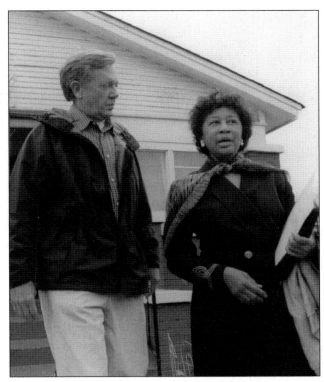

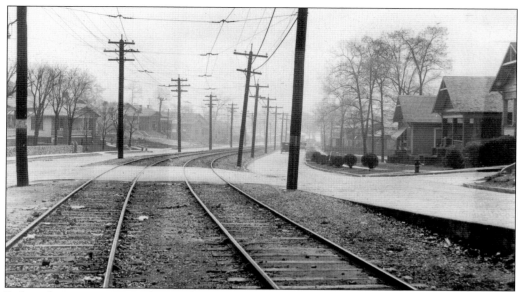

Before the interstate corridor, Ensley Highlands was considered part of Ensley. Ensley Avenue extends out of the Tuxedo area and towards Fair Park and cuts through the Ensley Highlands neighborhood. This photograph is a view of Ensley Avenue at Thirtieth Street. Ensley Highlands contains four squares, Queen-Anne cottages, and Tudor Revival–style homes that belonged to upper-class businessmen and company management for TCI. (Courtesy of Birmingham Public Library Archives.)

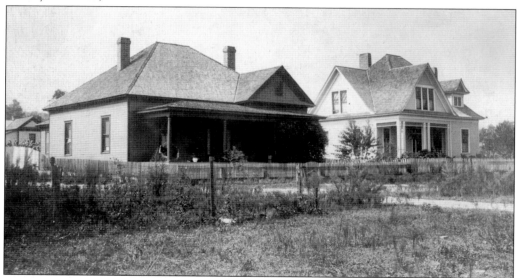

These two cottages belonged to Dr. George Fields (left home) and Fletcher Swann. Both homes are colonial-style cottages dating to the 1890s. In 1915, Dr. Fields lived at 1611 Pike Avenue and Fletcher E. Swann lived at 1617 Pike Avenue, making them neighbors. At the time, Dr. Fields was the owner of Avery Drug Company, but later, in 1940, he is listed in the city directory as living at 2309 Avenue F and owning Fields-Goodwin Drugs, a company located in the Ramsay-McCormack building at 1825 Avenue E. Swann was a steelworker at Tennessee Coal Iron and Railroad Company and later moved to 1616 Pike Avenue. (Courtesy of Birmingham Public Library Archives.)

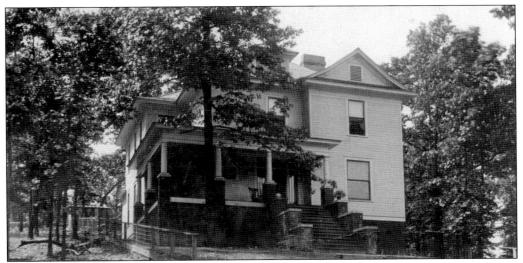

This American four-square home, with additions, belonged to Maj. Frederick Dodge. The entrance sidewalk and rising stairwell leading to the front door demonstrate the hilly geography of the neighborhood and how the neighborhood name of Ensley Highlands originated. (Courtesy of Birmingham Public Library Archives.)

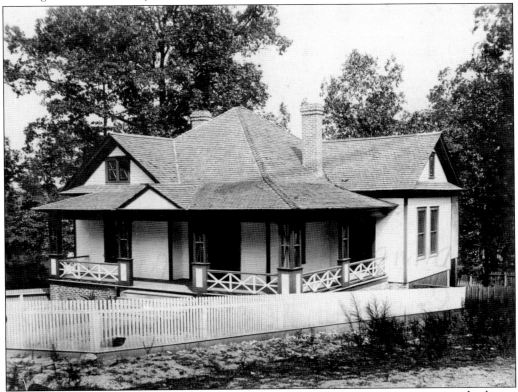

This photograph is of the home of a Mr. Glasgow. An 1890s composite cottage, the home features a full wraparound porch and a hip-and-gable roofline. (Courtesy of Birmingham Public Library Archives.)

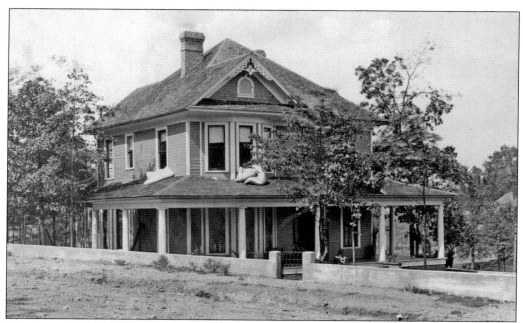

This home in Ensley Highlands belonged to Jonathan Morrison. In 1915, he lived at 2632 Ensley Avenue, Ensley, and managed Morrison Motor Car Company. This Queen Anne–style home has a full wraparound porch, decorative shingles in the gables, and interesting stonework. (Courtesy of Birmingham Public Library Archives.)

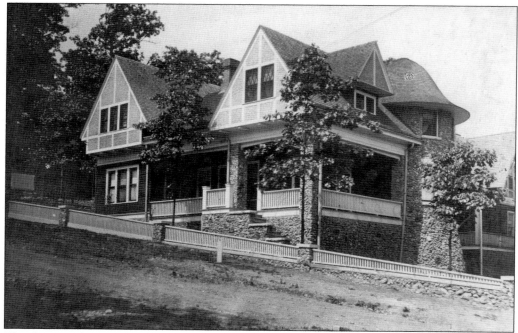

This home is located on Ensley Avenue in the Ensley Highlands neighborhood. It is a large Tudor Revival with stucco and half-timbering in the gables. (Courtesy of Birmingham Public Library Archives.)

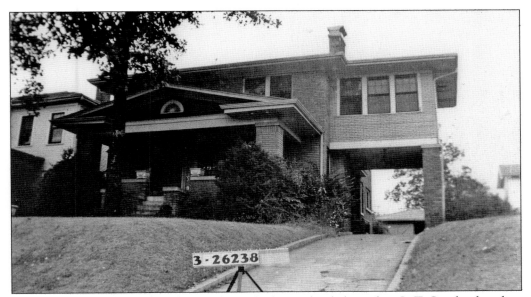

This photograph, taken in the 1930s, shows the home that belonged to C. T. Crooks, founding owner of Central Hardware and Seed in downtown Ensley. The home is located at 2014 Twenty-sixth Street. His first home in 1915 was at 2430 Eighteenth Court. He is the grandfather of Dana Crooks Dortch. (Courtesy of Dana Crooks Dortch.)

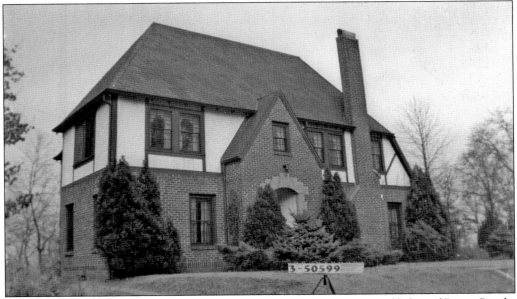

This 1930s photograph shows the home of Augustus Noojin, great-grandfather of Dana Crooks Dortch. By 1920, he lived at 1020 Forty-third Place West, the home pictured above, and worked for U.S. Steel as the chief metallurgist. His previous home was at 916 South Twentieth Street. (Courtesy of Dana Crooks Dortch.)

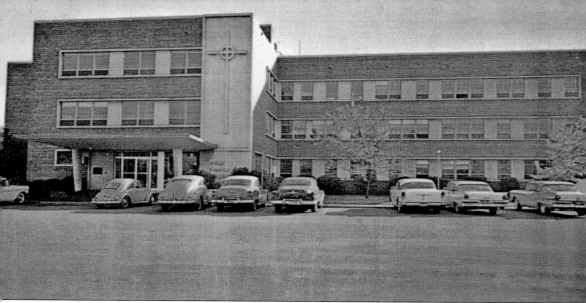

HOLY FAMILY HOSPITAL
BIRMINGHAM, ALA.

This postcard is of Holy Family Hospital. Mother Ann Sebastian of Nazareth, Kentucky, convinced the Sisters of Charity to send three Sisters to care for the sick and destitute African Americans in the Ensley area. With $12,360, the Sisters of Charity purchased land and started a clinic and convent in a small hut. Mother Ann Sebastian and several others Sisters arrived in 1941 and became the beginnings of a nursing staff. With in-kind support and other contributions, the Sisters replaced three homes with the facility and opened in 1946 with a 12-bed ward, chapel, medical clinic, and kitchen. The costs of construction were limited to just $1,000. After a drive to raise $250,000 for a new facility, a larger hospital opened on November 1, 1953. (Courtesy of Holy Family Church.)

DAVID SANDERS BIRTH
PLACE SEPTEMBER 5, 1962

This photograph of the medical records department shows Sr. Catherine Leo, Willa Dean Young, and Doctor Stewart standing by the file cabinets. The 1953 facility included all necessary administrative resources needed to operate professionally. The nuns and the many staff members worked together over many years to ensure quality health care for the black community. (Courtesy of Holy Family Church.)

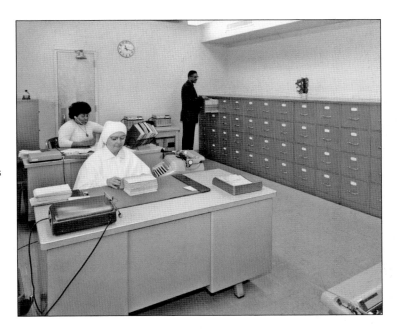

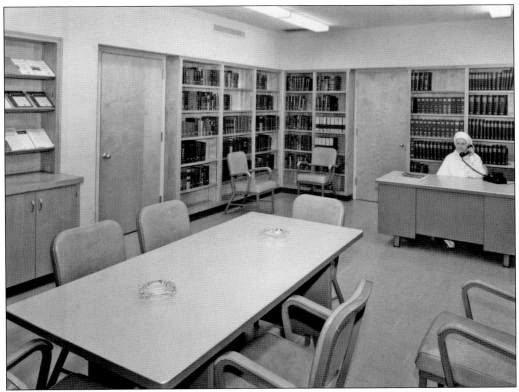

Sr. Robert Maria, R.R.L., attends the medical library in this image. Holy Family Hospital was an important source of employment for African Americans pursuing professional careers in the medical field. (Courtesy of Holy Family Church.)

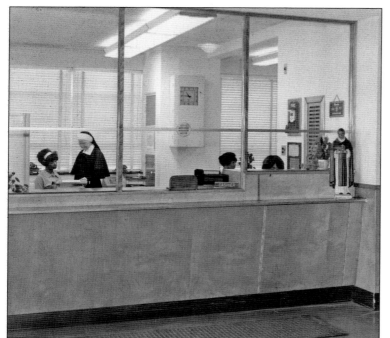

This photograph of the admitting office includes Sister Evelyn. To provide for her children, Addie Louise Jackson Kennedy worked as the admitting clerk at the Holy Family Community Hospital. Sarah Joe Daniel Owens Howard, born in 1933, worked for many years as a switchboard operator and admission's clerk. (Courtesy of Holy Family Church.)

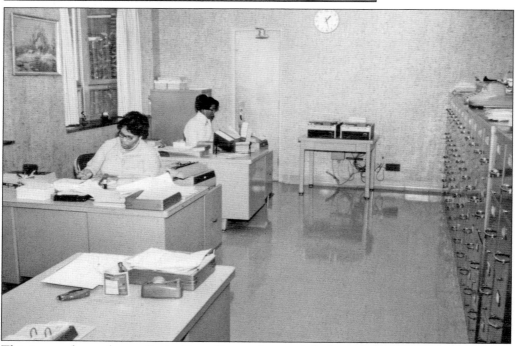

This image shows the medical offices. Former hospital clerks include Jo Ann Harris, Teresa Bell, and Sandra Campbell. Jackie Bryant worked in the business office. Former nurses include Jacqueline Coker, Annie R. Thomas, Lillie Mae Sharp, Joseph Wilodean Douglas, Anthony Rose Brown, Edylene Mayo, Christine Bimbo, Gladys Wiley, Rhonda Parker, Shirley Crosby, and Mary Foy. Mae Houzer was a nursing supervisor. (Courtesy of Holy Family Church.)

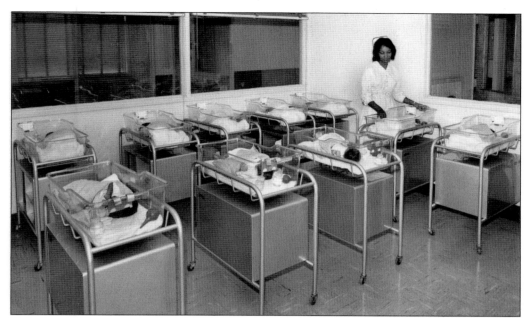

Holy Family Hospital specialized in working with premature infants, and the nursery was well recognized for its service. One of the more memorable alumni is Alma Powell and her son Michael. Many may know of her husband, Colin Powell. At the time of his son's birth, he was serving in Vietnam. His son Michael was born on March 23, 1963. Alma's parents, Robert and Mildred Johnson, lived in Ensley and cared for her in Colin's absence. Ronald Walker, a hospital employee, took photographs of the newborns. (Courtesy of Holy Family Church.)

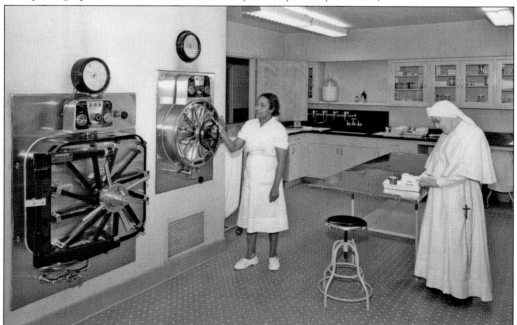

The hospital included a pharmacy and a dietary department. Former employees include Annie L. Smith, Othelia Stevenson, and Amelia Evans. (Courtesy of Holy Family Church.)

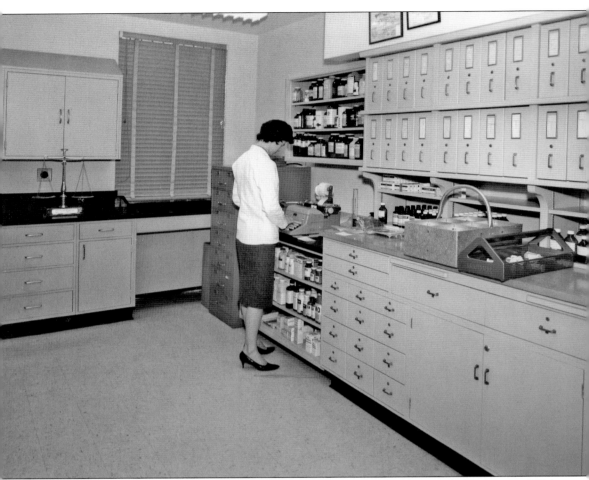

Shown here in the pharmacy where D. Koski types up an order or record. (Courtesy of Holy Family Church.)

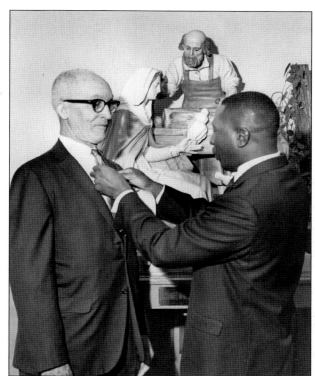

W. H. Childs (left), former executive housekeeper of Holy Family Hospital, and Dr. McCain, chairman to the board of directors of Holy Family Hospital, make preparations for the formal presentation of the first retirement check received by an employee of Holy Family Hospital. (Courtesy of Holy Family Church.)

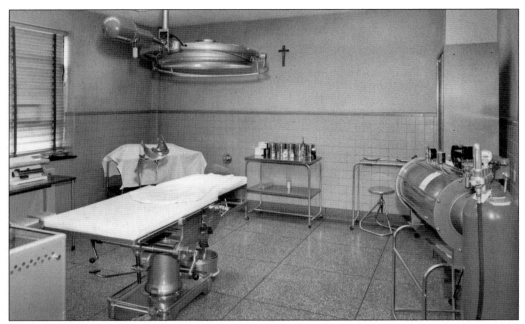

These photographs showcase the operating room. As documented in this series of photographs, the facilities at the hospital were multifaceted and comprehensive enough to meet the needs of the local community. The hospital was a major employer for the area. Many blacks in Birmingham and throughout the regional area were treated at Holy Family for primary care and emergency situations. (Courtesy of Holy Family Church.)

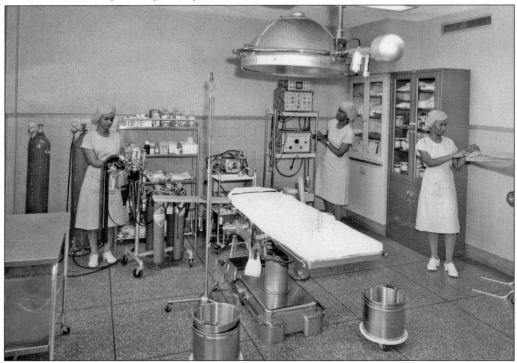

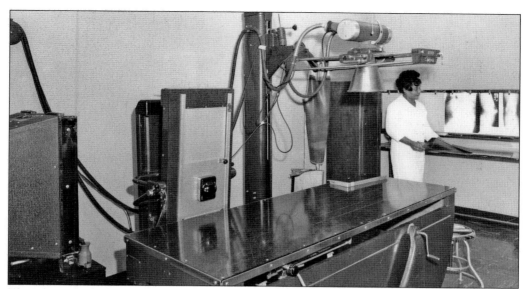

This photograph shows the radiology department with ? Edwards. On the morning of Tuesday, May 7, 1962, civil rights leaders, foot soldiers, and youths were engaged in marches outside the Sixteenth Street Baptist Church in downtown Birmingham, where they were met with fire hoses, dogs, and a combination of local police and state troopers. During the movement, black physicians and medical offices serving blacks, including Holy Family Hospital, played an important role in providing a safe and respectable place to be treated. (Courtesy of Holy Family Church.)

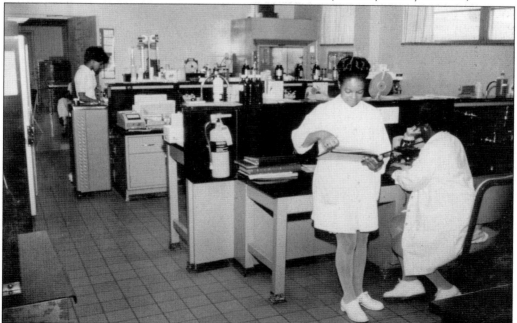

This photograph of the laboratory shows three assistants in attendance. Many employees stayed with the hospital for many years. For example, Lizzell Lane Richardson worked as a medical technologist for over 35 years. Former laboratory technicians include Klara N. Komo and Jeralene Walker. (Courtesy of Holy Family Church.)

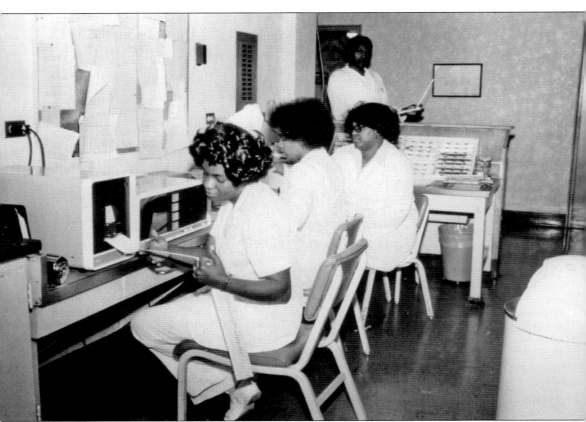

The front desk at Holy Family Hospital is captured in the photograph above. Many local individuals worked in the office over time, including Eddie Mae Thomas who recalls becoming friends with two of the nuns at the hospital, Sr. Agnes Gerald, the office supervisor, and Sr. Phillip Maria, the administrator of the hospital. Bernard Ann and Sr. Evelyn Huber were among the office supervisors at Holy Family Hospital, and Sr. Agnes Martha was administrator there. Lester Ann Whitman was also a former employee of the business office. (Courtesy of Holy Family Church.)

These behind-the-scenes photographs show the stockroom and the broiler room. One of the well-known maintenance men over the years was George Rueben Welch. Baptized at Holy Family Church on August 26, 1939, he served in the military and completed his studies in electronics in Detroit, Michigan. Frank Gunn worked at Holy Family as a security officer. (Courtesy of Holy Family Church.)

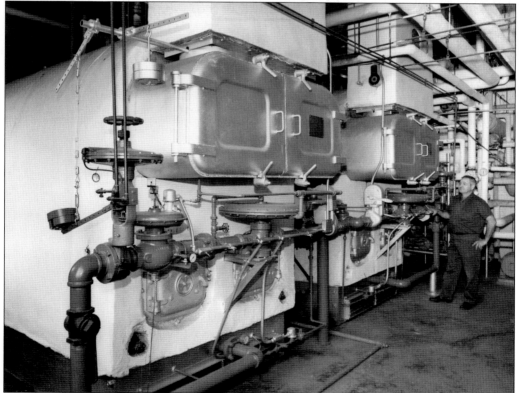

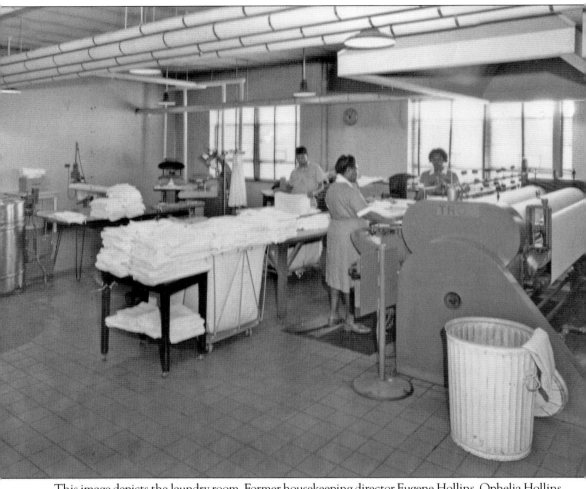

This image depicts the laundry room. Former housekeeping director Eugene Hollins, Ophelia Hollins, Mildred Hollins, and housekeeper Gloria Moffett attended the reunion held in January 2007.

Seven

TUXEDO JUNCTION

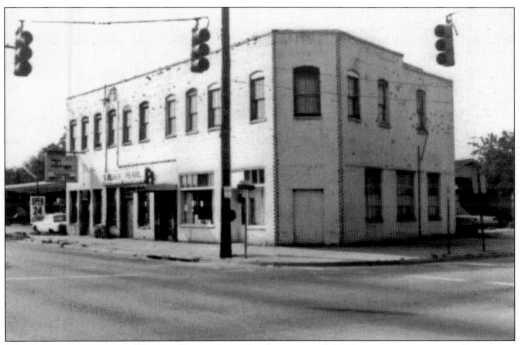

The historic Nixon Building still stands at the location of the famous intersection known as "Tuxedo Junction." By the 1940s, this specific location had come to age as the social, cultural, commercial, and professional hub of the African American community in Ensley and throughout the city of Birmingham. The only other location where blacks could go to have a good time was the Fourth Avenue District in downtown Birmingham. The Wylam and Pratt City streetcar lines were turning around just outside the Nixon Building as they transported steel mill workers to and from work. While the business district and musical heritage are testimony to the many contributions of African Americans, the community and surrounding neighborhoods were diverse, and persons of all backgrounds have shared memories of growing up in the Tuxedo Junction area.

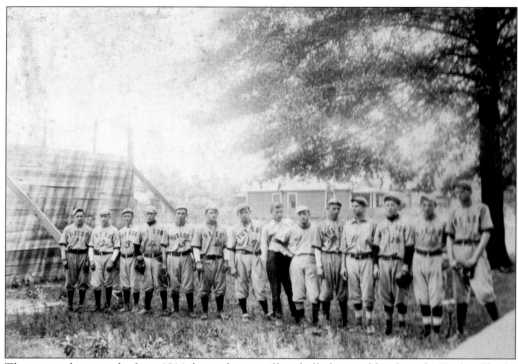

These two photographs from 1914 show a league of baseball players older than the Ensley Chicks wearing their Tuxedo uniforms. Baseball was an activity that lasted a lifetime for many. Boys could go on to play in the industrial leagues organized and sponsored by the mills and mines and then move on up into the minor and major leagues. Not too far away from Ensley is historic Rickwood Field, the original home of the Birmingham Barons and Black Barons.

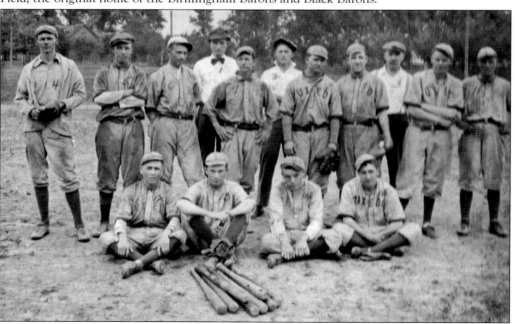

Located at 1728 Twentieth Street, and constructed in 1922, the Nixon Building is the last remaining commercial structure at Tuxedo Junction. The expansion of Twentieth Street and Ensley Avenue, and the construction of the expressway, all had an impact on the local constructed environment. The building's second floor had many physician offices, and the downstairs commercial spaces hosted a pharmacy and a variety store. At one time coal was sold from the first-floor shop. The building's upstairs was also home to the American Woodmen of the World. The fraternity could have occupied a small hall where parties could have occurred.

The Nixon Building also housed professional medical services upstairs and commercial establishments downstairs. During the years 1967 and 1968, the Nixon Building served as the headquarters of the Alabama Chapter of the National Association for the Advancement of Colored People (NAACP), due to Dr. John Nixon Sr.'s role in the organization as head of the state chapter, the Birmingham chapter, and the southern chapter. Dr. John Nixon Sr. joined fellow civil rights leaders and prominent black businessmen in the establishment of USAI cleaning services. His two partners were Arthur Shores and A. G. Gaston, who moved a section of his offices to the Nixon Building, which became the headquarters of USAI. (Courtesy of Birmingham Public Library Archives.)

Dr. Nixon Sr. was a diverse and talented entrepreneur and leader. In addition to opening his medical practice, he was an actor, educator, author, businessman, civil rights leader, and an advocate for community arts. He led the NAACP in efforts to address labor issues with U.S. Steel and worked on many of the court cases against the company. Nixon played a role in several movies including the Medgar Evans story about the civil rights leader gunned down in his driveway in Mississippi. He also performed locally with the Town and Gown group at Virginia Samford Theater. He started arts and cultural programming at Sixth Avenue Baptist Church and performed in the schools and churches during Black History Month. He worked as a professor at the University of Alabama and served on the presidential cabinet of Dr. David Mathews. (Courtesy of the Nixon family.)

This picture of Dr. John Nixon Sr. promotes the building as an African American heritage site, a goal that continues today. The historical marker provided by the State of Alabama sits in front of the original doorway that led upstairs to doctor's offices. It provides the words to the song for tourists and visitors who attend the annual festival or travel off I-20/59 to visit African American heritage sites.

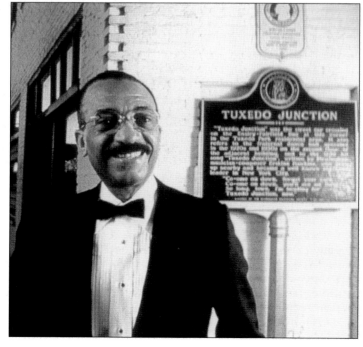

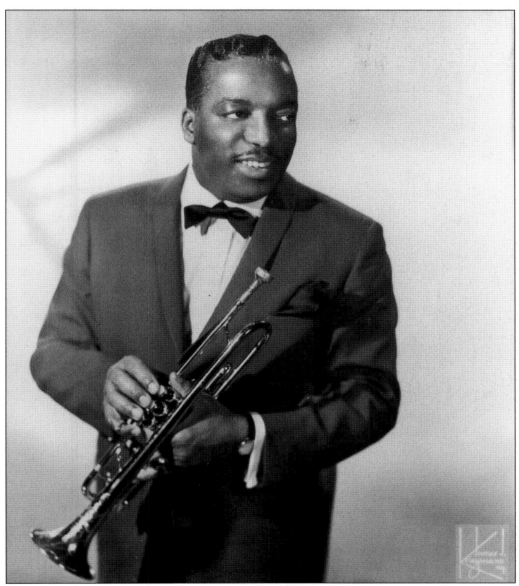

Erskine Hawkins is a composer and trumpet player form Ensley who gained national and international attention. He performed locally with the Bama State Collegians, but gained much acclaim and notoriety while performing in New York with his big band. He wrote the song, "Tuxedo Junction," which immortalized his hometown and the sites and sounds of the dance halls of the area. After the Glen Miller orchestra recorded the tune, it rose to the top of the charts where it remained for many weeks. The time was the 1940s, and it is known as one of the most popular wartime tunes. Along with many other members of the Alabama Jazz Hall of Fame, he is not the only musician from Ensley. Jothan Callins, Sun Ra, and Eddie Kendricks and Paul Williams, founding members of the Motown legendary group the Temptations were also Ensley natives. (Courtesy of the Birmingham Public Library Archives.)

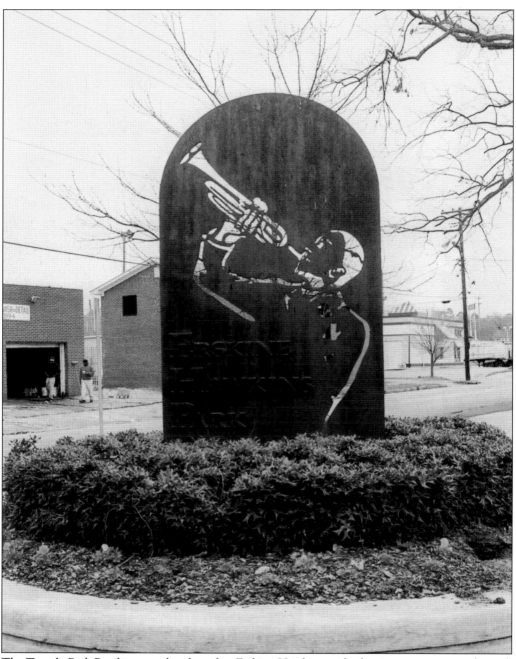

The Tuxedo Park Pavilion was the place that Erskine Hawkins and other jazz musicians performed. Many danced the night away at the many dance halls of the junction location. Unfortunately the original Tuxedo Park became part of the massive landscape incorporated into the Village Creek buy out that occurred, so it was lost. Today the city of Birmingham has provided Erskine Hawkins Park at the corner of Nineteenth Street and Ensley Avenue where the Annual Function at Tuxedo Junction Jazz Festival is held every year. In 2010, they held their silver anniversary event. The event occurs the fourth Saturday in July to honor Erskine Hawkins's birthday of July 26.

ABOUT MAIN STREET BIRMINGHAM, INC.

Main Street Birmingham, Inc., (MSB) is a nonprofit organization formed in 2004 to target historic Birmingham neighborhoods, enhance economic development, and facilitate the completion of revitalization projects. MSB's mission is "Growing Business, Revitalizing Neighborhoods, Empowering Communities". MSB believes in economic development based in historic preservation and is one of the leading preservation groups in Birmingham. The Ensley commercial district is one of the target districts for MSB efforts. As an economic development partner of the City of Birmingham, MSB fosters the growth of the city by improving the quality of life for neighborhood residents through the development of their commercial cores. MSB utilizes the Main Street Four-Point approach to commercial revitalization developed by the National Trust for Historic Preservation.

In Ensley, Main Street Birmingham, Inc., has been instrumental in the development of empty storefronts and historic buildings into thriving businesses that contribute to the tax base and create jobs. MSB, Inc., partnered with the City of Birmingham on a Preserve America grant, awarded by the National Park Service, that resulted in the listing of the Nixon Building at Tuxedo Junction and historic downtown Ensley on the National Register of Historic Places. The organization has helped to organize a local merchants association and assisted several entrepreneurs with securing capital and financing needed to open a business and achieve financial independence. Main Street Birmingham, Inc., continues to capitalize on the historic and cultural assets of Ensley that provide tools for heritage development initiatives.

www.arcadiapublishing.com

MAP SEARCH

Discover books about the town where you grew up, the cities where your friends and families live, the town where your parents met, or even that retirement spot you've been dreaming about. Our Web site provides history lovers with exclusive deals, advanced notification about new titles, e-mail alerts of author events, and much more.

MADE IN THE USA

Arcadia Publishing, the leading local history publisher in the United States, is committed to making history accessible and meaningful through publishing books that celebrate and preserve the heritage of America's people and places. Consistent with our mission to preserve history on a local level, this book was printed in South Carolina on American-made paper and manufactured entirely in the United States.

This book carries the accredited Forest Stewardship Council (FSC) label and is printed on 100 percent FSC-certified paper. Products carrying the FSC label are independently certified to assure consumers that they come from forests that are managed to meet the social, economic, and ecological needs of present and future generations.

FSC
Mixed Sources
Product group from well-managed
forests and other controlled sources

Cert no. SW-COC-001530
www.fsc.org
© 1996 Forest Stewardship Council

Find Your Place in History.

COCKATIELS

CO-012

A tame lutino cockatiel flying down a hallway.

*Young cockatiels for sale
in a pet shop.*

COCKATIELS

A tame cockatiel enjoys human companionship.

COCKATIELS

COMPLETELY ILLUSTRATED IN FULL COLOR

Cockatiels on their playground.

Elaine Radford

Photographs: Gerald R. Allen, 25, 42, 48, 49, 55 bottom, 61, 82, 84, 88, 90, 111. Dr. Herbert R. Axelrod, 14, 21, 26, 39, 66, 68, 102. Horst Bielfeld, 18. John Daniel, 83. Michael Gilroy, 19, 51, 77, 89, 96, 98, 105, 109, 117, 122. E. Goldfinger, 32, 52, 55 top, 56, 120. M. Guevara, 47. Ray Hanson, 33, 41, 46, 69, 112. Ralph Kaehler, 100. Bruce D. Lavoy, 62, 78, 85, 91, 92, 93. W. Loeding, 74, 86. E. J. Mulawka, 27. H. Reinhard, 75. Nancy Richmond, half-title and title pages, 11, 23, 37, 43, 54, 57, 58, 63, 65, 81, 67, 70, 71, 73, 79, 87, 97, 113, 121. Courtesy of San Diego Zoo, 107. Brian Seed, 103, 116. Vincent Serbin, 29, 115, 119. Louise Van der Meid, front and back endpapers. Courtesy of Vogelpark Walsrode, 10, 15, 17, 59. Matthew Vriends, 108. Wayne Wallace, 22, 30, 31, 34, 38, 40, 44, 45, 50, 53, 64, 72, 99.

Distributed in the UNITED STATES by T.F.H. Publications, Inc., 211 West Sylvania Avenue, Neptune City, NJ 07753; in CANADA to the Pet Trade by H & L Pet Supplies Inc., 27 Kingston Crescent, Kitchener, Ontario N2B 2T6; Rolf C. Hagen Ltd., 3225 Sartelon Street, Montreal 382 Quebec; in CANADA to the Book Trade by Macmillan of Canada (A Division of Canada Publishing Corporation), 164 Commander Boulevard, Agincourt, Ontario M1S 3C7; in ENGLAND by T.F.H. Publications Limited, 4 Kier Park, Ascot, Berkshire SL5 7DS; in AUSTRALIA AND THE SOUTH PACIFIC by T.F.H. (Australia) Pty. Ltd., Box 149, Brookvale 2100 N.S.W., Australia; in NEW ZEALAND by Ross Haines & Son, Ltd., 18 Monmouth Street, Grey Lynn, Auckland 2 New Zealand; in SINGAPORE AND MALAYSIA by MPH Distributors (S) Pte., Ltd., 601 Sims Drive, #03/07/21, Singapore 1438; in the PHILIPPINES by Bio-Research, 5 Lippay Street, San Lorenzo Village, Makati Rizal; in SOUTH AFRICA by Multipet Pty. Ltd., 30 Turners Avenue, Durban 4001. Published by T.F.H. Publications Inc. Manufactured in the United States of America by T.F.H. Publications, Inc.

Contents

Introducing the Cockatiel

The demure and winning little bird known as the cockatiel has been steadily growing in popularity ever since the first European explorers returned from Australia with live birds for sale. Today, although it's no longer necessary to trap these free-breeding birds in the wild, more people than ever enjoy the companionship of a pet cockatiel. And no wonder, for a quick look at its many virtues should convince even the most skeptical that a cockatiel comes about as close to being the perfect pet as anything you care to name.

In the avian beauty pageant, the cockatiel may

Above: *Lutino and silver are two of the color varieties not found in the wild but fostered in captivity by cockatiel breeders.*

win no prizes for flashy feathers like its smaller rival, the budgerigar, but its agreeable personality more than makes up for its subdued coloring. Gentle and easygoing, it happily befriends its human owners, eagerly looking forward to playtime spent with you and often calling for your attention with a peremptory "peep." Because it's both easygoing

The wild, or normal, coloration of the cockatiel is gray. Genetic mutations alter the pigments visible here.

and relatively small, the cockatiel is one of only two commonly kept parrots—the budgie is the other—that can be safely cared for by children. And because it's hardy as well as smart and eager to please, you'll enjoy its company for many years to come. Although 12 to 14 years is more likely, a few ancients have lived over 20 years.

Still, it doesn't matter how sweet your pet is if the landlord or neighbors won't have it around, as many dog and cat owners have learned to their sorrow. Fortunately, the cockatiel is also well suited to apartment and condominium living, and few people will ever have cause to complain even if they're aware of your pet's existence. Although the cockatiel's cry can be insistent, it isn't especially loud or irritating, so noise isn't a problem. "Messiness" shouldn't be a concern, either; like all seed-eating birds, cockatiels are extremely neat in their habits. Even if you don't succeed in potty training your bird to defecate only when in its cage, you'll soon notice that when it's free it always flies to a few favorite positions around the house. Once you fix these spots up with paper or washable fabric, you'll be able to keep your home clean while letting your pet get its exercise.

Finally, cockatiels are one of the few easily bred pets that yield offspring of value.

We're all aware of the dog and cat overpopulation problem; their young often cannot even be given away, meaning the offspring end up abandoned to starve and spread disease—and the problem will only get worse as more people move into multi-family dwellings. Birds, on the other hand, are growing in popularity; if you or your children want to raise some cockatiels, you can do it safe in the knowledge that healthy, reasonably priced offspring will always find a buyer. Furthermore, cockatiel breeding is excellent practice for parrot breeding in general, a wonderful enterprise for any bird enthusiast concerned about the status of the many vanishing species of parrot in the world.

Life in the Wild

By happy coincidence, its life in the dry Australian interior has helped make this congenial bird the agreeable little pet it is. *Nymphicus hollandicus,* as scientists the world over call the cockatiel, is a nomadic inhabitant of a continent that seems designed to produce pet-quality birds. Because rain may not fall in one region for months or years cockatiels must travel in flocks in search of water. Pairs can't settle down to nest at regular, predictable intervals, but must instead be ready to raise young whenever the drought happens to break. As a consequence, the cockatiel is

The cockatiel as depicted in
Greene's Parrots in Captivity
(1884–87).

Above: *Among the birds kept as pets, the cockatiel is one of the species that does best in the artificial habitats of cages and aviaries.*

a good-natured, sociable bird that gets along well with other members of its nomadic flock, as well as a tough survivor that can be ready to breed at practically the drop of a hat! In captivity, your family becomes the cockatiel's flock, and you will soon notice that your pet thrives on the kind of constant attention it would have received from its companions in the wild. Incidentally, it's interesting to note that the same environment has shaped two other popular and personable avian pets, the zebra finch and the budgerigar.

Unlike many parrots, cockatiels do most of their feeding on the ground, foraging on ripening grasses. Hence their natural reaction to being startled is to fly up, leading to their infamous skill in colliding with windows and ceiling fans when frightened. You'll also notice that your cockatiel seldom or never holds its food in its claw like the parrots evolved to eat sizable morsels such as fruit and buds will do. Both behaviors are sometimes mistaken for evidence of low intelligence in the cockatiel, but they're actually perfectly normal adaptations to their special environment.

In the wild, all birds of a single species tend to look alike, and cockatiels are no exception to the rule. The gray, or normal, variety with the long white wing bars has the same coloring as that seen in wild birds, a quietly attractive plumage that helps it blend into the background when sitting on its favorite wild perch, a dead tree. If a predator does dive into a flock, the fact that all the birds look much the same can prevent the attacker from focusing on a single individual and chasing it to exhaustion.

A troublesome problem for breeders of most parrots is that you can't easily distinguish males from females by eye, causing one vet to write that the number-one reason for parrot-breeding failures is people misjudging the sex of their birds! Fortunately, the

agreeable cockatiel hasn't taken the lookalike principle to this extreme. Adult males and female are very easy to sex once you've seen a pair together—the males are the ones with the much brighter yellow heads and prominent orange cheek patches. However, since the brilliant male plumage doesn't appear for six to eight months, young birds are quite difficult to sex.

The Domestic Varieties

In captivity, of course, cockatiels don't have to worry about predators. If a mutation (genetic change) occurs that affects a cockatiel's color, it can still grow up to raise babies of its own and pass on the new color trait. Therefore, breeders have been able to capitalize on such beneficial changes to develop many beautiful varieties of colored cockatiels. However, you will probably never have the rainbow of choices that you do with budgies because the basic cockatiel pigments are red, yellow, and black. The gray feathers, for instance, result from a mixture of black and yellow pigment, while the orange is a mixture of red and yellow. White feathers contain no pigment at all. With this limited palette, even the most artistic breeder isn't likely to ever come up with a, say, leaf-green cockatiel because such a development would require more than a change in how cockatiel pigment is distributed on the body; it would entail the appearance

Above: *A handsome heavily pied male cockatiel.*

of a new pigment altogether. Expecting such a change is comparable to hoping that someday a human baby will be born with naturally fuchsia hair.

The first mutation noticed by breeders was a splotchy-looking variety called the pied. Pied cockatiels have white and yellow spots on their body wherever they lack black pigment, often giving them an absurd "harlequin" appearance. "Heavy pieds" have more than 50 percent white and yellow feathers, while "light pieds" can have much less—perhaps only a few out-of-place white and

The Domestic Varieties

yellow feathers scattered about normally gray areas of the body. The ideal pied would have symmetrical body markings, but that almost never happens! Since it's more amusing-looking than beautiful, the pied never really caught on as a pet. Most breeders also pass on the pied, having learned that there is no way to predict the appearance of the young. Heavy pied parents may produce light pied offspring, and vice versa—and every chick in the bunch may turn out to have lopsided, asymmetric coloring.

In contrast, the second mutation developed with human help turned out to be the most popular of them all, the lutino. Lutino cockatiels lack black pigment, so that they have no gray or black areas on their bodies. Because the yellow pigment is still present, these birds are *not* true albinos, although some people mistakenly refer to them as such. The head is usually a particularly attractive deep yellow, and the orange cheek patches of both sexes are a deep, brilliant color untinged with gray. As it turns out, the female is not only as beautiful as the male in this incarnation, she is usually a richer, deeper yellow than her mate. Besides the gray, this is the variety you're most likely to meet in pet stores.

Depending on where you live and shop, you may encounter one of several

Below: *Cockatiels range over most of the Australian subcontinent.*

other attractive varieties. The true albino mentioned above is an all-white cockatiel with no cheek patches: some people say it resembles a tiny cockatoo and expect it to become a popular pet as soon as breeders can make more available to the public. The opaline, or pearled, cockatiel is especially lovely because each affected feather is white or yellow with a dark gray border, giving the bird a rich, scalloped look. (Unfortunately, adult males molt back to normal gray plumage, so only females retain the beautiful coloring for their entire lives.) In cinnamon cockatiels, the black pigment has turned brownish, giving the birds an attractive tan color. Silver cockatiels are a pale silver instead of the usual gray due to a partial reduction in black pigment. Early specimens suffered from blindness and low fertility, but because of the unusual beauty of the plumage, breeders have worked hard to establish a line of healthy silver cockatiels. In the not-so-distant future, you can expect to see some of these lovely birds as well as many other varieties become available to the bird-loving public.

What variety makes the best pet? Whichever variety you prefer! Personality and intelligence are the same for all healthy cockatiels of whatever plumage, so feel free to pick the one that pleases you best. Of course,

Above: *In Australia, wild cockatiels are often observed perched on telephone lines.*

the more attention it gets, the happier and more playful it becomes, so a "prettier" bird is bound to seem smarter if its looks win more of your attention. In this light, it's interesting to note that older books often disparage the pet qualities of female cockatiels, while books written since other mutations became available agree with the current assessment that both sexes are friendly. I can't help wondering if many old-time plain gray females became poor pets because their owners unconsciously gave more affection to their prettier mates. Now, in some varieties, it's the male who might get shortchanged in the attention department! In any case, since the difference in price between the lovely lutino and the ordinary gray is small, you needn't feel guilty about springing for the prettier bird.

Choosing Your Cockatiel

Because it's a living creature, a cockatiel shouldn't be purchased on impulse. Before you commit yourself to the responsibility of keeping an animal, you should take a long look at your current lifestyle. Parrots in general and cockatiels in particular are social birds that expect to become part of the family when kept as single pets. Do you honestly have time to

Above: *Normal, silver, lutino—these varieties show the extent to which pigmentation is diluted in the cockatiel.*

spend with your bird every single day? Unless you do, your naturally gregarious pet will become lonely and possibly neurotic. An unhappy dog may mope, but an unhappy bird dies. It's

This color variety combines the pearl and the cinnamon mutations.

Choosing Your Cockatiel

unfortunately not rare for a depressed bird to mutilate itself or even to commit suicide by tearing out its own feathers! If you party or travel a lot, you probably don't have time for a single pet cockatiel. Perhaps you could get a pair instead; although birds that amuse each other will never be as attentive to *you,* you'll know that your pets' psychological health is secure even when you can't dote on their every wing-flap.

Before purchasing a cockatiel for a child, do make an honest assessment of the youngster's interest and abilities. Even a mature child may be too active to pay much attention to a cage-bound pet. In my opinion, it's better never to give a pet parrot as a gift, although a pair of small finches may be perfectly suitable. However, a cockatiel is expensive enough that a child who has saved up his or her own money probably has a genuine interest that will be richly rewarded by the pet's gentle admiration. In that case, it would be a nice move for you to spring for the cost of the cage.

You should also consider how important it is to you to have a talking bird. Cockatiels, like all parrots, have the ability to learn to talk, but in practice they rarely do. The more inexpensive budgie is actually a far better talker in terms of vocabulary; it's possible for some specimens to utter hundreds of words. Large parrots, on the other hand, might not say much, but what they do say is clear and human-sounding. Cockatiels are neither particularly talkative nor especially easy to understand. If you know in your heart of hearts that you'll be disappointed if your pet never learns to speak, seriously consider buying another kind of parrot. Yes, there are exceptions, but in most cases you'll find that the owners of talented talking cockatiels have an unusual amount of time to spend training their pets.

A final consideration concerns you and your family's health. Feathers aren't irritating to most people unless they sleep on a pillow of them, so most parrots kept in clean cages aren't anywhere near as allergenic as a pet cat or dog. However, the cockatiel, like its larger cockatoo relatives, *may* aggravate some allergy-prone individuals. The reason is that these birds shed a white dandruff-like powder called "cockatoo dust." Most people won't be bothered by the dust if they mist their pets with a light spray each day, but if a family member has severe allergy or asthma problems you would do well to consider buying a budgie instead. It wouldn't hurt to ask the allergist. In my case, I can attest that despite my severe house-dust and animal-dander allergies, my doctor correctly predicted that bird

Cockatiels, unlike some other parrot species, do not have any strong odor.

keeping wouldn't create any problems.

Choosing Your Bird

All things considered, you'll probably find the cockatiel a terrific choice if your schedule and respiratory system allow you to keep a pet at all. The next step is the enjoyable chore of shopping around. In most areas, a check of the Yellow Pages and a major newspaper's classified section will yield several potential sources of cockatiels. Unless you've got your heart set on a rare type like an albino, you should

Below: *Cockatiels most easily become tame if they are accustomed to human contact while still young.*

have your choice of healthy, young pets, so take your time and look around. If you have the tiniest doubts about a particular specimen, keep looking. You'll find the one you want sooner or later, probably sooner.

The first thing you'll notice is that you can easily buy cockatiels both at pet stores and from private breeders. Both sources have their advantages. The pet shop will often accept credit cards, and it will certainly have suitable cages and other supplies for sale. The breeder, on the other hand, will be able to give you a better idea of the bird's background, possibly even showing you your pet's parents. Breeders are also more likely to have special mutations and "show" quality birds, although you may have to do some begging and pleading to coax a special specimen out of them.

If you decide to buy from a breeder, go to the pet store and buy the cage first. The cage can wait for the bird, but the bird shouldn't have to wait for the cage.

Choosing the right bird is a process that starts when you walk in the door, whether it's a private home or a shop in a busy mall. There is never any reason for a cage of cockatiels to smell; if any seed-eating birds or their cages stink, then the store or aviary isn't clean enough. Although wastes are going to accumulate in the cage bottom during the course of

Above: *Normal, pearl, and pied are some of the varieties readily available for purchase in pet shops.*

the day, they should be scent-free. Perches and dishes shouldn't be caked with feces, either. Because it's a temporary situation, some sellers will display several cockatiels to a cage, but they shouldn't be crowded in so closely that they have to sit pressed against one another. (Some birds like this. Cockatiels don't.) But you won't have any trouble eliminating overcrowded aviaries from your list. The broken feathers and irritable dispositions of the avian inhabitants will do that for you.

It's also a good idea to ask about the seller's policies. Many pet stores will sell you a cockatiel with a written guarantee that you may return it if it doesn't check out healthy with your vet. Cockatiels aren't costly, but they are expensive enough to warrant a post-purchase exam if you have this option. A small breeder might not be able to offer a guarantee, since his or her business isn't large enough to absorb losses from even the occasional crackpot customer, but the smaller operation is less likely to have been exposed to avian disease. Use your judgement.

23

Anatomy of a cockatiel: the bones associated with the limbs are colored blue.

If you want a breeding pair, you should start with an *adult* male and female so that you can be sure that's really what you're getting. With a household pet, however, you should try to get the youngest cockatiel you can that's ready to leave the nest. Don't worry about the fact that you can't tell yet whether it's a girl or boy; it won't make any difference in the pet quality of the bird. It's far more important that you start taming at an early age. If you're bothered by calling a family member "it," you're welcome to guess at the ultimate outcome. But since you'll probably guess wrong—at least, *I* always do—give it an androgynous name anyway!

How to determine age? To a certain extent, you'll have to trust the breeder or pet-shop clerk, but there are certain signs of youth you should look for. Juveniles quickly reach adult length, but they're often noticeably more slender than older birds. Fledglings less than two or three months old have pinkish rather than grayish bills. Until they're at least six months old, the whole brood will resemble females in their coloring, except that the pale stripes on their chests will be *more* prominent than in the adult birds. (This is unusual because in most bird species, juveniles have less distinct patterning than adults of either sex.)

Some breeders can offer handfed birds, that is, birds that don't have to be tamed because they were raised by human hands. Some people say that the cockatiel is so naturally loving that handfeeding's a waste of time, but most agree that these specially pampered babies make the smartest and most affectionate pets of all. Especially if you've never kept a parrot before, the knowledge that your new pet is already tame can be very reassuring! Since they seem to consider themselves tiny

Below: *This young cockatiel, probably a male, is four weeks old.*

humans, handfed cockatiels are also the ones most likely to learn to talk. Of course, you must expect to pay extra since human rather than bird labor went into raising these sweetheart specimens.

Before buying any bird, you need to give it a visual health exam. Unless your name is Rockefeller (and you don't

even alarm, when you draw near. A bird that just sits and looks at you may be tame—or it may just feel like it's beyond the point of caring. If it's puffed up to keep warm or sleeping on the floor rather than up on its perch, it's definitely not feeling up to par. Of course, most birds siesta in the early afternoon, and a

have any other birds at home), I suggest that you make it a rule never to take in a sick bird because you feel sorry for it—not even if it's being given away for free. The additional stress of moving from shop to home is more likely to kill the cockatiel than to save it, and if you do have other pets, you run the risk of bringing a disease home to them.

Watch how the cockatiel behaves when you approach its cage. If it hasn't been handfed or otherwise tamed, it should move about and show some signs of alertness,

Before choosing a cockatiel for a pet, take time to observe the individuals available. Before long, differences in temperament among the birds will become apparent.

very calm specimen may manage to catch a snooze even in the midst of the noon rush, but at the very least it should be dozing normally, sitting on its perch with one foot drawn up near its belly, and it should certainly open

While the cockatiel you intend to purchase is in the hand,
examine it closely for signs of illness.

Acclimating the New Cockatiel

an eye once you start talking to it.

All body openings, including the vent, should be checked for abnormal discharges. When the seller catches the bird for your attention, ask him or her to turn the bird over so that you can make sure that there are no caked feces blocking the vent. Any fluid around nostrils, eyes, or vent is cause for rejection. Also check the condition of the plumage. It's okay if a rambunctious cage partner pulled out a wing or tail feather; those grow back pretty quickly. But only a sick or depressed bird fails to keep what feathers it does have spotless.

Acclimating the New Cockatiel

Meeting a bunch of new people is stressful even for a tame cockatiel, and it's doubly hard on an untamed one. To get off on the right foot, you want to make sure you have the proper cage waiting in the proper spot. A light, comfortable, draftfree room where the family members spend a lot of time is best. Unfortunately, the kitchen is out, even if it is the center of your home universe. There are just too many overwhelming fumes produced here that can irritate a bird's delicate respiratory system. Incidentally, natural gas is especially bothersome, so don't put the cage near any gas heaters or stoves. By

contrast, a cozy den or TV room is usually a great place for a cockatiel, who will be happy to prance from shoulder to shoulder diverting your attention from the latest network idiocy. Of course, if the cockatiel isn't tame yet, you should start with a quieter spot and work up to introducing your pet to the family circus.

Before you plop down the cage, check the proposed position for drafts. Locate any vents and make sure no air, either hot or cold, will be blowing on the bird's cage. A candle test will quickly tell you whether a particular spot is safe for a cockatiel; if the flame doesn't waver or flicker, you've found a draftfree position.

When you place your new cockatiel in the cage, be sure to talk to it in a reassuring tone. Because it may feel disoriented and confused, it may not be up to looking around for the food and water dishes, so have some seed scattered on the floor of the cage where the ground-feeding cockatiel naturally looks first. No doubt everyone will want to hover over the cage to welcome the newcomer, but take it easy and give the bird a rest after its journey. Tell the kids to whisper, not shriek, their delight. The cockatiel will be in the rough-and-tumble of family life soon enough, far more quickly and easily than you'd ever housetrain a new puppy.

Since a pet cockatiel will spend a great deal of time in its cage, be sure that you choose a suitable cage and select its location carefully.

29

Your Cockatiel's Home

Many people have such a bad attitude toward cages that I wonder if they think "cagebird" and "jail bird" mean the same thing. Actually, all parrots tend to think of their cages as their homes unless the accommodations are truly dreadful. If the roof's constructed for comfortable perching, you'll probably soon notice that your pet enjoys spending a good deal of time playing on the top of its cage. The security of knowing food and a safe retreat is near is as nice as the freedom to visit you or to flap around the room for some exercise.

Cages also protect your bird when you can't be there to supervise. Let's face it: The

Above: The principal furnishings needed in a cockatiel's cage are perches and feeding utensils. The wire top of this cage can be detached from the base, making cleaning easy.

average home is a disaster waiting to happen when a small flying creature is free to spend eight working hours a day looking for trouble. The tragic accidents that commonly befall cockatiels include drowning in a half-full water glass or open toilet bowl, eating a delicious-looking but poisonous houseplant, and taking off out an open door when you come home. A serious accident can

also befall your furniture—
that little snub beak is a lot
more damaging than it looks.
And if you have other pets
loose in the house, the
possibilities are endless. A
cockatiel cage, therefore, is a
necessity, not a luxury.

Three considerations will
dominate your choice of a
cage: size, chew resistance,
and ease of cleaning. The
most important factor is size.
The cockatiel must have room
to play with its toys and putter
around when it's left alone.
They seem to like games of
climbing up and sliding down,
and flipping beak over tail
around a perch, so a *tall* cage
is better than a long one of
the same volume. As a
minimum, it should be wide
enough to let the cockatiel
spread its wings without
brushing the sides. Good
dimensions for a pair or a
single bird are a foot and a
half to a side and at least two
feet of height. Although this
suggestion constitutes an
absolute minimum for a *pair,* I
don't advise going much
smaller for a single bird. It will
need the room for extra toys
and such, and besides, since
cockatiels can be bred
without sacrificing their pet
qualities, you never know
when you might get the urge
to breed your bird.

Large cages do cost
significantly more than small
ones, and the cage might well
cost more than your pet. It's
worth it, though, in the
increased life expectancy and
happiness of your cockatiel.

These birds aren't happy
sitting like bumps on a log all
day; they need room to
stretch and play. Without it,
they can get fat from
spending too much time
eating and not enough
exercising, and the resulting
obesity can lead to a host of
physical ailments. More likely,
the bored bird will start
tearing at its own plumage or
simply mope itself to death.
Only one of a kind of bird
belongs in an antique or
designer cage just big enough
to turn around in place—the
ceramic kind! Unless your

Below: *A door hinged at the
bottom makes a convenient
landing perch for the
cockatiel to enter or exit.*

cockatiel is injured or ill, its cage really can't be too big.

The cage should also be able to stand up to the cockatiel's relentless beak. Unless you want to build a new cage every few months, that means a metal, not wood, frame. Plastic trim is okay, as long as it's where the cockatiel can't chew it off. If you must have a bronzed or painted cage, please buy it from a reputable *pet* supplier, not from an antique dealer, department store, or somebody's granny's attic. The pet dealer's offerings may not be as glamorous but they'll be safe. Ritzy brass and pseudo-brass creations, by contrast, are sometimes put together with lead solder, a deadly poison to pet birds. Cages painted by people with no bird knowledge may even be completely coated with poisonous lead-based paint! If you must have a cage that matches a particular color scheme, then have it painted yourself with a lead-free paint safe enough to use in a baby's crib. Read the labels. The safe products will be happy to tell you about it.

At the other end of the spectrum are the people who don't give a hoot *what* the cage looks like, as long as it's cheap and homey for the bird. If that's you and you're handy, you can build your own simple rectangular cage from sturdy hardwire cloth, joining the sides with strong poultry staples. Be very careful to

Below: *In additional to nutritional value, a cuttlebone offers the cockatiel an opportunity to exercise its propensity for chewing.*

check your creation for rough edges, and file down anything that could catch a tender foot. It won't be fancy, but the cockatiel will think it's a castle—especially if this arrangement allows you to buy your pet some extra room.

A final question: how easy will it be to clean the proposed cage? For cockatiels, I like the cages with pull-out trays that can be whipped out in a flash for a change of paper. However, such cages really should have a bottom screen to prevent your pet from munching on newsprint. It can't be one of the deadliest poisons, since all parrots seem to grab a taste of the daily news sooner or later, but it has been known to kill some individuals. If the cage bottom lacks a protective screen, you may prefer to keep the tray filled with corn-cob or wood-shaving litter. Good litter can go two or three days between changing, but the trade-off is that each change is a bit harder to make.

Should you cover the cage at night? You shouldn't have the cage in a spot where covering it is absolutely necessary to protect from cold drafts or blasts from the heater, but it is valuable to cover the bird to give it some quiet, especially if some family members are night owls. A cover also discourages late visitors from pestering a pet who's trying to sleep. Bear in mind that your cockatiel likes

Above: *A cockatiel kept singly should have its cage situated in a room where it can observe family activities.*

routine, though; it will want to be covered every night, not just the evening of the big party.

Perches, Toys, and Playpens

Other than the food and water drinkers, the most important item of "furniture" in your cockatiel's cage is its perches. Most cages will come with perches already supplied, but you'll need to get extras anyway. Plastic perches should be replaced immediately since they aren't very comfortable for the

33

cockatiel's feet and don't keep its nails in trim. The wooden kind which do provide comfort for feet and exercise for beak get chewed up sooner or later. With luck, your cockatiel cage will come with the right size perch for your pet's feet, but if not, the pet store probably has a nice selection of more appropriate perches. If you have the choice between round, oval, and square perches, great. Take one of each so that your bird won't always have to grip the same way. You should also make sure that the diameter of the perch is wide enough so that the toes don't wrap around on top of each other, but not so wide that the bird can't get its claws three-quarters of the way around it.

Nice, natural perches are even better, and the price is certainly right when they come from your own back yard. Twigs and small limbs from birch, willow, and fruit

Above: *Perches of various diameters promote the exercise that prevents foot problems from occurring.*

trees are great for chewing as well as perching. The main drawback is that you must be sure that the tree hasn't been sprayed with insecticides for several years since such chemicals are, after all, poisons that can weaken or kill a small bird. Unfortunately for the urban dweller, spraying isn't always under your own control. Down here in New Orleans, for instance, it's necessary for health reasons for the city to spray neighborhoods regularly to combat mosquitoes. Any front-yard peach tree is sure to absorb at least a little of the insecticide. But if you *can* give your cockatiel a fresh, green twig for perching— flowers and all—your pet will get vitamins, exercise, and

good clean fun from slowly chewing its new perch to smithereens.

An occasional problem with employing natural perches that have been previously used by wild birds outdoors is the chance of a red-mite infestation. These tiny creatures hide in aviary crevices during the day, creeping onto a bird to suck its blood at night. Therefore, if your bird has been scratching and fidgeting a lot, you should check for red mites by waiting until nightfall and covering the cage with a white cloth. The blood-filled mites will show up as mobile red dots fleeing the bird when you turn on the light. Fortunately, the horrid little things are quite easy to get rid of. Many safe mite sprays are available in pet stores for using directly on birds. To prevent re-infestation, thoroughly clean cage, perches, nest boxes, and toys and then dust with a pet-store mite treatment or a little Sevin dust mixed with talcum powder. One treatment is usually enough. Better yet, you can probably avoid the whole problem by using the small hanging "bird protectors" that guard against mite invasion in the first place. Just don't forget to replace the protective disk at the recommended intervals.

Don't overcrowd the cages with perches in your enthusiasm. Too many perches prevent your pet from moving freely and hence obstruct the very exercise and comfort you're trying to provide. A couple of perches is plenty for the usual home cockatiel cage. Be sure to position them in such a way that the cockatiel can sit without defecating into the food and water drinkers. Such accidents aren't just unsightly; they're a threat to health.

All parrots love toys. Mainly, they love to eat their toys. Because chewing is excellent exercise for keeping its beak in trim, expecting your cockatiel to treat its toys nicely or do without is impractical. Give the fact that any toy your pet likes well enough to play with will end up in its mouth, you need to screen proposed playthings pretty carefully. Whether homemade or store-bought, the toy should be sturdy enough to take a fair amount

Below: *The red mite is a parasite that feeds at night by sucking blood from its host.*

of chewing, safe enough to prevent poisoning or injury, and cheap enough so that you can replace it periodically without breaking the bank.

Some very nice, not terribly costly toys should be available in the pet store or pet-supply house. Wooden swings are such a universal favorite among cockatiels (and, indeed, any parrot) that this item should almost certainly be on your list. Sturdy rawhide-chew donuts or lava-rock-and-hardwood combinations are especially tough and long-lasting, but metal mirrors and bells are also strong enough to take the cockatiel's attentions. You may have to experiment a bit. All cockatiels are individuals, and you can't predict which toy is going to catch its fancy. I have a young hen who determinedly destroyed a chain-suspended lava rock meant to keep a macaw busy; she eagerly set aside a part of each afternoon to whittle it down. Yet the previous owner of this toy, a sassy conure with a bigger beak, hadn't even touched it, and certainly many other cockatiels would prefer a toy more their own size. You just never know.

One warning: The bright and shiny plastic toys are for budgies, not cockatiels. A cockatiel might take longer than most parrots to tear a plastic penguin apart and choke on its cute little flippers, but it can happen. Better safe than sorry.

Some cheap, if very temporary, toys can be provided on a regular basis when you're playing with your cockatiel. Many love to chew up magazine renewal cards, junk mail, wine corks, corrugated packages, toilet paper and towel rolls, and old-fashioned wooden clothespins that lack the wire springs that could trap a cockatiel's foot. All are fine, as long as the paper and cardboard items given are free of colored dyes. The only problem is that parrots often seem to prefer chewing up pretty, colorful things! Soaking a temporary toy in juice or Kool-Aid to soak up a little flavor and color can help make up for the fact that you refuse to let your pet chew up that shocking pink postcard.

The very best toy any cockatiel can have is a portable parrot playpen. It doesn't have to be expensive or store-bought, as long as it's light enough for you to carry easily from room to room yet entertaining enough to give your cockatiel plenty to do. A simple plywood tray that can be lined with paper or litter makes an excellent base. A sturdy Y-shaped hardwood branch or a miniature jungle gym of swings and ladders are both excellent. Other hanging toys can be added as inspiration strikes or old components wear out. You don't have to get too fancy; in fact, it's better if you don't. You don't want the cockatiel getting bonked in the head every time it turns around!

Like most parrots, cockatiels use their beaks to help them climb.

I really can't overemphasize the value of a playpen. A cockatiel at liberty in a room usually likes to go to two or three favorite perches, and a playpen is a much better "home away from home" than an awkward spot on top of the drapes! The fact that you can conveniently enjoy your pet out of its cage even when your hands are busy will encourage you to take it out to play more often, and that's

Above: NYLABIRD *products offer durability, nutrition, exercise, and occupation to a pet cockatiel.*

all to the benefit of the cockatiel's psychological and physical well being.

Cleaning the Cage

For health as well as aesthetic reasons, you need to keep any bird's cage and

Overall, the normal cockatiel hen is colored more dully than the male.

accessories as clean as possible. Theoretically, a single pet bird is far less likely to become exposed to disease organisms than a bird who comes in contact with many others, but you lose that advantage fast if conditions permit harmful bacteria to take root and thrive. Open food and water dishes should be cleaned daily, and while closed seed and water feeders can go for a few days, *any* soft food must be

Below: *In addition to desirable horizontal wiring, this cage features a door that becomes a playground when opened.*

removed after 24 hours. For those days when dishwashing is just too much of a chore, it's nice to have extra interchangeable dishes on hand. Paper-lined tray bottoms should also be changed every day, while litter tray bottoms can be changed every two or three days.

Ideally, you should clean the entire cage once a week. It really isn't as hard as it sounds when you only have the one pet or pair. Pet stores sell small, stiff-wired perch scrapers that make removing caked-on feces from wooden surfaces a breeze. The rest of the cage can be wiped out or hosed down while the cockatiel's visiting another

family member's shoulder or its convenient playpen.

In warm weather, you may take bird, cage, and all outside for a shower. Make sure only a light mist hits the bird, and it will probably love it. Many cockatiels act as if a shower is the height of sensual pleasure, closing their eyes beatifically and stretching wings and head to catch the droplets. You'd swear you could practically hear them purr, and you will definitely hear the indignant squeals if you end the fun too soon! Dry cage and bird off in a half-shaded spot so that your pet can move out of the shade if it gets too warm. Although a desert bird, a cockatiel doesn't like to fry any more than you do. Remember, a hot bird in the wild is free to move into the shade, and your pet cockatiel should be too. If you think it's too cool in the shade, it's probably too cool for a shower. And do give the shower early enough in the day that the bird will have time to dry out before evening.

A warning to owners of red-eyed cockatiels such as lutinos: The black pigment absent from these birds' eyes is what normally protects cockatiels from the intense glare of the sun. Like Hollywood's gremlins, these varieties must be protected from bright light. You may want to keep them indoors, especially if they show any signs of discomfort.

Above: *Pet cockatiels taken outdoors should not be left unsupervised, even if apparently safe in their cages.*

There are some circumstances under which you won't be able to adhere to a strict once-a-week schedule. For instance, if a pair is trying to go to nest, you have no business moving the cage about and upsetting their routine. Don't worry. Good habits in the past will carry you through until you can give a thorough cleaning once more. Of course, you are never excused from providing spotless dishes!

Care and Feeding of the Cockatiel

Above: *In the wild, cockatiels feed mostly on seeds found on the ground.*

"Diet" and "nutrition" are words surrounded by more mystery and mystification than any other element of bird care. Almost everyone has heard that birds instinctively know what to eat to meet all their nutritional needs, and almost everyone has heard wrong. Birds are not tiny computers with a running total of minimum daily requirements ticking off in their heads. Instead, like humans and most other omnivores (a word that literally means "eaters of everything"), they tend to eat many different kinds of food, depending on what's available at the moment and what tastes good. If they eat a wide enough variety in sufficient quantity, they'll probably take in all the nutrients they need to thrive and reproduce.

The variety of food eaten by wild omnivorous birds is truly staggering. Stomach analyses of various species have shown that literally hundreds of different foods are taken, including various kinds of animal matter such as insects, spiders, and worms, as well as vegetable feed ranging from buds through petals to fruits, seeds, and nuts.

Although cockatiels follow roughly the same pattern, feeding on seeding grasses and incidentally ingesting some protein-rich insects

A well-nourished cockatiel, like this pied, displays sleek, shiny plumage.

43

along with it, they're better equipped to handle deficiencies than the parrots who didn't evolve to cope with a rugged semi-arid environment. The fact is no doubt a key reason why cockatiels and their Australian buddies the budgies were the first parrots to breed reliably in captivity. Nevertheless, they will certainly live longer and better if provided with an optimum diet instead of a minimal one.

An additional reason for being extra concerned with a captive cockatiel's diet is that there is just no way a house pet can eat the same volume of food as a wild bird. Wild cockatiels, remember, migrate hundreds of miles in search of water, in the process burning far more food energy than any bird hopping around its playpen. Clearly, since the pet can't take in as much food, what food it does eat must be especially high in nutrients. For this reason, I think it's useful for the owner of even such a hardy bird as the cockatiel to know a bit about the nutritional basics.

Below: *A mixture containing several kinds of seeds is the basis of the diet of a pet cockatiel; yet without supplementation, over time a seed mixture proves nutritionally deficient.*

Water

Who would have thought that decent water would be so hard to find? My local water supply is from the Mississippi River, so that we never really know what odd color or strange flavor will come out of the tap next. Since chemical spills have become a way of life, I don't even fill my goldfish tank with tap water, much less permit my birds to drink the stuff! Unless you're quite sure of your water supply, you should stick to tested, bottled waters. In the past, pure distilled water was disparaged because it lacks the calcium and other beneficial minerals that give the best water its pleasant taste. I agree that an uncontaminated natural water is better than distilled, but if you have no other choice, give the distilled stuff and let the bird get its minerals somewhere else.

Cups for food and water are best kept off the floor. Instead, attach them to the cage wires where they can be reached from the perches.

The Basic Diet

In some areas, you can probably get away with boiling tap water to remove the chlorine and any possible bacterial pests. However, you should be aware that boiling doesn't remove many dangerous chemicals. Only you can make the best judgement about what to do in your area.

from sickness and injury. Because there is relatively little protein in seeding grasses, some people think that cockatiels do not need it. That's absolutely untrue. Your pet may get by with less of it than many another bird, but it will die if deprived indefinitely. Remember, wild cockatiels get protein from the insects

The Basic Diet

There are three main kinds of food—protein, fat, and carbohydrate. All foods are made of these basic ingredients, and for optimum health, your cockatiel should get a balanced supply of each. But what exactly are these components, and how do you get them into your bird?

Protein is the building block of life. It is used whenever the body grows or repairs itself. There is no substitute for protein. A baby chick will cease to grow and will die without it, and an adult bird will have difficulty recovering

Above: *Most cockatiels enjoy greens.*

they swallow along with their seeds, but since your home is hopefully bugfree, you'll have to supply your pet with another protein source.

Carbohydrates and fats, the main components of seeds and grains, are the energy foods. Carbohydrates (sugars and starches) are readily digested for use by the body as fuel for moment-to-moment activities. Fat is more compact and complex, providing a source of energy that can be stored by the body for times when less food is available. Since you won't

be starving your pet, fat is the least crucial element of the diet. As with people, it's better to store food in the larder than around the waist! Nevertheless, some amount of fat should always be left in the diet to provide the oils needed for healthy feathers.

It's worth noting that if, for some odd reason, a bird eats nothing but protein, its body can break down some of that food for energy. But in the more usual case where a bird eats only the energy-givers, its body can't build a protein from the carbohydrates and fats. To sum up, all three elements are necessary, but protein is absolutely irreplaceable.

Besides the big three, birds also need the minuscule components found in food, namely, vitamins and minerals. Vitamins are complex chemicals that help the body use food efficiently to maintain health and construct new tissues while minerals are simple elements used to complete the building of healthy bones, blood, and other structures. A deficiency of even one key vitamin or mineral can lead to disease or even death of the bird. However, since a bird's body makes its own vitamin C as well as some of the B vitamins, the most common deficiencies seen in cage birds are lack of vitamins A and D and the mineral calcium. Since all three work together in preparing the female for egg-laying, these

deficiencies are particularly dangerous to hens. Don't suppose that your pet is safe because she's unmated. The proof that unmated birds can lay eggs is no further than your own refrigerator; all of those chicken eggs sold in grocery stores are unfertilized by a male unless the box specifically tells you otherwise.

Well, so much for theory. Now how do we go about getting all these nutritional goodies into our pet bird? There are several good approaches, but ultimately, the choices you make will depend upon how much time and money you can spend on

Below: *Today commercial seed mixtures often contain, in addition to seeds, dietary supplements designed to make the mixture a better balanced diet.*

feed, and what your particular cockatiel will actually eat.

Many people still give their cockatiels a simple seed cup supplemented only with greens, the occasional bit of apple, and a mineral block. From what I said earlier, you

Above: *Cuttlebones or mineral blocks are the usual ways to ensure adequate amounts of minerals— notably calcium—in the diet.*

can probably figure out that their pets are short on protein. Since cockatiels are tough birds, healthy nonbreeding adults can do well for a long time on such a diet. But should they get sick or injured, their bodies can't

repair themselves efficiently, putting them at much higher risk for their lives. The situation is particularly hazardous for a laying female, since her body will steal nutrient supplies from her bones and other vital organs to form the egg. Let's look at some simple ways to add protein to the diet so that you won't have to risk a beloved pet's life.

The easiest method is to offer one of the new pelleted cockatiel formulations as the basis of your pet's diet. A lot of time and effort has gone into making these new feeds the most balanced cage-bird diets ever. Although by far the costliest option, they're certainly worthwhile when convenience is more important than price. A cheaper and more traditional method is to combine a good seed mix with a good protein food such as game-bird starter, mynah pellets, or dog food. The problem here is that many cockatiels will pick out all the seeds and leave the protein food behind, effectively proving that they'd rather eat what they like than what's good for them! (Most cockatiels won't touch dry dog food with a ten-foot pole.) I've found it better to offer seed and game-bird starter or mynah pellets on alternate days. The protein dish may be greeted with a squeal of rage, but at least it gets eaten! Some people prefer to offer the protein food in the morning and the seed bowl in

the afternoon. Whatever works for you is fine. Remember that vitamin powder sprinkled on seeds may get thrown away with the shell, but vitamin powder on the protein foods will get where you want it to go.

If you're prepared to do a little cooking, you can whip up a better-liked alternative in the kitchen. Eggs are the highest quality protein known, and they're also a good source of vitamins. A hard-boiled, mashed egg should be greeted with the utmost enthusiasm. If you mix the egg with a teaspoon each of powdered avian vitamins and a milkfree protein powder for people, the egg mash will be

dry enough to sit out 24 hours. Otherwise, it's best to remove the dish after an hour.

To round out the diet, green food and a mineral block or cuttlebone should be available on a daily basis. Well-chosen green food is a good vitamin source, while the mineral block provides much-needed calcium for healthy bones and eggs. Vegetable sprouts, kale, spinach, dandelions, and dark green lettuce are best. Iceberg lettuce, the pale kind used in most American salads, is unfortunately almost totally devoid of vitamins *or* flavor, so you should switch to darker greens for your own sake as well as your pet's. Give a fresh supply each day. Mineral blocks and cuttlebones, found in pet stores, can be hung in the cockatiel's cage until eaten or soiled.

Below: *That water should be changed daily is an important point of hygiene in keeping cockatiels.*

The Cockatiel at Dinner

The grit cup is a puzzling element of a pet cockatiel's diet for some people. "Why should I feed my bird crushed rocks?" they wonder. The answer's simple: Birds lack

Below: *Some cages are designed so that food cups may be serviced from the outside.*

teeth, so they swallow bits of stone to grind up food particles in their stomachs. A little goes a long way, and one box is more than your cockatiel will eat in its whole lifetime! Because a stressed or nervous bird may eat an excessive amount of grit, always remove the grit cup during periods of stress such as illness, injury, a change of home or environment, or introduction to another bird.

The Cockatiel at Dinner

Many pet cockatiels love nothing better than sharing your dinner. Because cockatiels, like humans, are omnivores, giving people food to your bird can be very beneficial if you're wise about what you eat. It can also be an unqualified disaster! Here are a few tips to make mealtimes healthy as well as fun.

, Soft drinks and other beverages are out. You don't want your cockatiel to get in the habit of sticking its head way down in the bottom of a glass to slurp some sweet fluid. Too many pets have drowned that way when their owner was out of the room. Milk is sometimes suggested as a health beverage for birds, but actually it's quite worthless to them since their bodies lack the ability to digest it. (After all, milk is one of the things that make us mammals different from birds; the very word *mammal* derives from the presence of the milk-producing mammary glands in mammalian mothers.)

Salads, on the other hand, are great if you don't waste your time with limp canned fruit and pallid iceberg lettuce. Small bits of fresh vegetables and fruits are excellent treats. Unless the veggies are daubed with a bit of dressing, the fruits will

Apart from hulling seeds, a cockatiel's beak is designed to tear large pieces of food into smaller ones.

Handling the Picky Eater

probably be better liked, but both are valuable and easy to offer in small chunks. Many people give their parrots their own miniature salad bowl, a great way to keep your cockatiel's head out of *your* plate.

Whether or not you should offer treats from the main course depends on how well you yourself eat. In general, you should avoid filling up your pet on non-nutritious foods that will crowd protein, vitamins, and minerals out of

eat are bits of fruit, cheese, seed, and nuts. (Although a dairy product, the processing of cheese naturally converts it into a more digestible form than the milk from which it came.) No sugar! No candy, ice cream, cake, or cookies! I promise you that you'll be sorry if you break this rule even once. Sugar is a wonderful perverter of taste buds, and the average cockatiel has no more self-control around it than the average human. Unless you

its diet. The more natural, unrefined foods such as whole-wheat bread, whole-grain pastas and cereals, and brown rice are excellent; white bread, ordinary pasta, and white rice are not. Lightly cooked vegetables, perhaps with a small amount of butter or cheese, are probably best. Be stingy with meat. It's high in fat as well as protein, and if you give your cockatiel any seed at all, it already has enough fat.

The only desserts and snacks your cockatiel should

Above: *Pet cockatiels often want to try the foods their owners enjoy.*

want the rest of your desserts for the next ten years to be accompanied by peremptory squeals for a nibble, avoid giving your pet the chance to develop a sweet beak.

Handling the Picky Eater
The wild cockatiel isn't a picky eater. It couldn't afford to be, not in its harsh environment. The domesticated cockatiel

Sprays of millet are nutritious, and cockatiels enjoy nibbling the small seeds from the stalk.

can be a bird of quite a different feather. While you can make sure that birds you've raised yourself develop the best nutritional habits, an older bird comes with a set of likes and dislikes that can be quite resistant to change. I have a female cockatiel so set in her ways that although she's tame enough to beg me to scratch her ears, she absolutely won't take treats from the hand. Or from the dish. Or from any other place pouting. But for the sake of your pet's health, it's worth it. Remove the seeds and leave only the most nutritious foods. At your meals, offer vegetable bits lightly coated with dressing or ripe bits of fruit. Sometimes it helps if the cockatiel sees *you* eating the food in question; some pets will only eat lettuce, for instance, when they can grab it from your salad plate. While the seed's out of the diet, you can be a little freer about

I've been able to think of. Left to her own devices, she carefully picks out the tiny millet seeds—chosen, no doubt, because they're the least nutritious stuff in the bowl—and completely ignores everything else.

To get something other than a favorite seed into a picky eater, you may have to put up with a few angry squeals and some eloquent

Commercially available cockatiel treats are designed to be both nutritious and appealing.

offering high-calorie treats from your plate, which should console the cockatiel and convince it that other foods can taste good too.

The Well Groomed Cockatiel

Above: *Offering food in the hand will promote a cockatiel's tameness.*

Below: *After bathing, birds spend considerable time preening to rearrange their plumage.*

The Well Groomed Cockatiel

A good diet will go a long way toward producing a beautiful cockatiel, but for perfect plumage, you need to know a bit about keeping your pet well groomed. I already talked about bathing in the previous chapter, but let me comment here that most cockatiels prefer a spray bath to splashing in an open tub of water. In hot weather (and any time if a family member is allergic), spray at least once a day. If you forget, you may get splashed by a furious bird forcing itself into its water dish! Always spray gently in a warm location, with plenty of time for cockatiel and cage to dry before bedtime.

People differ on the issue of clipping a cockatiel's wings. These birds are more flight-oriented than most parrots, so that they may not get

55

Above: *Some cockatiels are not inclined to bathe in a dish of water.*

Below: *One style of feather trimming allows two or three feathers to remain uncut at the end of the wing to preserve a good appearance.*

enough exercise if they can't fly. On the other hand, many a flighted cockatiel has flown out the door, become confused, and been lost forever. If you tend to be absent-minded about leaving doors open or walking outdoors with a bird on your shoulder, you'll probably want to keep your pet's wings clipped. If a new cockatiel isn't tame, ask the seller to clip its wings for you to make the taming process easier.

The Well Groomed Cockatiel

It's easy to clip a cockatiel's wings, once you've seen how it's done, and it isn't any more painful to the bird than it is for you to have your hair cut. Have a helper hold the cockatiel gently while you stretch out one wing. Clip only the long outer feathers on the lower end of the wing to prevent hitting a still-growing "blood feather." Clipping three or four feathers on one side won't completely stop flight, but it will prevent the cockatiel from getting much lift or control over the direction it's flying, discouraging wild escapes, if not short hops about the room.

Oftentimes, a cockatiel that spends a lot of time in a cage develops overgrown claws and beak. An overgrown beak is a serious problem that can actually prevent the bird from eating enough to stay healthy. Since it's easily prevented by giving challenging chew toys like lava rocks and rawhide doughnuts, your pet shouldn't have this problem. But if it does, you should probably let a vet or a professional pet groomer handle the tricky job of trimming back the beak.

Claw-clipping is much easier—a lucky thing, since overgrown nails are much more common. You'll need some supplies: an old towel, a nail file, a pair of dog clippers, and some styptic powder. Have a helper hold the cockatiel gently in the towel, being careful not to press on its chest or diaphragm.

Quickly clip or file the very end of the bird's nails. It's better to take too little and have to repeat the job next week than to clip too much

Above: *Scissors with notched blades facilitate claw clipping, as does the bird's tameness.*

and draw blood. If you do have an accident, though, quickly press a bit of styptic powder against the end of the claw. The bleeding should stop quickly. In pale-footed varieties of cockatiels, it will be easy to avoid the vein since you'll be able to see where it runs through the claw.

Taming and Training

Taming a young cockatiel is easy, especially if you've chosen a bird under two or three months old. (Remember to check for a pink beak!) Experts differ in their favorite techniques, but all methods boil down to two types—gradual or intensive. The gradual method is best for very wild birds such as older cockatiels because it allows the bird to get used to human company without putting too great a stress on its system.

Above: *A finger pressed against the cockatiel's breast induces him to step up.*

Youngsters just out of the nest can handle more intensive training because their young minds and bodies aren't yet set into wild habits. Such adaptable specimens can be scampering about on your arm within minutes of

Adult cockatiels, whether male or female, are less amenable to training than young birds.

beginning the first training session.

Because an early start is so important to easy taming, you don't have a moment to lose once you get the new pet home. However, don't hover over its cage for the first few days or hours; it needs time to get used to the new situation and to relax enough to eat and drink. In the unlikely event that it doesn't settle down enough to eat after 24 hours, you should contact the seller for help. Otherwise, you're ready to begin.

It's absolutely essential that you tame the bird in a quiet, isolated spot. Your new pet is overwhelmed enough by the unfamiliar environment. You can't expect it to calm down if other people or birds are standing around watching and offering advice. In fact, until the cockatiel's tame, it should be completely isolated from other birds, and only one person should be allowed to work with it. Even a toy mirror can present a distraction that causes the cockatiel to focus on its reflection instead of its lessons, so consider yourself warned.

Once you're in a quiet, uncluttered room, you can choose the taming method that seems most appropriate to your situation.

Intensive Training: The Young Cockatiel

Intensive training involves subjecting the bird to continuous contact that it can't escape. After a time, the cockatiel's nervous system becomes overwhelmed by your constant attention and the bird stops trying to flee. In a relatively short period, it realizes that being around you is pleasant, not dangerous. Although some experts disagree, I feel obliged to state my opinion that such intensive training is best reserved for very young birds in top-notch condition. Cockatiels rarely die of fright as do some smaller birds, but too much stress always has the potential to allow disease organisms to gain a foothold in the body.

Taming a young cockatiel is quite different from taming larger, wilder birds. You don't need a stick or heavy pair of gloves; although the cockatiel may hiss and threaten, it probably won't bite. The risk of a baby's nibble is certainly worth taking to train the bird to step directly on your hand.

You may start the taming process while the cockatiel is still in its cage. (Again, this technique is quite different from that used with the larger parrots, which bitterly resent any intrusion into their private homes.) I like to start by offering a special treat such as a bit of grape or a twig of millet spray. Slowly, speaking in a soft, reassuring voice all the while, put your hand into the cage with the treat between two fingers. Try to approach from the bird's side, rather than from head-on, which is often interpreted as a

Head study of a female cockatiel.

gesture of aggression. The cockatiel may try to frighten you away by hissing, slashing forward as if to bite, and vigorously flapping its wings. You may pause for a moment, but don't pull back. If you do, you'll have taught the bird that it can scare you away!

Eventually the cockatiel may snatch at the treat in your hands. If it eats it, great. Don't stop praising it in a soft voice. If it merely throws it furiously to the ground, try again. As the cockatiel will almost invariably accept the chance to step up. Don't worry if it uses its beak as a steadying third leg; it won't bite you in the process. Now, with bird on hand, slowly remove your arm from the cage.

Once outside, the cockatiel may panic and try to fly away. If its wings are clipped, it will probably head for the floor; if not, it may make a couple of circuits of the room before landing. In either case, wait

long as you move slowly, without any sudden jerky motions, the cockatiel will soon accept your hand as a normal part of the cage. At that point, it may step on board of its own accord. If not, you can easily encourage it to do so by placing your hand against its chest. Birds instinctively like to perch on the highest spot around, and

Above: *The initial stages of training are designed to accustom the cockatiel to having a person close by.*

until it lands before moving slowly and reassuringly to fetch it. Some trainers actually pick the bird up

Intensive Training: The Young Cockatiel

(gently!) and return it to the hand; I perfer to coax it back onto my hand by placing my forefinger at its chest. In either case, speak softly the whole time to gain the cockatiel's confidence. It may fly away several times, but don't lose patience. It will tire before you do. Once it does decide to remain on your hand, praise it effusively and offer it a special treat.

Now you may try a couple of variations. Using a game called the ladder, you can coax the cockatiel to practice stepping from one hand to the other. While it stands on one hand, place the other level with its chest. When it climbs onto the new hand, place the old one at the new chest level, and so on until you're holding the bird as high as you can in the air. To teach it to leave your hand for its cage, hold it so that the top of the cage is at the level of its chest and it should step off onto the roof. To return it to the cage at the end of the lesson, put hand and bird *slowly* into the cage, holding your hand so that the perch is at the level of the bird's chest. Why all this practice for getting the bird *off* your hand? Well, hard as it may be to believe in the beginning, many pet birds are much harder to get off a beloved arm or shoulder than on!

Once the cockatiel willingly steps on and off your hand on command and is no longer afraid of human company, it is technically tame. You may very well tame your baby in one lesson! However, I do advise taking the time to complete the taming process by teaching it to accept being held and cuddled. Not only does being scratched and petted help keep a pet's feathers in good condition, its being able to tolerate free handling without fear makes claw clipping and vet exams much easier on both of you.

Although some people switch the order, I prefer to start by scratching the cockatiel's cheek patches. Approach its head slowly,

Below: *Since flight is a cockatiel's principal method of escape, wing trimming may significantly facilitate taming.*

The Gradual Method:

from the side, always murmuring reassurances. Don't be discouraged by small feints and hisses. Once you've started to scratch, the cockatiel will calm down amazingly. It will soon learn to beg for the favor by bowing its head and closing its eyes. At that point, you may get hissed or squealed at if you fail to provide the scratching!

Once head-scratching is accepted, work back to patting the cockatiel's back. Gently! It may never learn to actually enjoy this behavior, but it's important that it accept it. Once it resigns itself to back-patting, you should try to slowly and carefully encircle its body with your hand, always keeping the head free and never pressing it on the chest. Put a slight pressure on the wings to prevent it from flapping wildly and hurting itself. Many cockatiels won't like the treatment, but letting them get used to it can make all the difference in the world if it ever has to be handled while sick or injured.

The Gradual Method: For Older or Stressed Cockatiels

If your cockatiel has reached late adolescence or early adulthood without being tamed, you will have to take a little more time with its education. An aviary bird raised by its parents can be surprisingly shy of humans if they weren't part of its day-to-day experience when young. Taming these birds isn't hard, just a matter of time and patience.

You start as before, giving the cockatiel a few hours or overnight to settle into its new home and get something to eat. Then you may start regularly approaching the cage, murmuring reassurances whenever you come by. Don't forget to talk to the bird when you're changing its tray or food!

Below: *Mirrors are appealing because the reflection is taken to be another cockatiel.*

THE WORLD'S LARGEST SELECTION OF PET, ANIMAL, AND MUSIC BOOKS.

.H. Publications publishes more than 900 books covering many hobby aspects (dogs, , birds, fish, small animals, music, etc.). Whether you are a beginner or an advanced byist you will find exactly what you're looking for among our complete listing of books. a free catalog fill out the form on the other side of this page and mail it today.

CATS . . .

. . . BIRDS . .

. . . ANIMALS . . .

. . . DOGS . . .

FISH . . .

. . . MUSIC . . .

For more than 30 years, *Tropical Fish Hobbyist* has been the source of accurate, up-to-the-minute, and fascinating information on every facet of the aquarium hobby.

Join the more than 50,000 devoted readers worldwide who wouldn't miss a single issue.

Above: *Most likely, head scratching resembles being preened by a conspecific.*

Take every opportunity to show it that it's safe when you're around. At first it may hiss and protest whenever you approach, but it will soon stop when it sees that threats make no difference in your behavior. Depending on the bird, a few hours or a few days may pass before it's perfectly calm in your presence.

As with the previous method, you must now clear the room of clutter and human as well as avian distractions. Then you may *slowly* put your hand in the cage, again approaching from the bird's side with a small treat between your fingers. If you're especially afraid of being bitten or if the bird in question seems especially

aggressive, you can wear a pair of heavy gloves. However, be aware that you will later have the extra step of training the bird to accept your hand without the gloves. It's really best to offer the bare hand if you can. Keep in mind that although adult cockatiels may inflict pain, they probably won't unless startled. In any case, they're unable to do any real damage. Just move very slowly, stopping but not retreating when your bird acts nervous or aggressive, and you'll both do just fine. In a first session with an older bird, you've achieved your goal when it takes the treat from your fingers or steps onto your hand. Let it rest for an hour or so before repeating the lesson.

You may repeat the lesson several times a day each day, but try not to work longer than 20 or 30 minutes each time. Remember that an older bird needs time to recover from

the taming stress. How long will it take to get an older cockatiel to hop reliably on and off of your hand? I can't give an exact timetable, because so much depends on your patience and the individual personality of your cockatiel. But I would certainly expect even the wildest specimen to step reliably onto your hand within its cage by the end of a week of regular lessons.

Follow the directions given previously for removing the bird from its cage and teaching it to ride about on your finger or shoulder, with the difference that you must accept a much slower rate of progress than with the younger bird. While baby's lesson two may find you scratching its head and patting its back, the adult's doing well if it stays on your hand without immediately flying down. Again, it's better to have several short sessions throughout the course of the day than a single, long, intense one. There's really no

Above: *Since birds do not naturally take to being petted, it must be done very gently.*

need to rush things. Even if it takes as long as a month to train the adult to accept your petting and cuddling—and it probably won't—you've still invested a short amount of taming time in relation to the decade or two of pleasure you can expect from your new pet's company.

Biting
Suppose your cockatiel bites you or starts chewing on something dangerous. What do you do? If the bite is really a harmless nibble, ignoring it will probably tell your pet that biting doesn't work. But if the bite is really painful or you want it to drop something really fast, you should say, "No!" in a loud, firm voice. The unexpected scolding is usually enough to startle the cockatiel loose. If it bites again, repeat the firm "No!"

Punishing the cockatiel (or any other bird) will *not* work because it frightens rather than educates the bird. The best way to discourage biting is to encourage your pet's love so that it won't wish to displease you. Fortunately, since cockatiels are so eager for affection, real biting (as opposed to harmless mouthings) is unlikely to persist.

It's unwise to return your cockatiel to its cage immediately after it bites you because you may thus unintentionally teach it that biting is the way to let you know it wants to go back in.

Training

Once the cockatiel's tamed, you'll probably want to train your pet to do tricks or to talk. A wonderful idea! It's a misconception that training is cruel and unnatural. In the wild, a cockatiel spends a lot of time searching for food and water, and avoiding predators. In captivity, where the necessities of life are given, trick training is an excellent way to exercise intellectual capabilities that could otherwise atrophy.

Most home trick training is accomplished by offering food

Below: *While a cockatiel's bite can be painful, its beak is not powerful enough to do serious injury.*

Above: *Untame cockatiels typically retreat to the farthest corner of the cage when approached.*

create an avian ham, you'll be the envy of everyone you know. The only thing cuter than a bird that does tricks is a bird that begs for the chance to do tricks!

Tricks are taught by conditioning the bird to react in the same, desired way each time a particular command is given. For instance, it's valuable to teach a bird to "come." During the first few lessons, the cockatiel may be placed on top of its cage before the command is given. If sufficiently tame, it may fly to your shoulder simply because it wants to be with you, not because you've asked it to come. Nevertheless, you reward it with a treat. After it has responded well to several repetitions, you may place it on another surface, perhaps a table top, and command it to come from there. Be patient, repeating the command if it doesn't fly to you at once. When it finally does get the idea (or just decides to flap on over), heap on the praise and offer the reward. Of course, be prepared for several lessons of no longer than twenty minutes each before the cockatiel learns to respond to the word "come" by automatically heading for you. Be patient. Long, boring lessons or grumpy, irritable ones won't teach your cockatiel that it's fun to obey you!

If you have the odd cockatiel like the hen I mentioned who hates

rewards. Before training begins, you need to observe your cockatiel to see what foods it particularly enjoys. It's also helpful if you cut rations in half, which will make the bird more interested in receiving the food reward. In a tame bird, the desire to please is also a powerful motivation, so don't forget to praise your pet effusively when it does well. There's no such thing as too much praise going to its head. If you do

Above: *This tame young cockatiel stays placidly on the finger as it is returned to its cage.*

everything edible except itty bitty millet seeds, you can offer an affection reward instead of food. In her case, a head-scratching usually gets her purring with delight. The only problem with offering affection rewards is that they do take more time and tend to slow training progress. But, after all, what's the big hurry if you're both having a good time getting there?

To come and to defecate on command are especially useful tricks. Most cockatiels aren't housebroken, but it's certainly possible to teach a smart student to defecate over its cage when you give the word. In order for potty-training to take, you should choose a word not normally used in conversation as the command for defecation. (Otherwise, you could accidentally give the word while you're talking to someone else and have the bird use your new shirt!) You must also be aware that parrots aren't built to "hold it," and cockatiels are no exception. Never expect it to sit on your arm or shoulder for more than 20 minutes without a quick trip to its cage to defecate. Don't punish accidents, and praise the bird highly whenever it goes on command even if you suspect that its performance was just coincidence. It takes longer to potty train a cockatiel than to teach it to perch on your arm or to come on command, but it's worthwhile if you're

Teaching a Cockatiel to Talk

Above: *A playground offers exercise opportunities and a change of scene from the cage.*

squeamish or own lots of expensive clothes.

By offering love, patience, and a well-chosen snack, you can also teach a cockatiel a few showier tricks. Because they aren't used to holding food in their claws, they aren't the naturals at pulling or hauling toys that most other parrots are. However, they can do very well at tricks that allow them to use their beaks

as hands. Picking up a penny and placing it in a piggy bank is a good example of a fairly complex trick. In the first few lessons, you should reward the bird just for finding and picking up the penny. (It will eventually, if only because the coin is pretty and parrots love bright things.) Next, praise it for taking a few steps with the coin. Later, praise it only when it steps in the direction of the bank. When it approaches the bank, you can tap your fingers near the slot to draw its attention. When at last it drops the penny in the slot, reward it well and praise it highly! In succeeding lessons, you must offer praise only when the bird equals or exceeds previous progress. Once it has learned to put the penny in the slot, for instance, coax it to complete the entire trick before offering a food reward.

Teaching a Cockatiel to Talk

Don't make your love contingent on your cockatiel talking. Most don't talk at all, and few talk as volubly as several other parrot species. In a survey done by *Bird Talk* magazine only one out of 52 cockatiels had a vocabulary of over 100 words. By contrast, 2 out of 6 ringneck parakeets had a vocabulary of over 100 words, and the average number of words spoken by these birds was 77. (The average *talking* cockatiel knew 19 words.) Two 10 or 15 minute sessions morning and

night will probably teach your cockatiel to talk if you stick with it, but the first word may not be spoken for several months. Patience and consistency are the watchwords. It's possible for a sharp cockatiel to pick up words in day-to-day conversation, but without

some work on your part, it's pretty unlikely.

During speech training, you can hold the cockatiel on your hand or leave it in the cage. If left in the cage, you should remove the feed cup and the toys for the duration of the lesson. Turn off any radios or televisions, and retire to a quiet room free of distractions. Choose a simple word like "Hello" or the bird's name to start with. (Some experts feel that birds learn faster from people with

Below: *The tricks that a bird does best depend on its natural propensities, such as climbing.*

higher-pitched voices, such as women, girls, and pre-adolescent boys. If several family members are competing for the job, you

Below: *Teaching a cockatiel to talk is best carried out in an environment free of distractions.*

may want to keep this suggestion in mind.) Try not to feel idiotic if the cockatiel just sits and looks at you through the course of several lessons.

If your patience isn't up to repeating one word over and over for 20 minutes a day for weeks on end, you may want to try playing one of the commercial tapes or records available for training birds. As I write, one enterprising company is even offering a video that you can play on your TV, showing an actual parrot repeating the lesson of the day. If you don't watch so much TV that your cockatiel tunes it out, this option may just do the trick. Otherwise, you can try playing the record each morning before uncovering the bird and each evening after covering it for sleep. In the darkness, it should theoretically have nothing to concentrate on but learning its lesson.

Warning: I once trained a parrot using a tape I played each morning while I took my shower to drown out the repititious sound. Unfortunately, the brat associated the words with background shower noises and tried to speak only when the water was running, meat was sizzling on the stove, the vacuum cleaner was going, or my friends were speaking. Rather than deal with the resulting squawkfest, I eventually abandoned the lessons altogether! The moral of the story is to train your bird to talk when everything else is quiet.

Some birds will only talk around the trainer or trusted members of the family. That's embarrassing after you've already bragged to all the guys at the office about your brilliant bird, but unfortunately

Above: *A cockatiel that is very tame toward its owner may behave very differently toward strangers.*

it isn't at all uncommon. Talking is done to please and draw attention, and a shy bird understandably doesn't wish to draw a stranger's attention. If the visitor is willing and responsible, you may allow him or her to hold the cockatiel on hand or shoulder. If you're all gentle rather than boisterous and speak to the bird in low, kind voices, you may elicit a conversation once your pet feels comfortable in the guest's presence. Don't push it. It's when you least expect it that your bird's likely to break in with a pert, "Hello!"

Breeding the Cockatiel

The cockatiel is a naturally prolific bird that's easy to breed if certain requirements are met. However, in most cases, cockatiels usually won't breed as successfully in cages as in pens, and the hobby breeder working with a few cages may encounter more problems per pair than the pen breeder. Experience helps, so don't be discouraged if you have some failures at first. You may not produce birds by the ton, but following the basic rules should ensure you some very nice, healthy chicks.

Cockatiels are sexually mature and able to breed at six months, in many cases before an inexperienced human eye can tell whether the youngster is male or female! Nevertheless, they shouldn't be bred until they're

Above: *Pearl and lutino chicks in a nest box, four to five weeks old, just prior to fledging.*

over a year old, and most experts recommend waiting until the younger member of a pair is at least eighteen months. Very young cockatiels aren't ready to settle down and take on the responsibilities of caring for eggs and babies, and their restlessness can mean broken or abandoned eggs, or negligent or no feeding of hatchlings. Young hens are at special risk for disease or nutritional problems if they breed too young, since the demands of their own growing bodies will compete with the developing egg for vitamins, minerals, and protein. Finally,

With cockatiels, mutual preening serves to reinforce the bond
of mated pairs.

Breeding the Cockatiel

waiting until the birds are older allows you to be sure that you do, in fact, possess a pair.

In many cases, a pet owner just getting interested in breeding will have only one adult cockatiel and will need to acquire a mate for it. To get a bird of the right sex, you need to buy either another adult or a juvenile of known sex. Although it means another wait, buying a younger bird is usually better for beginners because adults on the market are often specimens that have shown breeding problems in the past. (Otherwise, the breeder would have kept them!) But how do you know whether the youngster is a boy or a girl? Usually, of course, you don't, but there is one exception— the product of carefully mated parents chosen so that males will be one color and females the other. In that case, the breeder will be able to tell you what's what and who's who.

To see why this can be done, we must recall that the sex of a baby bird is determined by the genes, chemical messages that come from each parent. The structure that carries a large number of genes is called a chromosome. If a chick is male, it has received an X chromosome (named for its shape) from each parent. If it's female, it has received an X chromosome from its father and a Y chromosome from its mother. The Y chromosome doesn't carry as much

information as the X chromosome. Traits carried on the X but not the Y chromosome are called sex-linked, because their expression is related to the sex of the bird in question. Conveniently, for our purposes, certain color mutations, including the popular lutino, are sex-linked. The upshot of all this hairy theory is that if the father is pure, his daughters will always be the same color that he is since they won't receive conflicting color instructions from their mother, the donor of the incomplete Y chromosome that makes them female. His sons, however, receiving complete X chromosomes, may receive conflicting color instructions from each parent. If mother is a pure gray, the dominant color, while father is lutino, the sons' bodies will exhibit the dominant gray from the two choices carried in their pair of X chromosomes. Therefore, by a careful choice of parents, the offspring may be forced to be all lutino females and gray males, and it will be obvious who's who well before sexual maturity. You must realize that this technique only works if a breeder is careful about keeping records and pairing *pure* birds!

If you can't find sexed youngsters, you should be as choosy as possible about the adult you take home to mate with your bird. Culled show-quality birds may be excellent

In the cockatiel, the factor that produces the lutino coloration
is linked with those that determine sex.

parents for the beginner, even if they aren't top prize winners. Moving sales and the like may also be good opportunities to get a bird being sold for no fault of its own.

Although usually sweet-natured, the occasional cockatiel will let you know it wants to reproduce through will breed reliably. If you're housing the potential parents in a cage of less than 2½ feet long and 2 feet tall, you will probably not have much luck unless you allow them to spend a good deal of time with the cage door open, so that they have the option to fly about as the urge takes them. Since it isn't wise to give

an unexpected personality change. Two common symptoms of the urge to mate are nipping and a sudden insistence on being handled by only one family member. Sometimes it will also suddenly decide it only likes humans of one sex.

Preparations
A cockatiel pair needs to feel in control over a certain amount of space before they

Above: *The nest box for this pair is mounted outside the cage.*

cockatiels unsupervised freedom in most households, you will simply have to spring for bigger accommodations if no one is home during the day to keep the loving couple out of trouble. Some breeders have had reliable results with cages 3 feet long, 1½ feet wide, and 2 feet tall. Four feet

Cockatiels of the same sex housed together provide companionship for one another.

long is even better, and the ideal situation is the long flight pen that allows optimum opportunity for exercise.

In the wild, cockatiels nest in holes in rotting or dead trees. Because they had to adapt to a variety of sizes and shapes depending upon what they found in the wild, they learned to be pretty accepting of a wide assortment of nests.

inches wide, and a foot tall, with an entrance hole, 2½ to 3 inches in diameter, some three inches below the top. Place a sturdy perch below the entrance hole. Many people use a hinged roof to simplify checking on the progress of the nest, but since cockatiels are often nervous about being looked down on, you may prefer to

For aviary or cage use, it's better to buy or make a nest box rather than to try to use a found log because the natural nest is harder to clean and may introduce mites into the cage. Cockatiel nest boxes are a standard item at pet stores specializing in birds as well as at pet-supply houses. You may also build them yourself for relatively little effort. Use a hardwood or exterior-grade plywood to prevent the cockatiels from chewing it to bits. The dimensions should run about 10 to 14 inches long, 10

Above: *Nest boxes for cockatiels typically follow this design.*

make a small door in the back instead. In any case, hang the nest as high as you practically can.

What about nesting material? Opinions differ. Wild cockatiels don't usually line their nest hollows, and many breeders don't either, simply chiseling out a small depression on the nest-box bottom to keep the eggs from rolling around. Others prefer

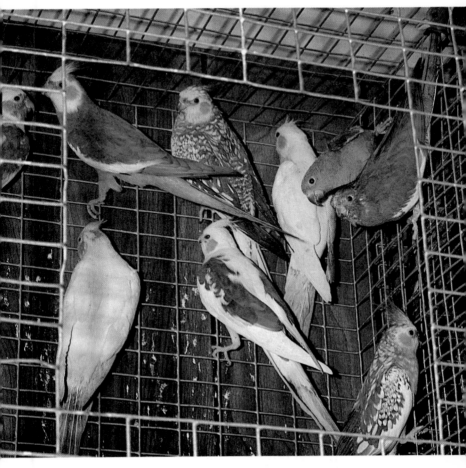

Above: *Housing several cockatiels in the same enclosure allows them to choose mates they prefer.*

to use a layer of pine or cedar shavings. Some have success with peat or sod linings, which are good for very-low-humidity environments such as many temperature-controlled homes, but may allow the growth of harmful molds and bacteria in more humid areas.

A high-quality diet is particularly important at breeding time. The hen, especially, will need protein, calcium, and vitamins to form healthy eggs that are easily passed. She may demolish cuttlebone after cuttlebone with surprising speed to meet her calcium needs, so have extras on hand. Hard-boiled eggs, fresh fruits and vegetables, and other foods will also be taken in larger quantities. The male should also be well-fed, of course,

Care of the Eggs

since caring for the young takes a lot of energy, and he accepts an equal share in incubating the eggs and rearing the brood.

It's much easier to introduce your pet cockatiel to a potential mate than it is to introduce potential partners of most other parrot species. Although the occasional pair may not hit it off, most cockatiels are very good about accepting the mates chosen for them. The

Below: *In the wild, cockatiels nest in tree cavities.*

only problem that may arise is if you break up a pair to mate an inexperienced bird with an experienced breeder. As long as the experienced partner can hear its former mate calling, it will not accept the new bird. Nevertheless, since the benefits of having a more experienced bird coach an inexperienced one are so great, it's worthwhile to take this option while using extreme care to separate former partners aurally as well as visually.

Care of the Eggs

If both parents are beginners, especially if they're "underage," they may neglect or break the eggs, yet care for future broods perfectly. Don't let first-time nerves, either yours or theirs, ruin the breeding experience for you. It's valuable to remember that nature allows for a certain loss of eggs and chicks to accident or disease, and since youngsters are particularly vulnerable, a certain percentage won't survive even under the best conditions. Relax, do your best, and don't blame yourself or the birds if everything doesn't go perfectly at first. Even experienced breeders have losses.

Expect your hen to lay four to seven white eggs at the rate of one every other day. At first the hen may spend a lot of time inside the nest, with the cock sitting just outside on the perch, but once incubation begins, he will also

Above: *At hatching, cockatiels are covered with a sparse yellow down.*

disappear inside the nest box for long periods of time since the male usually broods the eggs during the day. The hen usually takes her turn at night. There are exceptions, and sometimes the birds work out their own schedule. Don't fret too much, but do notice if the cock isn't helping at all, because you will want to limit breeding to prevent exhausting the hen.

It's valuable to offer more spray showers or even a shallow tub of pure water for bathing during incubation, especially when breeding indoors. The cockatiel often returns to the nest box with wet feathers in order to provide the eggs with the moisture they will need to hatch properly.

It's a good idea to check on the progress of the eggs once a day, to get the parents used to your looking in the box. With tame cockatiels, your daily checkups shouldn't frighten them enough to cause them to abandon the eggs. On the sixth day after incubation has begun, you should check the eggs for fertility so that the parents won't have to waste their energy on infertile eggs. An experienced eye can readily distinguish the clear, infertile eggs from the opaque, developing ones by holding them up to a bright light. A beginner, however, should avoid mistakenly tossing good eggs by preparing a simple candler for checking fertility. Enclose a light bulb within a box with a small hole on top for holding the egg. When you look through the egg at the light, you should be able to make out the blood vessels of the developing embryo. If the egg is translucent instead, it is infertile.

Care of the Young

The eggs should begin hatching some time between 17 to 21 days, sometimes taking a while longer if the temperature is low or the brooding irregular. Although downy rather than naked at hatching, the chicks are entirely helpless and blind. Yet, when well-brooded and fed by its parents, a chick may reach half its final body weight by the end of its first week of life! Such rapid growth cannot be sustained without protein, and it's best to offer lots of egg food, crumbles, and other protein-rich foods as well as soaked or sprouted seed. Because the eggs are laid over a period of days and some cockatiels don't wait until all the egg are laid to start brooding, the first-hatched may be much larger than the last-hatched for a while. Fortunately, unlike many bird species in which parents only feed the larger and stronger babies, cockatiels are very good about making sure the runt of the litter gets it share of the food.

At around seven to ten days, the chick becomes the right size to receive a metal band. Soon the foot will grow too big to allow the ring's removal without wire cutters, giving the bird a permanent identification bracelet. This convenient ID helps simplify bloodline records and proves that you bred the bird for show or sale purposes. It may also come in handy if the bird is ever lost or stolen. If you've checked on the brood daily, removing the young for a short period to band them shouldn't cause the parents to refuse to feed them when they're returned to the nest box. Official bands may be obtained from either the American Cockatiel Society or the National Cockatiel Society.

If the parents aren't banded, they may be especially annoyed by the appearance of a bright shiny ring on each of their young.

Below: *A cockatiel pair mating near a tree trunk that is their nest.*

Above: *The smallest chick is three days old, the others more than a week.*

To prevent them from tossing the irritant—and baby with it—you may blacken the ring by holding it over a burning candle. (Be sure it's cool before you try to band the chicks!) It isn't hard to slip the ring over the toes of the baby at this age, but to make it easier, use a tiny dab of petroleum jelly. Many people place the back two toes against the leg and point the front two toes forward before slipping on the ring. Others find it easier to hold the three largest toes forward so that the ring has only to pass over the smallest toe along with the leg. Whatever works for you is fine.

Expect the chicks to fledge—take flight—within four or five weeks of hatching. They aren't quite ready to eat on their own, however. Either you or the parents should keep feeding them for another 2 to 3 weeks. At that point, the parents may want to start another brood. To preserve their health and vitality, remove the nest box after they have produced two or three clutches in a given year. Otherwise, a dedicated pair could breed themselves to exhaustion.

Artificial Incubation and Hand-rearing

First-timers may get flustered and abandon their eggs or a hard-working hen may lay more eggs than she can efficiently raise. What to do? Breeders of several pairs can

85

Artificial Incubation and Hand-rearing

foster their extras to a pair with an excess of infertile eggs or simply divide up the eggs among several nests, but a beginner isn't likely to have that option. If you have just the one pair, you must either incubate the eggs yourself or toss them in hopes of better luck next time.

Before beginning an incubation project, be aware that cockatiel chicks are fairly fragile and quite demanding during the first two weeks of life. In particular, during the first week, the babies will have to be fed once every 2 or

Below: *When a month old, a cockatiel chick is completely covered with feathers.*

3 hours. If there is no one home during the day to provide regular feedings, you can't take on the job. Don't feel bad if you must toss the eggs. Nature allows for such losses; if every cockatiel produced to its maximum capacity, we would be knee-deep in birds by now!

It may happen that you want to schedule the eggs to hatch during a student's summer vacation or other period that will allow someone to be home to tend the brood. Figure that the eggs will hatch after around 3 weeks in the incubator. To store them until you're ready to start, put them in a cool cupboard or other place where the temperature is between 40° and 60° Fahrenheit. Turn them once or twice a day to keep the embryo from sticking to one side of the shell. It's best if you plan not to store them longer than 2 weeks to a month, because they're much less likely to hatch after prolonged periods of storage.

Storebought incubators can be pricey, so you may wish to build your own. I have used a homemade styrofoam box, designed from junk by a friend, with great success. It's heated by a 40-watt light bulb wired to a relay that switches it on and off at intervals to maintain the proper temperature. Since my talented hobbyist was able to repair a discarded air-conditioning thermostat to regulate the internal temperature, my incubator

The pied mutation inhibits the deposition of melanin pigment when the feathers are formed. Pied cockatiels vary widely in appearance.

Above: *A young cockatiel shows conspicuous barring.*

cost less than a couple of dollars. (Only the light-bulb socket and relay had to be purchased from a store.) However, if you must buy a working thermostat, you'll find that they run at least $20 or $30, making it just as worthwhile to go ahead and buy a cheap incubator kit. Some people do have success using a light bulb alone, without a thermostatic regulator, but the odds are against it.

The simplest incubators will maintain only the temperature, in contrast to expensive versions that rotate the eggs, maintain humidity, and regulate air flow. With the cheaper versions, be sure to turn the eggs yourself twice a day, removing the lid for a bit to let some fresh air into the box. It's also useful to keep a half-filled cup of water in the box to provide moisture. You can also take a tip from the parents and occasionally mist the eggs with water. Don't overdo it, though; too much dampness is as bad as too little. Set the thermostat to 100°F.

It is especially important to candle incubator eggs after a few days of incubation, since infertile eggs left inside an incubator may explode. Believe me, your nose doesn't want that to happen. Besides producing a horrid odor, the molds harbored in rotten eggs can also kill your otherwise healthy embryos or chicks.

If some of the eggs don't hatch on time, you may

The melanin pigments that produce much of a normal cockatiel's markings are absent from the lutino.

wonder whether you should open them and help the chicks out. In my experience, this "help" is rarely a good idea. If it isn't strong enough to make it out of the egg by itself, it probably isn't going to make it anyway—and it's a lot more heart-breaking to lose a chick than an egg.

The first two weeks after hatching are the toughest. If you possibly can, you should leave the youngsters with the parents for this period even if you wish to handfeed for special tameness. But, if you must—and you certainly must

Below: *Cockatiel youngsters in an outdoor flight.*

Above: *Syringes filled with a formula in preparation for hand-rearing.*

if the parents didn't even care for the eggs—then you should lower the incubator temperature to 95°F for the first seven days, lower it again to 90° for the next seven days, and so on until you reach room temperature. The chicks will tell you if they're not comfortable; cold chicks will huddle together near the heat source and have trouble digesting their food, while overheated chicks will separate and hold their heads up. It's important to change the lining that the babies sit on often to prevent infection; plastic trays, soft towels, and disposable diapers are popular linings that are easily

replaced for cleaning.

People who don't own incubators or brooders have had excellent results using glass aquariums heated by an infrared lamp or a heating pad. Use a small jar with holes punched in the top to maintain humidity while preventing babies from accidentally drowning themselves in an open cup of water. Whatever you do, you'll need to keep the top partly open to provide fresh air, so use a screen cover if the room isn't secure from curious pets and small children.

Feeding and growing are the big chores during the first few weeks of life. Your handling will ensure that the babies are naturally tame without the need for special lessons. Many, many baby-

Above: *With older chicks, a spoon is often the preferred hand-rearing tool.*

cockatiel formulas have been used with great success, and naturally everyone is fiercely loyal to the mixture that has worked best for him or her. If convenience is important, you can use one of the commercial baby-bird formulas. Although they may be too costly for large breeders, they can be very cost-effective for the small hobbyist who has a lot of leftovers after mixing up a home formula.

If you make your own formula, keep in mind the need for protein! Although most good formulas will be based on some good carbohydrate such as sunflower meal, cornmeal, or oatmeal, there must also be some kind of protein component to permit proper growth. The easiest way to do this is to use a high-protein (human) baby cereal. A simple basic mix could contain 2 cups of the baby cereal; ½ cup cornmeal, powdered oatmeal, or sunflower meal; and ¼ cup powdered wheat germ. (The wheat germ and sunflower meal are found in health-food stores. Notice that good-quality wheat germ

and sunflower meal must be stored in the refrigerator, since the vitamin E and related oils can spoil quickly at room temperature.) To use, *slowly* add boiling water to a few heaping spoonfuls, and let it cool until it's lukewarm. Be sure to test the formula against your wrist or lip each time you use it; if it's too cold, baby won't be able to digest it; too hot and it could burn through the crop.

You were wondering just how much water you should add to the formula? Well, that's where experience comes in, even when using a commercial feed. If you are handfeeding from day one, start with a thin gruel that runs easily off a spoon. (The commercial-feed label will suggest using equal amounts of water and feed, but go a little heavier on the liquid at first.) Thicken the consistency of the formula *gradually* over the course of the next two weeks until it resembles canned applesauce. An eye dropper or syringe sturdy enough to be sterilized by boiling between feedings is the easiest way to give the infant formula. Fill the crop, but don't stuff it to the bursting point no matter how loudly the baby pleads!

Below: *Cleaning up after hand-feeding can be done with a moistened cotton swab; otherwise, food may harden and lead to problems.*

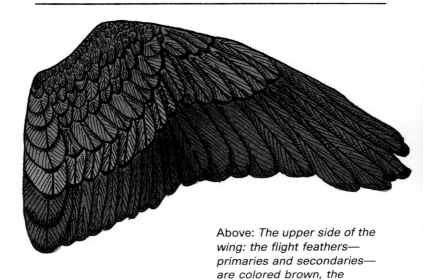

Above: *The upper side of the wing: the flight feathers— primaries and secondaries— are colored brown, the greater coverts blue, and the lesser coverts red.*

However, if you do overfeed, you will soon know it because the crop will still be more than half full when you return for the next feeding. In that case, give only a small amount of pure warm water to give the crop time to empty normally.

For the first 10 days to 2 weeks, feed the hatchlings every 2 to 3 hours between 7 A.M. and 10 P.M. Some people feed round-the-clock, but in most cases, night feeding is really unnecessary since healthy chicks normally go through the night without eating. After 10 days, you can taper down to feeding 6 times a day during the third and fourth week. Actually, it's possible to get away with feeding only 4 times a day during the second two weeks of life, but it's really safer to offer less food per feeding at

several feedings. These older chicks may take their thicker formula from a small spoon instead of a syringe. Whether fed with a spoon or a syringe, the little brood can be messy, so be sure to wipe the beak area with a soft towel after each feeding.

At 5 or 6 weeks, the youngsters should be ready to leave the brooder for the cage, but they'll still need supplementary feeding. Put a tube-type water font in the cage and cover the cage floor with a selection of various small seeds to encourage them to investigate the possibility of feeding themselves. (Clean the floor every day, despite the "waste.") Drop a feeding at the beginning of the fifth week and another at the beginning of the sixth. By the seventh

week, the chicks should be cracking seed for themselves, but you still need to check on their progress each evening. If a baby's crop is empty at bedtime, feed it a good helping of formula.

Often hand-raised babies take longer to wean than parent-raised birds, and sometimes you'll get an attention-hog which seems as if it might insist on being waited on hand and foot forever. Don't dispair: it too will grow up one day. Don't stop checking its crop each evening and offering it formula if it hasn't eaten, but do encourage it to sample treats during the day by offering millet spray, soaked seed, eggfood, or other goodies. Most of the time, cockatiels learn from each other, so that once you have

one chick feeding itself, the rest will quickly follow.

Common Breeding Problems

The upcoming list of problems may make you call me a liar when I report that cockatiels are easy to breed. Relax. Many of the most common problems can be largely prevented through careful attention to proper nutrition and cleanliness. It's a good idea to look over the potential hazards and do a little preventive work to protect your birds and make breeding a joy.

Starting with the (attempted) laying of the egg, egg binding is the first problem we face. Egg binding, a condition where the hen can't pass her egg, is particularly heartbreaking

Below: *The underside of the wing: the primaries and secondaries are shown in brown, while the greater and lesser underwing coverts appear in blue and red, respectively.*

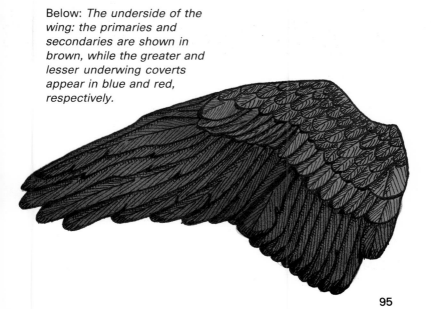

Common Breeding Problems

because it threatens the life of your hen as well as her potential brood. Many eggs are hard to pass because they're soft or irregular, probably as the result of a calcium or vitamin deficiency. Remember, even if your hen has all the cuttlebone in the world, her body can't use it unless she also takes in vitamins A and D. Other causes of egg binding are lack of exercise or obesity, both of which may prevent her from

moved a good way down the reproductive tract, you may be able to feel it through the abdominal wall. Be gentle! She will most likely die if the egg is broken within her. If a hen is egg bound, you must act at once to save her life. If she's fairly spry, you may be able to help her yourself by holding her in a towel over moist heat to relax the vent. A safe, easy source of moist heat comes from bringing a pot of water to boil *and*

easily passing the egg. Sometimes it results from a depletion of nutrients due to laying too many eggs or raising too many broods in a short amount of time. A pair of vets have reported on one cockatiel hen who became egg bound after laying more than 40 eggs in a single month!

Egg binding is pretty easy to detect in most cases—the hen will sit with puffed-up feathers, closing her eyes and straining. If the egg has

Above: *The sheath in which a feather develops dries and eventually flakes off, allowing the feather to unfurl.*

turning it off before placing the bird above it. (We women can tell when the steam's the right temperature because it's comfortable enough for us to "sauna" our complexions by holding our faces over the pot.) A *small* amount of petroleum jelly may help lubricate the vent. A beginner

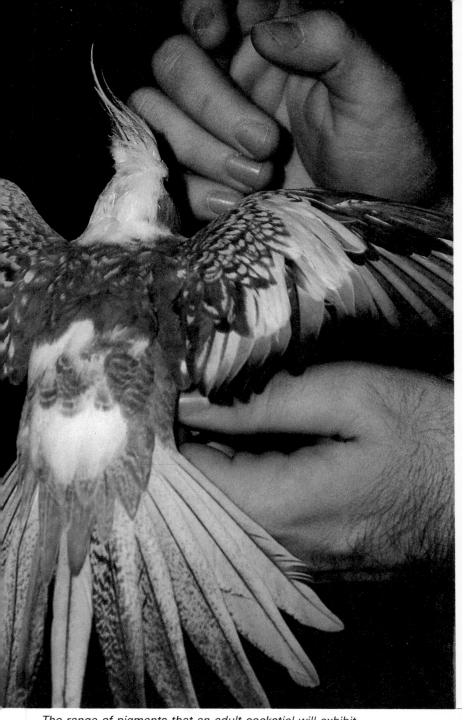

The range of pigments that an adult cockatiel will exhibit become apparent with the first coat of feathers.

Common Breeding Problems

should never try to move the egg down the reproductive tract through massage or other external manipulation because the chances of breaking the egg are just too high. If steaming the vent doesn't result in expulsion of the egg, contact a vet right away. Immediate action can make the difference between life and death for the hen.

To prevent egg binding, don't overbreed your hens. Two or three broods a year is enough. Always have cuttlebone or another mineral source available to the hen, as well as good sources of vitamins A and D. Unlike humans, your cockatiel can't manufacture vitamin D from vegetable matter, so egg yolk or enriched protein food is vital. Since outdoor birds can make vitamin D from sunlight, using a full-spectrum fluorescent light indoors may also help prevent deficiencies. A good avian vitamin mix will help prevent problems. Since cockatiels don't drink very

Above: *The bald area behind the crest is most pronounced in lutino cockatiels.*

much water, the kind that you sprinkle on their food is most likely to get inside the birds.

A problem that really isn't a problem: You see your hen producing loose, watery droppings around egg-laying time. This phenomenon is perfectly normal and not uncommon.

Birds frequently lay some infertile eggs along with the fertile members of a clutch. However, if clutch after clutch is infertile, something is wrong with one of the parents. Since the cock must mount the hen to fertilize her eggs, a male with an amputated or deformed leg can't be expected to father young even if he's perfectly fine otherwise. Keep him as a pet, and find another male for

A lutino cockatiel housed in a spacious flight.

your breeding project. An overweight male can also have trouble touching his vent to the female's; in his case, slim him down by removing fatty seeds and restricting him to protein food, fruits, and vegetables. Insist that he exercise even if you must remove him from the cage yourself to get him out into the room. Another treatable cause of infertility occurs when an overgrowth of feathers obstructs the vent. Trim these feathers carefully and look for improvement. Poor nutrition may also lead to infertility in either or both parents.

Another problem that probably results from poor nutrition is fertile embryos dying in the shell after only a few days of development. If the hen can't give her babies all they need to grow and

Below: *Indoor breeding cages constructed of wire mesh are easy to maintain.*

develop within the shell, they have a real problem since they can't eat until they hatch! Again, plenty of protein and a good vitamin supplement should prevent most cases.

The very young hatchlings are quite sensitive to diseases that might not bother an older bird. If you must handfeed from day one, giving a drop or two of cultured yogurt for the first few feedings may provide the beneficial bacteria the babies need to fight infection. (If parent-raised, these bacteria will come from the regurgitated food fed by the parents.) You can't do much about cleaning the box once a brood is established, so make sure any nest box you offer is clean before putting it in with the birds, and clean it again after every brood finishes. Change the litter or lining of the brooder containing handfed birds at least once a day.

Not so hard, is it? At least, not when you consider the results—a healthy brood of beautiful and affectionate cockatiels!

Below: *A shipping container for birds has one side angled to ensure adequate ventilation if something is stacked atop it.*

A Cockatiel Aviary

Setting up an aviary or flight cage is a great way to make sure your cockatiels get enough exercise, and it can beautify your home or garden as well. However, before you plunge into the carpentry business, take the time to do some planning. A thoughtful arrangement can be a pleasure for both you and the birds, while a thrown-together hodge-podge can have the neighbors petitioning you to leave the neighborhood!

The first thing you must determine is whether you will have your aviary indoors or out. You will probably have

Above: *Cockatiels are peaceable enough to be housed with a wide variety of other species, such a doves.*

more room if you can expand into the outdoors, and your birds will have the benefit of getting their vitamin D, "the sunshine vitamin," direct from the source. You will, of course, add to the beauty and interest of your garden. And, best of all, cockatiels get more exercise and breed

Chicken wire, though not ideal for an aviary, will not be damaged by a cockatiel's chewing.

A Cockatiel Aviary

more quickly and easily in a roomy outdoor aviary!

However, if you live in a suburban or urban neighborhood, watch out for zoning restrictions. A law meant to discourage backyard poultry may be interpreted as a ban on all bird keeping, while restrictions on commercial interests in residential neighborhoods have been used to persecute hobbyists who must occasionally sell excess stock. Your sweet, quiet cockatiels certainly won't bother anybody, but they can make a convenient target for cranks, so find out what the law is *before* you start pouring concrete.

Vandals and thieves are also a problem in suburban and urban areas. I have met uninformed individuals who didn't know the difference between a cockatiel and a cockatoo, but they certainly knew that one of the two can be worth hundreds of dollars! Indeed, I know of one theft where an ignorant teenager robbed an aviary and stole an inexpensive (but loved) pet parrot only to leave several macaws worth thousands of dollars apiece alone. In that case the owner got lucky—the boy's father returned the bird and refused the handsome reward offered by the owner—but why tempt fate? Plan to install a security system that includes both locks and alarms.

If you're in a rural location with a mild-to-moderate climate, you're in the best position for an outdoor aviary for cockatiels. Defenses against winged and four-footed predators are relatively inexpensive and quite reliable, and you'll find housing the hardy, adaptable cockatiel much easier than caring for a fussy tropical bird. If you have the land in this situation, you really have no reason to deny yourself or your birds the pleasure of an outdoor aviary. Just watch out: This hobby's highly addictive! You may end up with flight pens sprouting across your ranch like mushrooms!

Although this book isn't the place for an in-depth carpentry lesson, let's quickly take a look at some of the things you'll need to know before you build. *Every* outdoor aviary should have a well-lit enclosed section that you can drive the birds into during bad weather. The door between the outdoor and indoor portions can be left open most of the time, so that the birds can come and go as they like; if you provide proper, comfortable perches and roosts, most of your cockatiels will probably also use this inner area for sleeping. Don't try to do without such a shelter even if you enjoy a mild climate. Do you really want your cockatiels getting blown about, say, during a hurricane? In more extreme climates, the shelter will need a heat source. A couple of infrared heat lamps placed

These cockatiels show some of the range of delicate colors possible by combining mutations.

near the roosting boxes are fine for a few tough guys like cockatiels, but if you have more delicate species housed with them, you may need something more elaborate. You must also cover part of the outdoor roof so that there is *always* shade to be found within the aviary. To prevent escapes, build a double-door "escape hatch" system. Although a variety of aviary shapes are possible, keep in mind that a *long* flight pen will be best for a strong flyer like the cockatiel.

A concrete aviary floor is easy to wash down and will protect against rodents, but it isn't as attractive or simple to care for as a natural earth floor, which often will renew itself unless you have overstocked it with birds. It also allows for natural planting, which will be especially appreciated by any cockatiel occupants of the aviary. If you plan on a dirt floor, be sure to sink the aviary sides in trenches at least 18 inches into the dirt. Rats and mice will probably not go that far down to break in, but an armadillo certainly might! Be aware of the pests in your area so you'll know what to guard against.

A greenhouse or indoor bird room is also a nice option. Some handy hobbyists have even converted spare closets into small, comfortable bird rooms. (Not me! At my house, there's no such thing as a spare closet!) The floor and walls should be made of tile or other easily cleaned material, and the lighting should include full-spectrum fluorescents that are on 15 hours a day while the cockatiels are breeding. Plants in pots may be rotated in and out of the bird room to add a natural air without allowing an enthusiastic chewer a chance to gnaw anything to death.

Companions

Whether you opt for an outdoor flight or indoor bird room, you're unlikely to feel satisfied with a bare-bones set-up containing perches, nest-box, and cockatiels. (The cockatiels themselves, however, will thrive in such a situation.) You want a beautiful aesthetic experience out of all your hard work! So how can you turn a nice aviary into a little piece of Australian habitat?

Cockatiel-stuffing isn't the way. You will do best if you never keep more than one adult pair of cockatiels and their unweaned young to a flight. If cockatiel breeding is your main interest, you should build a flight, preferably 6 to 10 feet long, for *each* pair. Mixing many cockatiels can lead to nesting and territory disputes that cut down on breeding, and it prevents you from breeding superior offspring by controlling who mates with whom. Even if you did get a prize-winning specimen, you probably wouldn't be able to figure out which pair produced it so that

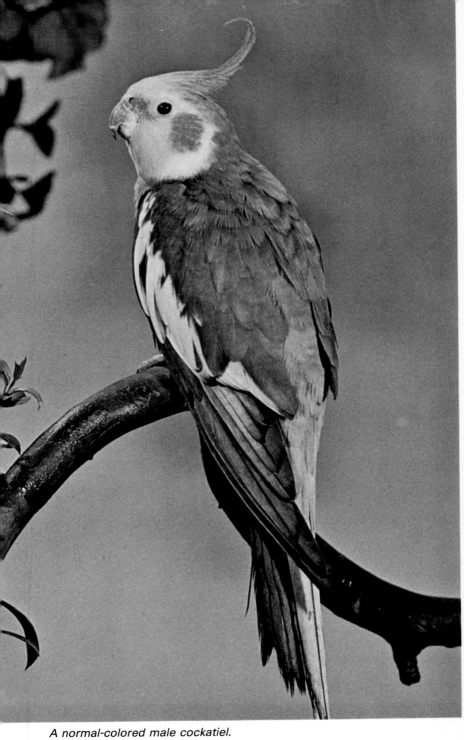

A normal-colored male cockatiel.

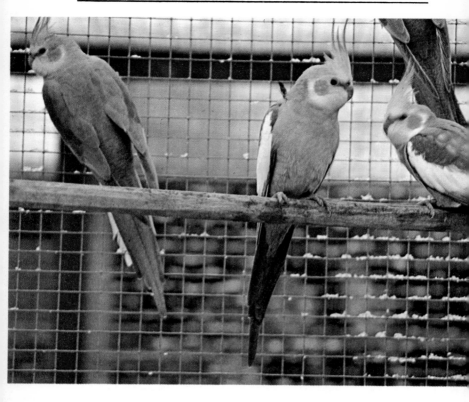

you could repeat your success! For these reasons, one flight, one pair remains the best rule unless you aren't breeding your birds.

Many other kinds of avian companions are perfectly fine and get along wonderfully with a cockatiel. Since cockatiels are gentle and unaggressive, you should go smaller rather than larger when choosing potential pals. Budgies, finches and canaries, and inoffensive ground-dwellers such as quail are good choices. Avoid lovebirds; they may look small and sweet, but they are bad sports about sharing with anyone but their mates. A

Above: *Outdoor aviaries are best furnished with natural perches.*

nice Australian grouping would consist of a pair each of cockatiels, zebra finches, and diamond doves. All three share similar habitats and are especially hardy in outdoor aviaries.

For a successful community aviary, you must provide sufficient feeders and water fonts, lots of cover, and above all, *room!* A small feeder for every pair of birds will prevent

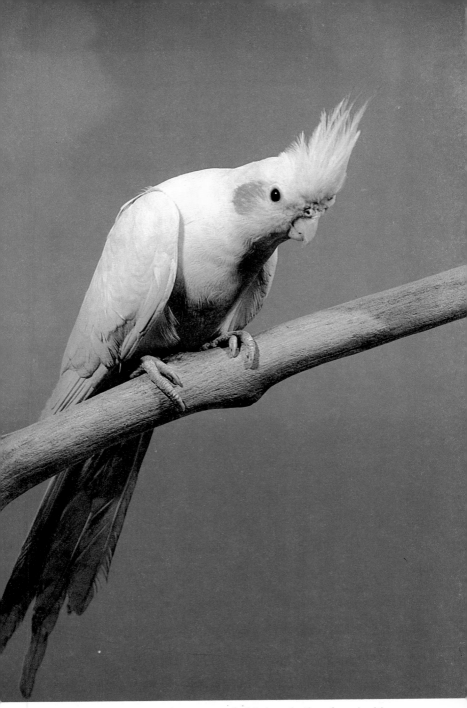

In general, cockatiels are steady birds, whether faced with people or other birds.

a bully from keeping others from eating their fill. (I have witnessed pairs of tiny zebra finches chase pairs of the much larger button quails from feeders and even their own nests, so don't think it can't happen because you made such wise choices.) Cover should be supplied by safe vegetation. A corner stand of grass is especially well liked by Australian birds; small fruit trees, eucalyptus, and privet can also provide good munching as well as safe cover. Smaller plants should be on the tough side so that they'll survive the birds' attentions; for instance, bromeliads and palms are excellent southern choices. Be sure you aren't inadvertently choosing a poisonous plant to place in

with your birds!

If you have enough cover and feeders, but the birds are still fighting, you just haven't given them enough room. You have a serious problem on your hands. Territory disputes may seem "cute" and "funny"—until the day when one angry bird corners another and tears it apart. You can't blame the aggressor, since its hormones (especially during breeding) are telling it to clear its territory of competitors for mates, nesting areas, and food. It's up to you to make sure that each bird feels like it has more than enough room to be generous with others.

Be *very* conservative when making your plans. A finches-only aviary might have as many as 1 bird for every 10 cubic feet, but a cockatiels-only aviary should have *100* cubic feet for every bird if you're putting more than one pair to a flight. Obviously, you

Below: *The typical aviary consists of a flight area and a shelter room.*

Above: *Increased room to fly is only one of the benefits of housing cockatiels outdoors.*

can decrease the birds' sense of territorial competition if you have only one pair of each species per flight, since different species fill different niches in nature; hence, a pair each of budgies, cockatiels, and finches could do very well in a moderately sized flight. Still, even restricting yourself to a pair of each different species, 1 bird for each 10 cubic feet is a good rule to follow. As you get acquainted with your own birds, you may find that you can get away with some more—or you may find you have to cull a few! Whenever you have personality clashes in the aviary, it's almost certainly a sign that you have too many birds in a confined space.

Got the picture now? Your perfect, peaceful dream aviary won't be cluttered with birds like the stuffed toy rack at the store. Instead, it will be a quiet, airy, natural environment where all have room to exercise, reproduce, and generally go about their business without harassment from others. If you're doing things right, you'll soon find yourself envying your birds' idyllic, uncrowded existence.

Coping with Injuries and Illnesses

I said it before and I'll say it again: Never put a new bird in with your old birds! Always keep it separated from the others for a month unless you've gotten a vet's okay. It's always possible that even the most carefully chosen pet sold from the cleanest shop with the best intentions somehow picked up a disease that isn't showing yet. My favorite cliché applies: Better safe than sorry!

I've also said time and time again that cockatiels are tough, hardy birds, and that's

Above: *Medicines can be administered orally with an eye dropper.*

certainly true. Their history of domestication even before aviculture was a sophisticated study proves that. However, living in an unnatural environment will always produce some degree of stress in an animal, whether bird or human. If the situation is pleasantly challenging—you play with your pet often and teach it tricks—your bird experiences the positive

Slightly fluffed feathers may indicate relaxation before sleeping as well as the onset of illness.

Coping with Injuries and Illnesses

stress that prolongs its life while making it fun. If the situation is tedious, your cockatiel suffers the stress of boredom, which can lead to a feather-plucked suicide. If the situation is actively unpleasant, well, the poor bird probably won't be around very long to complain about it. That doesn't contradict my statement that cockatiels are hardy; it merely confirms the fact that very few birds of any kind will live, much less thrive, under poor conditions.

You, of course, care enough to read a book about caring for your pet. You wouldn't force your cockatiel to spend its days picking at moldy seed in a dinky cage coated with filth. But it's so easy to forget about the thing your pet cockatiel needs most of all: companionship. If your circumstances change so that you're too busy to play with a solitary pet, by all means find it a mate or even a new owner! The social interaction vital to the psychological health of these friendly birds is your number-one protection against disease and self-inflicted injury.

Treated well, a pet cockatiel is in a great position to enjoy many years of health. Especially if it has no contact with other birds, it has relatively little opportunity to acquire many disease organisms. The individual attention it gets from you is a plus that provides it with physical, as well as psychological, resilience. Yet,

in this imperfect world, even the best-kept pet may be injured or stricken by disease. By preparing yourself in advance for an emergency, you can give your cockatiel the help it needs without fear or panic.

"A sick bird is a dead bird" is *not* true for cockatiels. Although no bird's illness should be treated lightly, you should remember that a good vet, especially one who specializes in birds, can frequently save a cockatiel's life. It's a good idea to locate an avian vet in advance. Get out your pencil right now and drop a line to the Association of Avian Veterinarians, P.O. Box 299, East Northport, NY 11731, requesting a list of members in your area. Although the association can't guarantee a member's expertise, you can certainly assume that a vet interested enough to join this organization cares about birds! Because avian science (other than poultry science) is so young, it may seem to you that your vet spends an awful lot of time looking up information in books or journals when working on your case. That's actually a good sign, not a bad one. There is no way that any vet could have learned all there is to know about the many pet birds in vet school when most of the findings are just being published now.

Getting to the vet shouldn't be a worry with a tame cockatiel. If its usual

Should a cockatiel become ill, tameness makes treatment easier to accomplish and less stressful to the cockatiel.

Coping with Illness

Above: *Pet cockatiels should occasionally be given a physical examination to detect any developing problems.*

cage is portable, remove cups, toys, and all except for one perch to make moving it less stressful. Put a millet spray and a bit of fruit on the bottom of the cage so that your cockatiel can nibble should the urge strike, but don't clean the tray now; many vets like to look at the droppings to help diagnose the illness. If the cage isn't portable, you should transfer your pet into a small travel cage kept on hand in case of

emergency. In any event, be sure to cover the cage when moving the bird to give it privacy and to keep it warm during transport.

Coping with Illness

It isn't always easy to tell when a cockatiel is sick. All birds have a tendency to conceal illness, leftover from days in the wild when showing weakness was sure to attract a hungry predator in search of easy prey. Behavior changes are often the first sign of sickness in a cockatiel. If your bird loses interest in its usual games and surroundings, especially if its stops preening its feathers, it's probably sick. Other symptoms include weight loss, puffed-out feathers, and discharges from eyes, nostrils, or vent. Sometimes you won't realize how much weight a "puffy" bird has lost until you feel under its feathers and find that its keelbone sticks out like a sharp little knife.

You can treat your cockatiel at home if its symptoms aren't too severe. It's a good idea to keep on hand a smallish, long hospital cage for the convalescent's use so that it will be able to get to food and water without much effort. A heat lamp or light bulb should be placed at one end of the cage so that the cockatiel can seek extra warmth if needed. Since a bird's body temperature is *normally* close to 110°F, a bird with a fever can burn up its fuel reserves in a matter of hours! The

The eyes are often a good indicator of health in a cockatiel: wide-open, bright eyes are a sign of well-being.

outside warmth will help prevent its body from exhausting itself. Place the cage in a secluded location so that the cockatiel will feel secure instead of self-conscious about others noticing that it's sick. The hospital cage is also excellent first aid until you can get in touch with a vet.

Many people successfully treat minor problems at home by combining the use of the hospital cage with a pet-shop or home remedy. However, you can't expect to diagnose avian disease yourself since many illnesses show the same symptoms. Only a vet or lab analysis will get to the root of some problems. If your pet doesn't respond to home care after a couple of days or if it takes a turn for the worse, get help immediately.

What about parrot fever? Don't worry. Although cockatiels and other parrots can certainly catch this disease, the name is a misnomer because they are not the major carriers. Pigeons, especially feral ones, are probably responsible for most of the spread of this disease. An indoor cockatiel has little chance of developing parrot fever, but if it does, it can be cured if given the proper treatment in time. In the unlikely circumstances that *you* catch parrot fever, you'll find that your doctor can cure you too. Of course, if you ever contract a mysterious ailment, you would tell your doctor that you keep

a cockatiel so that he or she could test for the possibility, but certainly don't let fear of this curable disease deprive you of the pleasure of a cockatiel.

Coping with Injury

Cockatiels are resistant to disease, but are they accident prone! If something panics them, they fly, and if they're inside, they usually fly right into a wall. Most of the time, they'll bounce right back, but if they don't, having a home hospital cage on hand can be a real lifesaver.

If an injured cockatiel is bleeding, act fast! A bird doesn't have much blood to spare. Styptic powder can stop bleeding from a broken claw or feather; otherwise, apply direct pressure on a wound to stop bleeding. The heat from the hospital cage will help combat shock until you get the cockatiel to a vet for help. Later, it can be used with the lamp off to prevent the bird from moving too much until fully recovered. Don't despair. Broken wings and legs splinted by the vet *can* recover full function. Even if your curious cockatiel got so tangled up in something that its foot must be amputated, there's no reason to give up. Although unable to copulate, cockatiels with one leg can otherwise lead perfectly normal lives.

Sometimes a cockatiel gets in trouble coming in for a landing—if the place it has decided to land looks like a

In the home, a cockatiel is likely to fly to the highest perching place available.

119

nice cool bubbly bath and is actually a pot of boiling water! If its feet are scalded, flush them thoroughly with cold water and dry gently with sterile gauze. It won't feel much like moving for a while, so, once again, let it spend a few days in the hospital cage. A severe burn, of course, requires immediate attention from a vet. It's better to avoid this heartache by keeping lids on your cooking containers.

Because cockatiels like to chew, they may also eat some thing around the house that's not good for them. If an object is lodged in the crop, they won't be able to digest or eat again until it's removed.

Above: *Never allowing a cockatiel the freedom of a room unless it is supervised is one of the best ways to prevent accidents.*

See the vet at once. Always consider the possibility of poisoning if your cockatiel gets sick. Mention to the vet any plants, unusual foods, medications, ball-point pens, or anything else you've noticed the bird gnawing. Also mention if you've done any spraying for insects, or used any form of flea control or insecticide on a family cat or dog.

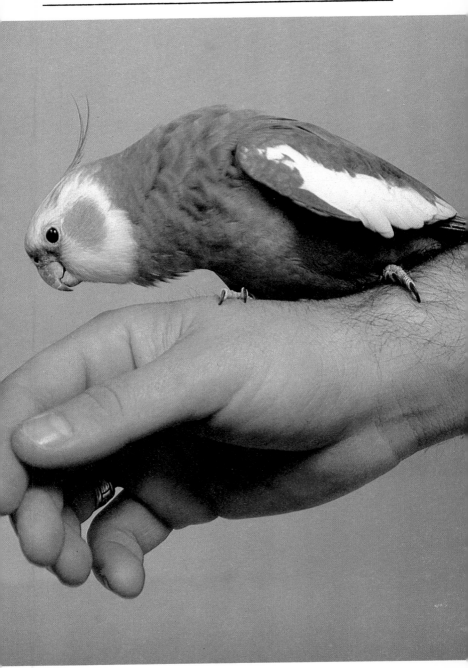

Hand-tame cockatiels are just as liable to have accidents as untame birds.

The coloration of lutino cockatiels makes distinguishing the sexes difficult.

Suggested Reading

ENCYCLOPEDIA OF COCKATIELS
by George A. Smith
(PS-743)

After placing the Cockatiel in the context of other parrots and relating the history of its domestication, Dr. Smith discusses it first as a pet: selection, care, taming, and talking. A chapter on behavior in the wild introduces the section on breeding, which covers accommodations, maintenance, the breeding cycle, and problems that may arise. Comments on each of the color varieties are succeeded by an exposition of the genetics involved. The final chapter deals with health maintenance. "If you needed to limit yourself to one book on cockatiels, this is the volume I would suggest." Arthur Freud in *American Cage-Bird Magazine*.
Illustrated with 60 color and 108 black-and-white photos. Hard cover, 5½ × 8', 256 pp.

ALL ABOUT BREEDING COCKATIELS
by Dorothy Bulger
(PS-801)

Discusses breeding Cockatiels, artificial incubation and head-rearing, hand-taming and talking, grooming and health problems, and adds helpful hints.
Illustrated with 30 color and 20 black-and-white photographs. Hard cover, 5½ × 8', 96 pp.

COCKATIEL HANDBOOK
by Gerald R. Allen and Connie Allen
(PS-741)

This authoritative handbook on keeping and breeding Cockatiels is the outgrowth of many years of study and observation by a husband-and-wife team living in Australia. Covering anatomy, natural history, pet care, and diseases and illnesses.
Illustrated with 77 color and 96 black-and-white photos. Hard cover, 5½ × 8', 256 pp.

EXPERIENCES WITH MY COCKATIELS
by Mrs. E. L. Moon
(AP-1280)

Tells how the Lutino mutation in Cockatiels was established along with other tales about Cockatiel keeping.
Illustrated with 28 color and 41 black-and-white photographs. Hard cover, 5½ × 8', 128 pp.

PARROTS OF THE WORLI
by Joseph M. Forshaw
(PS-753)

Every species and subspec es of parrot in the world, including those recently extinct, is covered in this authoritative work. Almost 500 species or subspecie ; appear in the color illustrations by William T. Cooper. Descriptions are accompanied by distribution maps and accounts of behavior, feeding habits, and nesting.
Almost 300 color plates. Hard cover, 9½ × 12½", 584 pp.

Index

Page numbers set in **boldface** type refer to illustrations.

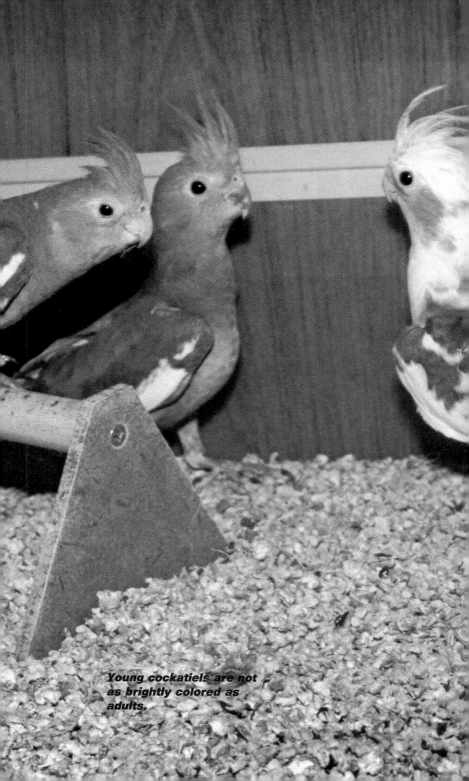

Young cockatiels are not
as brightly colored as
adults.

COCKATIELS

CO-012

A pair of cockatiels preening.